Tradigital Blender

T0386396

Tradigital Blender

A CG Animator's Guide to Applying the Classic Principles of Animation

Roland Hess

CRC Press
Taylor & Francis Group
Boca Raton London New York

CRC Press is an imprint of the
Taylor & Francis Group, an **informa** business

First published 2011 by Focal Press

Published 2018 by CRC Press
Taylor & Francis Group
6000 Broken Sound Parkway NW, Suite 300
Boca Raton, FL 33487-2742

CRC Press is an imprint of the Taylor & Francis Group, an informa business

Copyright © 2011 Taylor & Francis.

All rights reserved. No part of this book may be reprinted or reproduced or utilised in any form or by any electronic, mechanical, or other means, now known or hereafter invented, including photocopying and recording, or in any information storage or retrieval system, without permission in writing from the publishers.

Notice:
Product or corporate names may be trademarks or registered trademarks, and are used only for identification and explanation without intent to infringe.

Library of Congress Cataloging-in-Publication Data
Application submitted

British Library Cataloguing-in-Publication Data
A catalogue record for this book is available from the British Library.

ISBN 13: 978-0-240-81757-6 (pbk)

Typeset by: diacriTech, Chennai, India

Contents

Contents

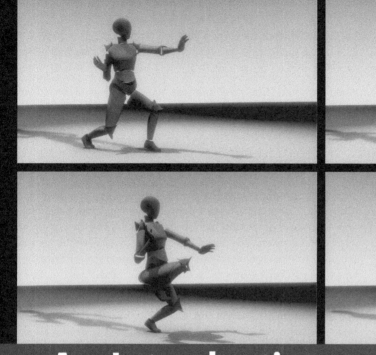
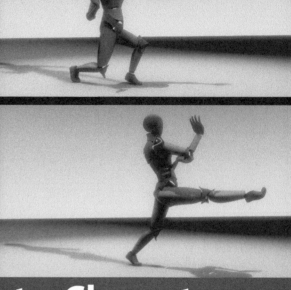

An Introduction to Character Animation in Blender

Animation as both an art form and popular entertainment has existed for almost a century now. The early attempts were received enthusiastically more for their novelty than for the quality of their craft. That even holds true today: animated movies often make it through the studio process not because of their true entertainment value, but based on the novelty of the technological innovation of the day. It turns out that the true core of quality animation as both art and entertainment lies in the joining of two elements: a compelling story and superior character animation.

Before we get too lofty though, let's take a little test.

Are you an animator at heart? Answer "True" of "False" to these questions!

1. I think I could have been an actor if only my face didn't look like this.
2. My techie friends think I'm a little too artsy.

3. My artsy friends think I'm a little too techie.
4. I can spend long hours pouring intensely focused attention into a single thing.

If you answered "True" to all of those questions, or simply found yourself nodding in depressed silence, then you probably have what it takes. If not, you can fake it, and I promise not to tell anyone.

Character Animation

To put it as simply as possible, character animation in computer graphics (CG) consists of posing a digital puppet, recording those poses along a time line, and then playing them back in real time as the computer interpolates between the poses. Later in this chapter, we'll take a look at the tools you can use to do this. Beyond the simple mechanics though, where do you begin? How do you know what pose to use, and when to use it?

The good news is that over the last hundred years, and particularly beginning with the 1950s, professional animators learned a lot about the language of character animation: what you can do, what you can't (or at least shouldn't) do, and what looks like life on the screen. A curious thing happens if you take real footage of a person engaged in some kind of action and trace over it, creating a kind of animation called *rotoscoping*. You would think that something traced from real life and motion would make the best animation, because all of its actions and reactions are perfectly true to life. The balance. The physics. The velocities.

To the contrary, rotoscoping gives you a fairly dead result. It looks okay, but there's clearly something missing, even though every line and jot is taken exactly from real life. The point is that, like with so many other art forms, the goal of an animator is *not* to exactly duplicate the real world, but to implement tools and techniques that give the *illusion* of reality when observed. In fact, once you learn the techniques and rules of animation, you can push the boundaries of reality quite a bit and get your viewer to accept as believable things that simply aren't possible.

Fortunately for all of us, the preceding generations of animators have already cracked this particular code. Through research, hard work, and a lot of trial and error, they determined a set of rules and tricks that when followed can help to give your own animations the feeling of life. Not all animators (or books, for that matter) agree on exactly what these rules are, or exactly how much emphasis you should put on one over the other. However, there is an acknowledged "core" set of rules that are generally used when teaching, and these are referred to as the "Twelve Principles of Animation."

The Twelve Principles

Throughout the rest of the book, we'll be animating a single shot using these principles. As we do that, you'll see exactly where and how they fit into the animation work flow. For now though, let's get an overview of the principles themselves. In order to demonstrate them, we need a model. The animation puppet that's included with this book will do. Say hi to "Junot" (Fig. 1.1). The character has four different skins, two female and two male, one each with a full skin (like in the figure) and another made of separate parts. You can see "Meyer" (the guy) in "tin can" mode in the other half of Fig. 1.1. Looking good, Meyer. Looking really good.

Squash and Stretch

In real life, when you jump from your porch and land on the ground, your knees and spine bend to absorb the impact. They only bend at the joints though, obviously. The bones themselves don't compress or flex in any noticeable fashion. If they did, it would be… bad. Likewise, if you were to slice your hand quickly through the air (*kiya!*), your hand would stay the same shape, no matter how fast you did it. In the world of animation, this is not the case. Depending on how stylized your animation will be, and how drastic the motions involved, actually squashing and stretching the otherwise rigid structures of the body can add life to the final result.

In Fig. 1.2, you can see Junot flying (or falling). Both the extended arm and the body itself have been stretched a bit. The effect isn't drastic, and in this case, you might not have even noticed due to the foreshortening

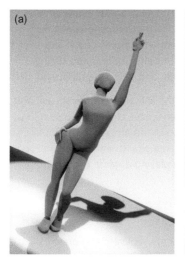
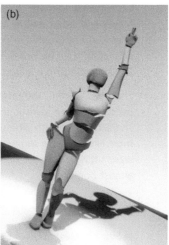
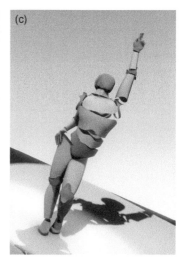

FIG 1.1 (a–c) Junot Strikes a Pose. Meyer Does the Same.

FIG 1.2 Junot Stretching as She Flies.

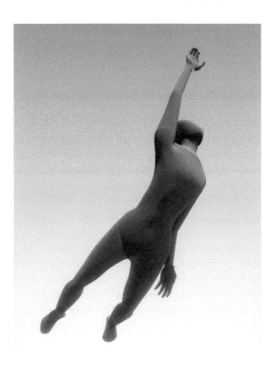

introduced by the camera angle. But it's in there, and if used for a brief moment in the middle of a fast action, it would add life to the animation, helping to emphasize her high forward velocity.

Let's meet one more character: Smith. Smith is the same basic puppet as Meyer and Junot, but he has been given cartoon-like proportions. A character like Smith can endure a lot more squash and stretch during animation than his more realistically proportioned siblings. **Fig. 1.3** shows Smith landing from a leap, with and without squash and stretch.

The rules are this: the faster the action, the more squash and stretch you need. The more realistic the character, the less you should use. So, a character like Smith who is bouncing around the room like Daffy Duck will most likely exhibit some extreme squash and stretch. If Junot and Meyer were sitting on a park bench playing a game of chess, they would have almost none.

Anticipation

In **Fig. 1.4**, Meyer is about to throw a devastating punch. What's that you say? He isn't? Clearly, Meyer does not look like someone who is about to strike. Myths about Bruce Lee being able to deliver a devastating blow from mere inches away without any kind of wind up aside, when one person—and thus,

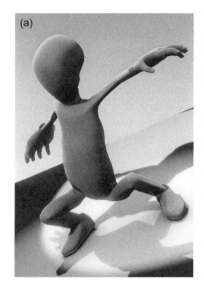
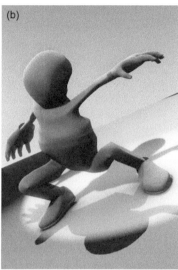

FIG 1.3 (a, b) Smith Just Fell Off the Roof. Don't Worry. He's Okay.

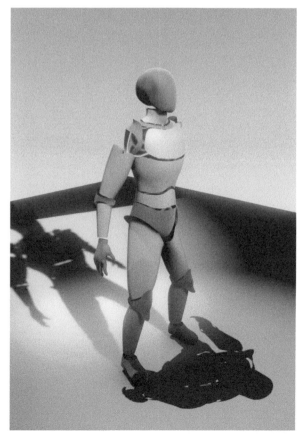

FIG 1.4 Are You Gonna Do Something, or Just Stand There and Bleed?

a character—does something, one almost always anticipates the action. The larger or more forceful the final action, the correspondingly big the anticipation must be to make it feel right.

Anticipation helps to bring balance to your animation, not in the sense of left-to-right or in making sure that the character's weight makes sense over its points of support, but balance in time. What comes *after* necessitates that something comes *before*. We don't think about it in those terms when we go about our daily lives, but that is only because our bodies are so good about planning ahead for us. Almost constantly, our bodies are one step ahead of us, preparing themselves for the next thing that they already know we are going to do. What happens when our bodies don't plan properly and that anticipation doesn't happen? We turn around and walk into the door (or flying ball, or car) we didn't see and a whole different branch of physics takes over.

Additionally, anticipation can be used to grab and direct the viewer's attention. Not only does it provide the proper physics, but it also shouts "Look what I'm about to do!" (Fig. 1.5).

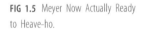

FIG 1.5 Meyer Now Actually Ready to Heave-ho.

Admittedly, that's a drastic anticipatory pose. It is pushed to the point that his body is breaking up, and you almost can't read it. I'm not even going to show you the fully skinned version. There is lots of pinching and nastiness. However, this type of extreme anticipation pose wouldn't show for more than a couple of frames, and the human eye isn't fast enough to note it in detail. Coupled with some motion blur, it will give an impression of extreme motion, great force and life, just before impact.

Staging

My preferred term for this is "Composition" because I think more photographically (Get the shot!) than theatrically (Places everyone!), but it amounts to the same thing. Where is everything on "stage?" How does it actually look in the camera? Where is the viewer going to be focused? Cinematographers have developed an entire language for directing the viewer's attention to different elements on the screen, and we get to borrow heavily from them. While we can use all of their tricks—lighting, color, focus, contrast, etc.—the basics will have to come first.

Fig. 1.6 shows Junot feeling sad. Well, it does if you can find her. Nothing about this composition favors the subject or theme. The eye is directed far away from her by the lighting, which is too bright and cheery to begin with. She is too small in the frame compared to her surroundings, and the proportions of the piece are all off.

However, if we take the exact same objects, compose the shot differently, and apply a different lighting scheme, we get something like Fig. 1.7 that is much more suggestive, and certainly more in keeping with the subject matter. There is no question what the focus of the shot is supposed to be and the visual lines of the light and the ground itself point us to Junot.

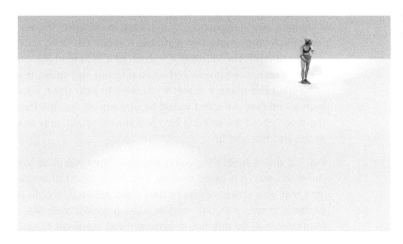

FIG 1.6 Citizen Kane This Is Not. Composition Matters.

FIG 1.7 Much Better.

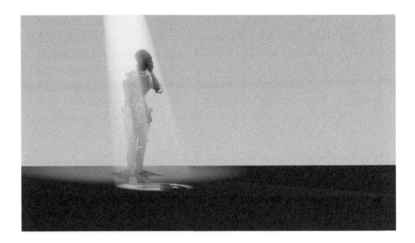

Not every shot must be a stylistic masterpiece, but you at least need to make sure that your staging isn't fighting against your animation. Your animation will lose.

Overlap and Follow Through

Although they are used for different effects, both of these terms demonstrate the physical principle of inertia on the character. Remember Newton's first law of motion (paraphrased): stuff wants to remain at its current velocity (which could include zero velocity—standing still), unless something happens to it. Kind of obvious, but the implications in animation are immense. Inertia is simply an object's desire to just keep doing what it is that it was doing before. A block of wood on the ground isn't going anywhere by itself. Give it a kick, and it takes off.

Think about the foot that gave the kick for a moment. It was just happily planted on the ground a moment ago, when all of the sudden the hip rotated, which pulled the upper leg along with it, which put torque on the knee joint, which transferred that energy to the lower leg, on again to the foot which finally moved. In real time, it didn't take long for that chain of motion to reach the leg, only a fraction of a second, really. But each part of the leg experienced inertia and wanted to just stay where it was until something else made it move. If you were to slow down a karate kick with high speed film, the effect would be obvious. At first, the foot and lower leg drag behind the rotating hips and driving quads, only snapping forward at the end like a whip.

Fig. 1.8 shows Junot's leg doing just this. When you make your characters move this way, it is called overlap. One other aspect of overlap is to make sure that your character's limbs (and other assorted bits) do not move perfectly in sync with one another. Motion professionals like dancers or magicians may do this, but in general if you reach out to grab something

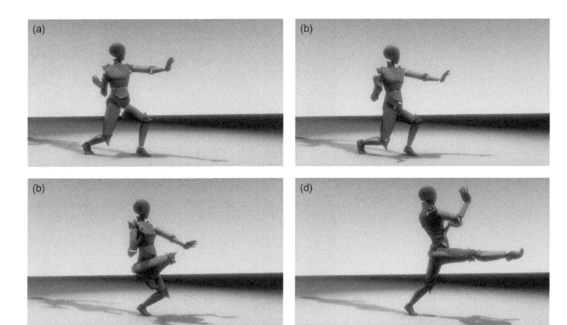

FIG 1.8 (a–d) A Leg with Overlapping Action Demonstrates the Inertia of the Body.

from a counter top with both hands, they will not hit the object at the same time. There will be only a fraction of a second of difference between the two, but in animation, you are responsible for those fractions. Only machines move in perfect synchronicity.

The second part of this principle comes into play after the motive force of the event is over. After the kick, what happens? The character doesn't simply withdraw its foot and return to a standing position. Weight shifts. Momentum probably carries the body forward into a new stance. If the character has long hair, loose clothing or pockets of fat, it will continue to move after the rest of the body has stopped. This is follow through. If you've ever played sports, you'll have heard your coaches encouraging you to follow through and finish your motion. You need to do that in CG as well.

Slow In and Out

CG animators often use the term "ease in" and "ease out" for this principle. It refers once again to the physical principle of inertia. If something is stopped, it can't just be moving rapidly in the next instant. It starts out slowly, gaining speed, until it has reached "cruising velocity." Then, before it stops, it slows down, unless it does something disastrous like smashing into a concrete wall, in which case it stops almost immediately and probably exhibits some extreme squash and stretch. Wiley Coyote, please call your doctor. This was a big deal in the days of hand-drawn animation, and many

FIG 1.9 Two Balls, Moved in Time
(Ball Bouncing along a Floor).

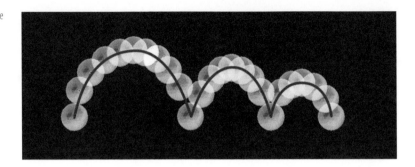

FIG 1.10 Two Balls, Moved in Time
(Ball without a Bounce Point).

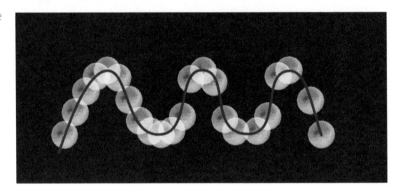

beginners think that since the computer handles this for you, it's not relevant any more.

While it's true that computer interpolation can generally handle ease in and out, the way that it does so encodes a lot of information for the viewer. Check the very standard "bouncing ball" diagram above in **Figs. 1.9 and 1.10**. The **Fig. 1.9** demonstrates a standard ease in/out for a moving ball. Note how the more widely spaced balls near the bottom of the figure suggest that the ball is moving rapidly there, while the closely spaced ones near the top of the arc indicate slower vertical motion. It looks like a ball bouncing along a floor. In contrast, **Fig. 1.10** shows a different motion path, one without a "bounce" point where our intuition tells us that a floor would belong in the other illustration. It certainly doesn't look right for a bouncing ball. Perhaps it's an overhead view of a ball weaving back and forth across a plane. Really though, the only difference between the two motion paths of the ball is the way that slow in/out has been handled. Properly handling this slow in/out is crucial to the perception that your motion is physically correct.

Arcs

This one's pretty simple, and not as much of a problem in 3D as it is in traditional animation. Fig. 1.11 shows Smith's arm moving at the shoulder. Note the arc that the fingertips make. It's pretty obvious why this

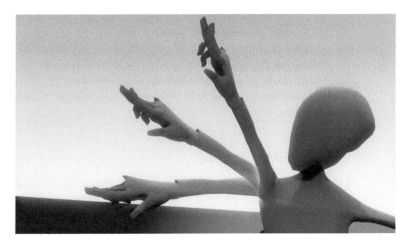

FIG 1.11 Smith's Arm, Moving Only at the Shoulder.

FIG 1.12 Tweening Arm Positions the Wrong Way. **FIG 1.13** Tweening Arm Positions the Correct Way, with an Arc.

happens. Your arm is more or less a rigid figure. If you brace the elbow, your arm will be the same length no matter how you position your shoulder. In traditional animation, artists called "In Betweeners" had the job of drawing the frames between the key frames drawn by the lead animators. **Figs. 1.12 and 1.13** show two different ways to draw the frame midway between the extreme arm positions. Clearly, **Fig. 1.13** is the correct way to do it, but apparently the industry had enough people silly enough to do it the other way that this was worth including among the principles.

In CG, we usually animate using a bone structure much like a real body's, so this sort of arcing isn't a problem. Arcs are still important though. If you're not careful how you do things between key poses—basically if you're not paying attention—you can end up with arc-less motion. So, as a sanity check on your animation work, you can show the actual paths that different limbs or objects follow to make sure that you *have* been paying attention.

Secondary Action

"What's going on" is the primary action. The punch. The leap. The walk. Secondary action is what the body is doing in addition to the primary action. This doesn't mean that every character you animate should simultaneously be skipping rope, cooking a steak dinner, and solving a puzzle. It does mean that you need to keep in mind what the other parts of the body are doing while the main action is taking place.

If the main action involves your character reaching out to grab a falling leaf, think about what the other hand is doing. Are the fingers rubbing together in nervous anticipation? Is it tapping out a rhythm on the character's hip while he hums? It doesn't have to be elaborate, but it can't be nothing.

Secondary action can give dimension to your characters. Is the secondary action at odds with the primary action in a meaningful (but subtle) way? Perhaps the character is conflicted. A purposeful, determined character's secondary actions will appear directly in service of the primary. Secondary action can also help to provide balance to your character, both physically and visually. A strong primary action will need to be balanced in time by anticipation and follow through, but an extreme action like reaching *way* up to grab something from a shelf should be balanced with a secondary action, integrated right into the pose. The rear leg lifting off the ground provides this, as shown in Fig. 1.14.

Timing

While arcs and secondary action are fairly easy concepts to learn, timing is probably the most difficult. There are so many aspects to timing that you could devote your entire life to studying it and probably not learn everything that there is to learn. Summed up simply, timing is "When things happen." It can convey an enormous amount of information.

Fig. 1.15 shows a ball colliding with a box. The timing of what happens next tells the viewer a lot about the reality of the scene. If the ball stops dead, and the box *slowly* tips over until it falls off the ledge, the timing has indicated to us the relative masses of the two objects. If both the box and

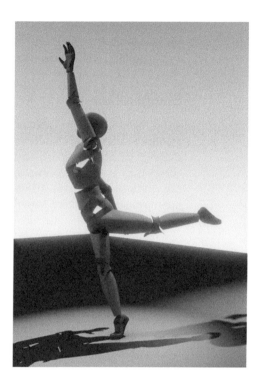

FIG 1.14 Junot Reaches High and Balances with Her Leg.

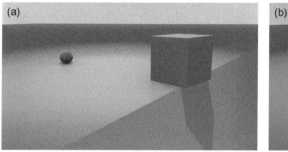
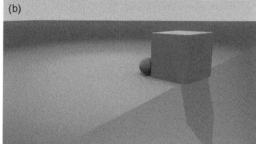

FIG 1.15 (a, b) A Ball Approaching a Box.

ball fly off the ledge, with the ball hardly slowing down, it tells us that the ball was heavy and that the box was probably empty.

Timing can refer to such overall issues as when one character enters a scene relative to something important that just happened. It can be as tiny as how long it takes a particular character to blink. Consider one more timing example: a character hits another one with a cast iron skillet. If it is done in a serious fashion, the timing of the action would need to be realistic, and the result would be violent. Change the timing though, and the whole timbre of

the scene changes. If the skillet is drawn back and the anticipation pose is held for an unusually long time, then the character strikes and returns to a resting position almost instantly, it could read as funny.

Exaggeration

As we mentioned earlier, attempts to simply rotoscope live footage do not produce "live" results. When we reduce the real world down to rendered shapes, a lot of information is lost. To counter that loss, we have to put energy back in to the process. One way to do that is through exaggeration. The anticipation pose (Fig. 1.5) demonstrates this. No one throwing a real punch would wind up like Meyer in that illustration. However, since we won't be showing all of the subtleties of a real person doing this—muscles tensing under their skin, eyes widening, and nostrils flaring with adrenaline, all the minute quirks that a real person has—we have to make up for it somehow. We do that by throwing in a few frames of an exaggerated pose. Perhaps we create a pose that actually represents what someone would look like in real life, but then we take it further, just enough that it registers with the viewer.

That extra bit of life will (hopefully) distract the viewer from noticing that our characters aren't real, and they will buy into the performance.

You can think of animation as a sort of "shorthand" for action. Live footage of a person walking down a street provides us with an unbelievable amount of information. Everything from the subtleties of how their hair is kept, to the look on their face, the tone of their skin, how hard they are breathing, where they are looking and how often, the condition of their clothing: all of it tells us a story. But in animation, we don't have the time, the facility, or even the desire to recreate the real world in such exacting detail.

We don't need to. We can use the shorthand.

Part of that abbreviated visual language lies in exaggeration. Take a look at the video called "Junot Strut" on the web site (Fig. 1.16). If a real person walked like that it would be ridiculous, but when you strip away all of the subtleties of the real world, it works. In fact, it *only* works because of the exaggeration.

Exaggeration is not only about making things bigger and more intense, although that's the simplest form of it. It is really about emphasis: what traits within our characters we choose to highlight as animators.

Solid Drawing

In traditional animation, this refers to the ability to draw. You have to be good at it. Really good, actually. If you're not, you're not going to make it. In CG, one can (in theory) be a very good animator without being able to draw even a bit. The goals of "solid drawing" in traditional animation are to

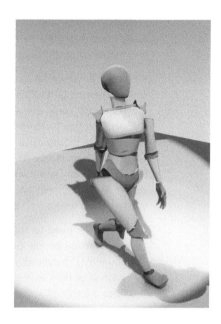

FIG 1.16 A Frame from "Junot Strut."

have your characters and sets drawn in a professional fashion and to have elements drawn identically from frame to frame. A face has got to look like a face, and if you can't draw one, well, forget it. Likewise, if you're animating a character turning around and you can't make sixty drawings of your character in a row that make it appear to hold its volume as it rotates in space…

Fortunately, the computer takes care of that aspect of "drawing" for us. Yes, you need construction skills when you design and model your own characters and sets, but once it's time to animate, you don't need to worry about it so much any more.

Solid drawing is not lost on us though. It comes through in our other decisions: how we pose the character, the camera angle, and how we use our tools. "Solid drawing" is a measure of how well a traditional animator uses a pencil, pen, and brush. The same metric applies to us: know the basics, know your tools, and use them well.

Appeal

Appeal isn't necessarily about creating animations with cute bunnies—but it can be! More generally though, it's really about knowing your audience and their expectations. For most of the twentieth century, when animation came alive as an art form, entertainment products had to be distributed through the established channels of film and television, both of which required massive investments. The consequence of that was that anything you wanted to distribute through those channels had to have a large

enough audience that was willing to pay for it in one form or another to make it worth anyone's while to fund the production. Mass appeal was key, and that is what this principle spoke to.

We live in a wonderful time when both the cost of distribution and the cost of creation (in cash) are negligible. Snag a $120 computer off of craigslist (dual core—I've seen them!), load it with Ubuntu Linux and Blender, and you have yourself a production studio. You could even put Blender on a thumb drive and run it on a library computer for no cost to you at all. Then, throw your animation up on Vimeo or YouTube and you have instant, free worldwide distribution. With the cost of production and distribution potentially knocked down to nothing more than the time you're willing to put into it, the definition of "appeal" changes drastically.

You no longer need to appeal to millions of people to make it worth your time. How many people need to see your animation for you to feel you've "broken even?" Maybe that number is one. With the cost so low, it might be worth your time to make an animation just for your own happiness. But the odds are that at some point, you'll want other people to see your work. Making something that has to appeal to millions to have any chance of distribution is old and busted. Making something that appeals to yourself and letting the Internet help an audience to find it is the new hotness.

Straight Ahead Action and Pose to Pose

This last principle has no fancy illustrations, as it refers more to a method of working than anything else. When an animator decides that they want to use the "straight ahead" method, they think: *Smith is being chased by a tiger. I want him to career through the jungle, flailing madly and tripping over himself and everything else around him in panic*. Then, they proceed to do just that, from start to finish, literally. On the first frame, they create Smith's first pose. Advancing a few frames, they create the next pose. Repeat. Now, a classical (i.e., hand drawn) animator might animate Smith's body and legs in a straight ahead fashion, then go back and fill in the arms, then, hair and any flowing clothes. But each time, the animator thinks about all of the other principles and builds them into each pose as he works. There is no "Well here's a key pose, and I'll just go back later and add the overlap and anticipation." It's straight ahead.

The result of well-done straight ahead animation is usually dynamic, full of energy, and often just on the verge of losing control. Happy accidents can occur while working that bring out aspects of the action you never would have considered from an analytical standpoint. The down side is that it sometimes doesn't fit too well with production schedules and plans ("It took him *how many frames* to get to the other side of the room?!"). It can also end up feeling too loose. To make it work, you have to really know what you're doing.

For the planners in the audience, we have the pose-to-pose work flow. The key poses and extremes are most likely planned out, roughly timed, and approved in advance on storyboards or in an animatic. The animator then proceeds to make intelligent decisions about the poses between those key frames, hoping to imbue the transitions with life and weight.

Done poorly, pose-to-pose animation can end up feeling lifeless and "by the book." On the plus side, it works very well with planning, gives good approval points for animation directors, and is good for beginners, as it is a stepwise process. First you do *this*, then go back and do *that*, and finally you do this *other thing*.

Fortunately, we are not constrained to use merely one or the other on any single project, as you will learn later.

Blender's Approach to Character Animation

In Blender, as in most 3D applications, characters are animated using a system of bones. The entire system of bones is grouped into an overall object called an **armature**. The various bones in an armature can be tied together with parent–child relationships (e.g., the lower arm bone is connected to the upper arm bones and moves when they move), with more complicated relationships created with something called a constraint (e.g., the finger bones that automatically curl when you adjust a control bone). The entire collection of bones, including the way that they are connected and any additional controls, is often referred to as the **rig**. **Fig. 1.17** shows Junot and Meyer in the same pose with the rig superimposed on them.

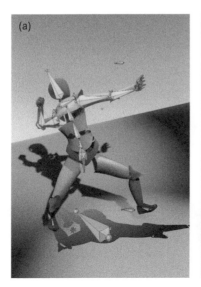
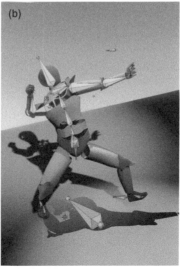

FIG 1.17 (a, b) The Armature Rig Exposed.

We'll go over how to work this rig in the next chapter, but for now it's good enough to just get a look. Some bones, such as the ones at the heel, between the feet, and extending from the back, can move independently of any of the others. Others bones, such as the arms, spine and head, can only rotate, with the location of their bases dictated by the bones that they "grow" from.

The easiest way to think of working with a character in Blender is to imagine that you have a poseable doll with a jointed steel skeleton inside. The skeleton will always stay exactly where you put it, and the joints themselves are perfectly flexible: there is no physical limit to how far they can bend. Of course, there are aesthetic limits, and deciding where those are is why we're calling ourselves artists, no? **Fig. 1.18** shows just how far the joints can bend. Not that you'd want to do this.

In order to animate, you need to create poses that change over time. Blender allows you to record your character's poses along a timeline. This recorded pose, which may be for every bone in the body or just for the rotation of the tiniest joint of the left little finger, is called a **key**. **Fig. 1.19** shows Blender's timeline view. Time is measured in frames, with twenty-four frames in a single second (although sometimes it's thirty). In the figure, the light gray area represents the active frame range (1–29), the green bar shows the current Frame (9), and the yellow bars indicate the presence of keys for whatever object is selected.

FIG 1.18 You Might Want to Have a Doctor Look at That.

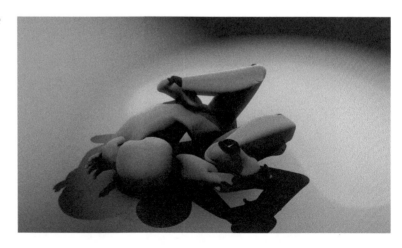

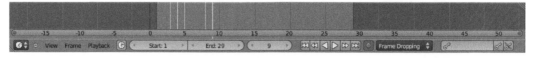

FIG 1.19 The Timeline.

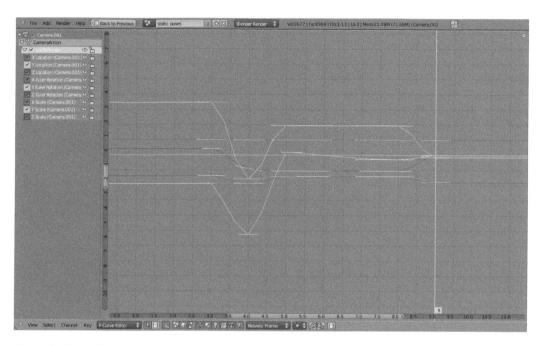

FIG 1.20 The F-Curve Editor. Note the Resemblance to a Pasta Dish.

The process of animating consists of setting the current frame marker to the frame of your choice (say, Frame 1), setting a pose and recording it as a key, then changing the current frame to something else (say, Frame 29), setting a new pose and recording another key. On Frames 2 through 28, the computer provides a smooth transition between the keys for you.

But simply setting poses in time is not the ending point of animation. All of that stuff we talked about earlier in the chapter like Ease In/Out? The fine tuning? **Fig. 1.20** shows the F-Curve editor. It displays the change in time of the different animation values (like location, rotation, and scale) as curves. The curves can be edited, for example, to make a motion begin slowly, but end abruptly.

There are tools that make this sort of thing easier, but every now and then you'll have to make a trip into spaghetti land to get the motion you want.

One of the tools that makes keys and motion easier to deal with is the **dope sheet**, shown in **Fig. 1.21**. The dope sheet is a summary and breakdown of every key in your animation. The left side of the screen shows the names of different things that are animated like bones, cameras, and lamps, while the timeline runs across the bottom. The diamonds in the main field of the screen are the keys. Just like any other object in Blender, they can be selected and manipulated, allowing

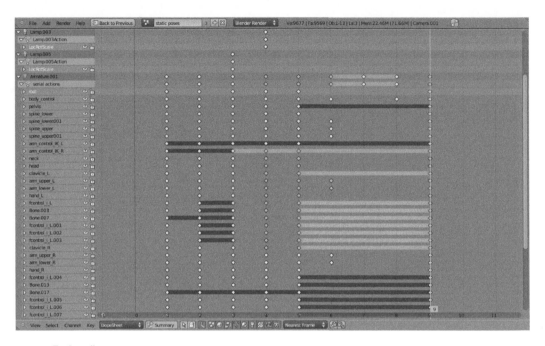

FIG 1.21 The Dope Sheet.

you to move already-created keys forward and backward in time, duplicate and delete them.

So, by posing our character in the 3D view, recording those poses to the timeline as keys, and adjusting those keys in both the F-Curve editor and dope sheet, we can create engaging character animation. We'll look at these tools and screens in detail in the next chapter so that when the time comes, you can concentrate on applying the principles instead of fighting with the work space.

What We Won't Be Doing

Modeling, rigging, directing, and lighting, in short, is what we won't be doing. We want to concentrate on the art of character animation, and those other things will only get in the way right now. We're going to animate a single short shot, and while we'll be paying attention to staging, it's not going to be anything fancy. The characters that are supplied with this book and used in the examples are ideal for the exercise. You can model and rig your own if you like, but everyone rigs a little bit differently, and the examples here will work for sure with the provided rigs. With your own? Maybe.

You'll note that our sample characters don't even have faces. Facial animation, while related, is a separate topic. As an animator, you should be able to tell the whole story with just the body language. If it reads right

without a face, adding good facial animation will kick it over the top. If it doesn't read right without a face, you need to keep working. Of course, this isn't to de-emphasize the importance of facial animation. If your character does have a face (and not all of them do), you are going to have to learn an entirely different branch of the art of animation to get it right.

Review

In order to create engaging character work, animators have developed the 12 principles of animation: squash and stretch, anticipation, staging, overlap and follow through, slow in/out, arcs, secondary action, timing, exaggeration, solid drawing, appeal, and pose-to-pose/straight ahead. Learning these principles and building them into your own work can help to add life and believability to your character animation.

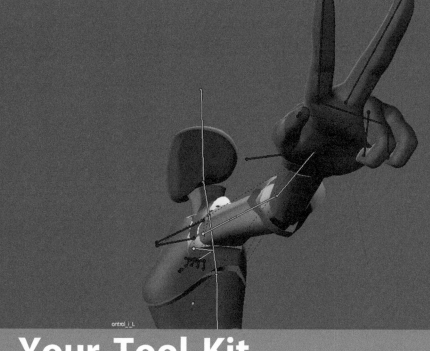

ontrol_i_L

Your Tool Kit

For Solid drawing, know your tools. If you don't, you're going to be lost.

This book assumes that you are already familiar with Blender, although no animation experience is required. You should be able to find your way around 3D views and properties windows with ease. The basics shortcuts (G, S, and R) shouldn't be something new. If they are, you should seriously consider taking a several week long detour right now to make that happen. There are a number of great online resources as well as a few excellent books on the topic (*Blender Foundations*, hint hint) that can get you started.

Optimizing the Screen for Animation

Fig. 2.1 shows the default animation screen that was shipping with Blender at the time I wrote this book. To my taste, it is way too busy. All of those controls and different displays kind of make my eyes go googly. Blender's view-switching is so fast that I don't need the camera view in the upper right. Likewise the Outliner. Organization is cool, but armatures are self-contained and when I'm focused on animation, I generally don't need to play hunt-and-peck through the scene's entire object hierarchy. So, take

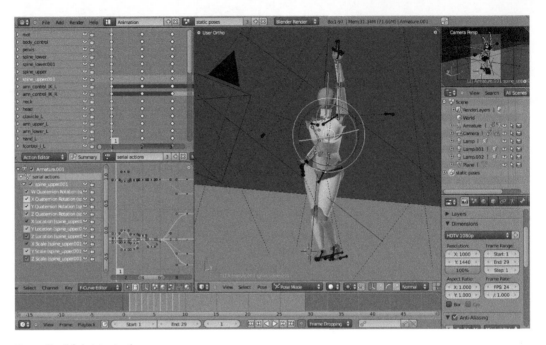

FIG 2.1 The Default Animation Screen.

both of those spaces and give them to the properties window below. We keep the timeline along the bottom, obviously. I also tend to use the dope sheet far more often than the F-Curve editor, so I'll let it take over that space.

That leaves us with something like **Fig. 2.2**, which is a lot less cluttered and to my mind, a lot more functional. While animating, the properties windows that I tend to use are the armature, bone, and bone constraint panels. It's easy to switch between them in one of the available properties window, so I leave it just like that. Of course, if you're blessed with a multi-monitor setup, you can always clone the Blender window and show all of the properties windows along with the dope sheet and/or F-curve editor on the second monitor, leaving your main screen for the 3D view. **Fig. 2.3** shows the three properties windows you will use most often when animating.

When you work with a character and its armature, you want to have the largest amount of space you can get. For that reason, unless I specifically need to see something on one of the other views, I animate with the 3D view maximized. If you don't routinely use the maximize feature in your own work, get familiar with it right now. Hover the mouse over the 3D view and press **Shift-Spacebar**. The 3D view fills the whole screen. Shift-Spacebar again to toggle back, quick as you please. I do posing work with the view maximized for the greatest amount of screen real estate

FIG 2.2 The Cleaned-Up Animation Work Space.

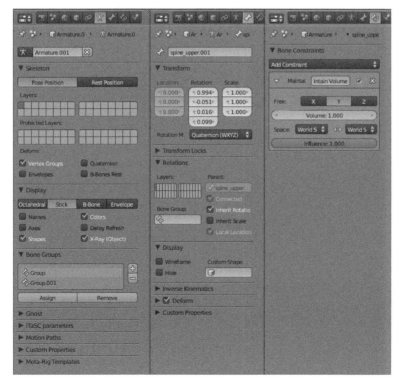

FIG 2.3 Armature, Bone, and Bone Constraint Properties.

and then drop back into the normal view if I need to change a setting or push a key around in the editor.

Controlling the Sample Character

Rigs can be fantastically complex and include all kinds of convenient built-in functionality. For our purposes though, we'll be using a fairly straight rig with only a few niceties. Posing a character in Blender involves rotating, translating, and sometimes scaling the bones of the character's armature. Selecting and manipulating these bones works almost exactly like those same functions when dealing with objects.

Fig. 2.4 shows the 3D view split in half to display both the front and the side view of Junot at the same time. This would be a good time to load the Chapter 2 sample file *tb_sample_02.blend*. When you do so, you'll see something much like the figure. Use the standard selection method in Blender—using the Right Mouse Button—to select the armature, which appears orange in the illustration. To get access to the individual bones, you need to enter **Pose Mode**. Just like Edit Mode allows you to play around with the individual vertices of a mesh object, Pose Mode lets you mess with the bones. Enter Pose Mode by using the **Ctrl-Tab** hot key. You can also do it with the Modes menu on the 3D view header; however, you'll be going in and out of Pose Mode fairly often, so it's worth committing the shortcut to your memory.

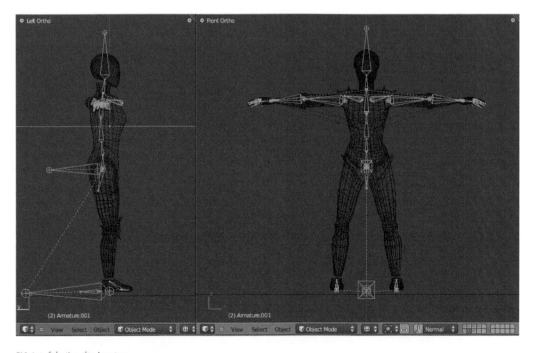

FIG 2.4 Selecting the Armature.

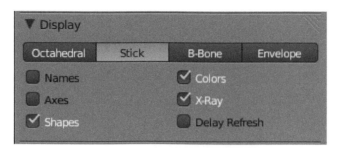

FIG 2.5 Choose Stick Mode When Animating.

When you go into Pose Mode, the bones change color. Some are gray, while others are green. Green bones indicate that they have **constraints** attached to them, which might give them special properties. We'll get to that in a moment. First though, take a look at the Armature properties panel. **Fig. 2.5** shows the **Display** panel, with the option buttons at the top set to **Stick**. In **Fig. 2.4**, and in the sample file, the armature is shown in **Octahedral** mode in which the bones look like elongated pyramids. While that's useful for rigging, it hides a lot of the character itself. When animating, I almost always change the armature to Stick mode so I can see more of the actual character.

The other important visualization setting is also highlighted in **Fig. 2.5**. **X-ray** causes the entire armature to show, even though it is "inside" the character. If you like, disable X-Ray momentarily. It looks nice; however, in Blender, if you can't see it, you can't select it. Keep X-Ray turned on.

Using the Right Mouse Button (RMB), select several of the bones in the armature. You'll see that selected bones in Pose Mode are outlined in a light blue. You can build a selection of bones by holding down the Shift key or by using some of the other standard selection tools (B-key border select works, while C-key brush select does not) as well. Select a single bone and examine. It appears as shown in **Fig. 2.6**. I've selected the upper arm bone in the figure. Note the red, green, and blue orbits around the bone. If they are not showing in your own 3D view, then enable the transform manipulator either by clicking on the highlighted control in the figure or with the **Ctrl-Spacebar** shortcut. Turning the manipulator off and on while animating is another frequent occurrence; so, you might as well stick that shortcut in your memory banks too.

Be sure only to LMB-click on the middle manipulator icon—the one for rotation—and set the alternate transformation space control to **Normal**. The alternate transformation space is set to the right of the manipulator widget enablers on the 3D view header, immediately to the left of the layer buttons. This setting aligns the rotation manipulator with the bone, making it a perfect controller for precise rotations. If you've never used it before, the transform manipulator (or widget) provides one-click access to transformations. LMB clicking and dragging on any of those colored orbits

FIG 2.6 The Character in Pose Mode, Manipulator Enabled.

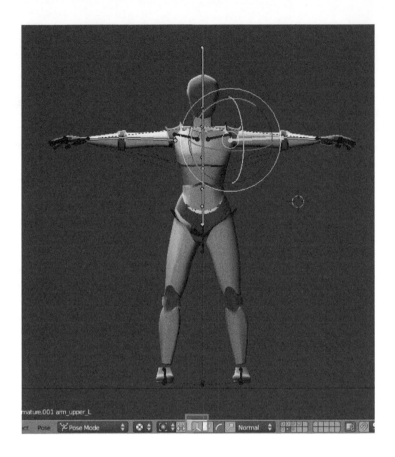

will rotate the selected bone around the appropriate axis. When animating a character, it is fantastically useful.

Here are the rules for posing this armature:

- The upper arm bones can be rotated or translated. Be careful not to move them too much while translating. It's only for fine-tuning how the shoulder works.
- The lower arm bones can only be rotated along the x-axis as shown in **Fig. 2.7**, where the rotation manipulator only shows the red (x) orbit.
- The collar bones, even though they are unattached, can only rotate. Don't forget to use them when posing the arms.
- Each of the bones in the spine, including the head and neck, can rotate around in all three axes. If you want the character to twist, it's better to build the rotation piece-by-piece, with each of the bones getting a portion of the rotation than to simply put the entire rotation on one of the bones.
- The bottommost bone of the spine, selected in **Fig. 2.8**, can also be translated. Once again, this is for fine-tuning, because it separates the upper body from the hips completely.

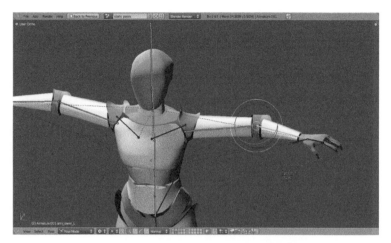

FIG 2.7 The Lower Arm Manipulator.

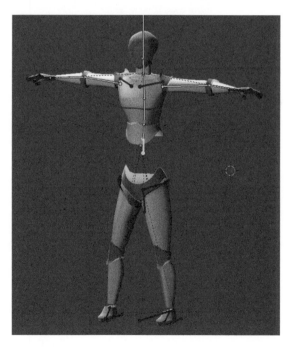

FIG 2.8 The Entire Upper Body Is Separately Movable.

- The bone that extends downward from the pelvis gives you independent rotation and translation control of the hips and upper legs. You will use this bone frequently to give the hips the correct angle for your poses. If you're playing along at home, you'll notice that as you move this bone, the feet stay perfectly in place.
- The bone that extends outward from the character's back can be used to control the motion of the entire upper body, including the hips and the top of the legs. Think of it as the "squat bone," as you can use it to

FIG 2.9 Squatter's Rights.

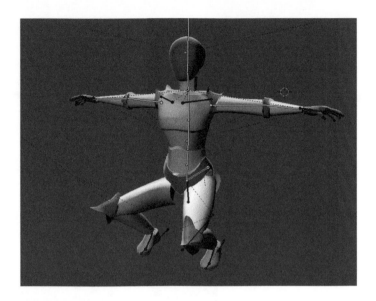

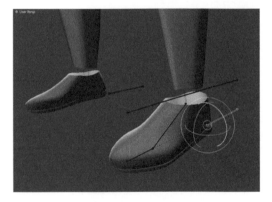

FIG 2.10 The Heel Bone, Selected.

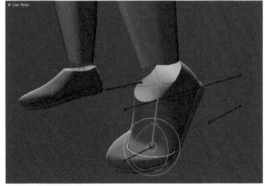

FIG 2.11 The Foot Bone Flexes the Foot.

make your character squat. Fig. 2.9 shows the result of doing nothing other than moving this bone straight down. As this bone controls so much of the body, it is called the "body control" bone.

- Fig. 2.10 shows the heel bone selected in a close-up of the foot. The heel bone is the main foot controller, and will be referred to as that. Translating the bone moves the foot itself and causes the rest of the leg to come along with it. Rotating the bone with the manipulator moves the foot and rotates the leg appropriately.
- The foot bone, shown in Fig. 2.11, is used to raise the heel as the though the foot was flexing, without moving the heel bone itself. It also leaves the toe in position. When we get to walking, we'll make it clear exactly which bone in the foot to use for what.

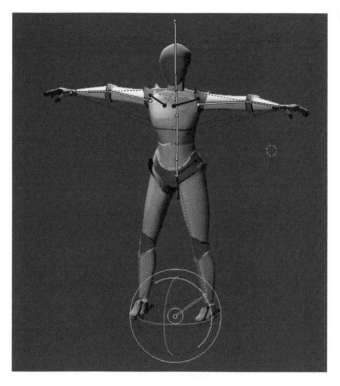

FIG 2.12 The Root Bone.

- The toe bone (yes, the one on the end), just moves the toe. You can use both this bone and the foot bone along all three axes for some subtle and impossible foot shapes, but mostly you'll just use them along the *x* (red) axis.
- The large bone between the feet in **Fig. 2.12** is the root bone of the entire armature. It is used for overall start-of-scene positioning of your character, but not for much else. Once you have established the character's starting position, almost any move it makes away from that point will be accomplished by keying the heel (foot controller) and body control bones.

Finally, let's take a look at **Fig. 2.13**, which shows the hand. The bone that runs the length of the hand (labeled "main") is fairly simple. You rotate it, and the hand follows. The fingers are a different story. To avoid having to pose each finger joint by joint every time you use the hands, we've taken advantage of the fact that fingers have a limited range of motion. Scaling any of the straight finger bones (A, B, C, or D) down causes that finger to curl. The bone can also be rotated along two axes. These two controls allow you to create a large variety of hand positions quickly and relatively easily.

Scaling any of these finger bones up just a bit hyper-extends the finger, allowing you to create positions where the fingers are pressed strongly against a surface. The bone at the end of the thumb acts much like the

FIG 2.13 The Hand Rig.

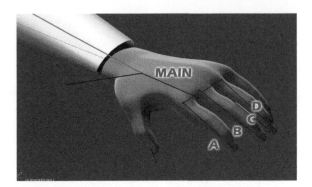

FIG 2.14 Peace Out, Peeps.

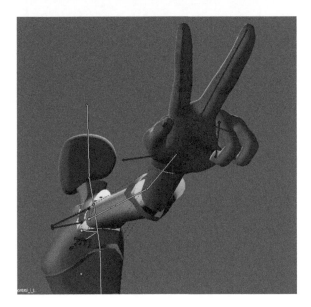

heel bone: moving it pulls the rest of the thumb along with it. **Fig. 2.14** shows the hand with the index and middle fingers hyper-extended (bone scaled up), the ring and little finger curled and rotated, and the thumb pulled inward. Note that because of the **X-Ray** setting, you can see the right hand bones even though they are on the other side of her body.

Can you see the mysterious bone sticking outward from the wrist joint in **Fig. 2.13**? That's going to be our handy segue into the next topic: Forward and Inverse Kinematics. You see, there are two ways to control a chain of bones. The spine and the arms represent one of those ways, called Forward Kinematics (FK). You pose an FK chain just like we described earlier with the spine: each bone individually. To create an FK arm pose, you position the collar bone, then the upper arm, and then the lower arm.

You've already used the other method too, on the legs, if you've been playing along at home. You may have noticed that no leg bones are

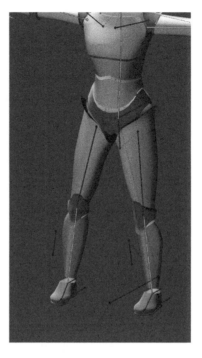

FIG 2.15 The Leg Bones, Out from Their Hiding Place.

showing in the armature. They exist. They're just hidden. I've made them unavailable because they are a part of an Inverse Kinematic (IK) chain, and therefore should not be posed or manipulated directly. **Fig. 2.15** shows the leg bones, just to prove that they exist.

With IK, you position the *end* of the chain, and the system calculates what the rest of the bones need to do in order to make that happen. If you think about it, you'll see that that's how your legs generally work. You concentrate on where you want your foot to go, and the leg adjusts (hopefully) in an appropriate fashion. The rule is this: weight bearing limbs use IK, because the end of the chain like the foot actually becomes an anchor point for the body, and freely moving limbs use FK.

So, to create a pose with the arms, which use FK, you would need to pose and set keys for all of the different bones in the chain. To pose the legs, which use IK, all that you need to pose and key is the heel bone, which is the **IK controller** of the leg chain.

What happens after you've run a marathon and find yourself gasping for breath, braced against a wall like Meyer in **Fig. 2.16**? Your hand is bearing some of the weight of your body. If we're consistently applying the rules we've just laid out, shouldn't that arm and hand be using IK?

Yes, it should. The arms in the rig are built with the ability to switch between FK and IK. In IK Mode, that protruding wrist bone is the arm controller. Grab

FIG 2.16 Just Breathe, Meyer.

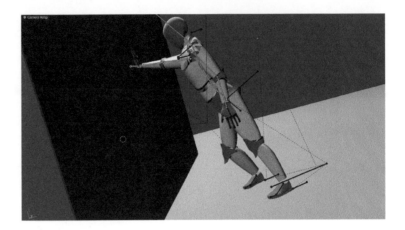

and move it, and the arm moves. More importantly, move the rest of the upper body now and the end of the arm stays put. It is anchored to the IK hand controller. The switch that controls whether or not IK is used on the arms is found at the very bottom of the Armature properties, in the **Custom Properties** panel, shown in **Fig. 2.17**. Setting the control's value to 1.0 uses the full IK solution. At 0.0, it uses the FK position. Values in between show a blend of the two different possible poses. Sometimes these blended poses can look less than great, which is why the management of a transition between FK and IK (or back) has to be handled with care if it has to appear on screen.

NOTE: The FK/IK switch in this rig is just one way to handle the problem. Other rigs you use will almost certainly implement their own method for switching.

So, when the Right Arm *IK* control is set to 0.0, you pose the arm by selecting and individually manipulating and keying the various bones of the arm, like **Fig. 2.18**. When the control is set to 1.0, the arm is posed entirely by moving and keying the bone extending from the wrist, as shown in **Fig. 2.19**.

The last control in the rig is already embedded in a number of the bones: squash and stretch. The upper and lower arm bones, as well as all of the teal bones of the spine, head and neck are all subject to automatic squash and stretch. If you scale them in Pose Mode, they will maintain a constant volume. Thus, scaling one of these bones to make it longer also makes it thinner. Conversely, scaling a bone to make it shorter also makes it fatter. I've taken the "pre-punch" pose from Meyer and applied it to the Smith rig, then made it even more extreme by stretching the arm (he's really reaching!) and squashing the torso (building up power!), in **Fig. 2.20**.

Fig. 2.21 shows the lower arm bone in its rest position, but scaled up and scaled down. Note the automatic volume adjustment as the bone gets longer and shorter.

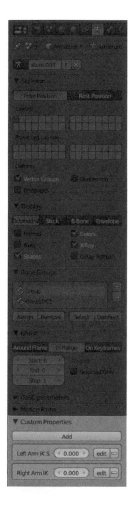

FIG 2.17 The Custom Properties for
IK/FK Switching.

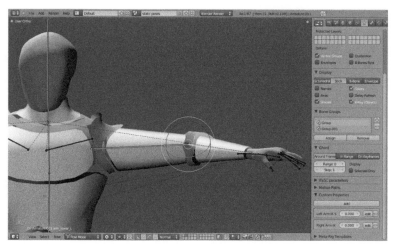

FIG 2.18 The Default Arm Controls: FK.

FIG 2.19 When the Hand Is Locked or Steadied against Something: IK.

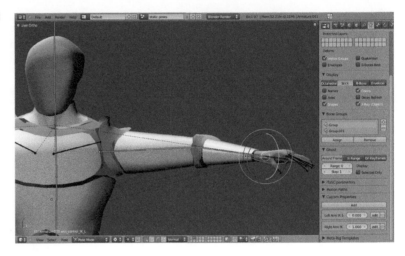

FIG 2.20 Delivering a Cartoon Whalop.

FIG 2.21 (a, b) Automatic Squash and Stretch.

(a)

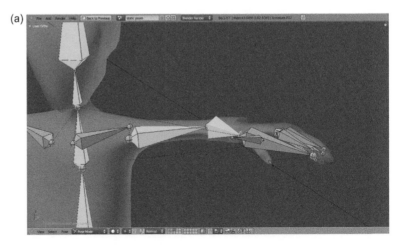

(b)

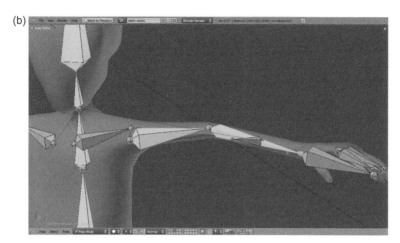

FIG 2.21 (Continued).

NOTE: Bone scaling wreaks havoc with IK poses. Currently, Blender's IK solver does not like scaled bones. Plan ahead so that your squash and stretch avoids directly affecting IK chains. This is why squash and stretch has not been included on the legs in this rig.

With that run-down of the controls, you will be able to pose the characters when we actually start to animate later. We'll reiterate key controls and give deeper explanations about which bones do what when the time comes.

The F-Curve Editor

To get a more in-depth review of the F-Curve editor, let's focus on a simple motion with only one bone. In the three parts of **Fig. 2.22**, you can see Junot's upper arm in a starting position, followed by a transition, and finally a resting position at the end. As the F-Curve editor can get kind of ugly, we've kept things simple and made the arm motion consist solely of a rotation of the shoulder. The motion begins on Frame 1 and ends on Frame 11. The midpoint in the figure is Frame 6, although keys have only been set at the start and end. The example file for this exercise is *flap_like_a_bird_02.blend*.

Fig. 2.23 shows what this motion looks like in the F-Curve editor.

First, let's work with cleaning up your F-curve view. If you're following along at home, you'll probably see a whole lot more displayed in the left-hand panel of the view than what you see in the figure. By default, the editor shows the curves for every visible object in the scene. When you want to concentrate on only one object or one bone this will not be a huge help. On the editor's header, find the button that looks like a mouse cursor (an arrow) between the control that reads F-Curve Editor and the little ghost. Enabling this control causes the editor to show curves only for objects that are selected. Hit that to clear out all of the extraneous objects and curves.

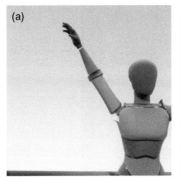 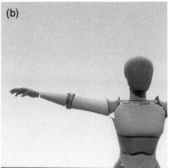 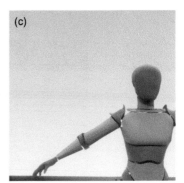

FIG 2.22 A Simple Arm Motion.

FIG 2.23 The Motion Displayed as F-Curves.

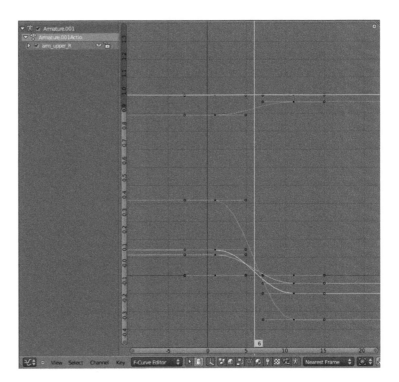

Additionally, you may need to scale the actual curve view in the editor's workspace to get everything to fit nicely like I have. I always start by hitting the **Home** key, which does an okay job of at least getting everything to fit inside your screen. From there, I use **Ctrl-Middle Mouse Button (Ctrl-MMB)** and drag in the view until it looks right.

Finally, we can show all of the available animation channels for the bone by expanding its line item on the left panel of the F-Curve editor. Click the expander triangle to see them for the arm bone, like in **Fig. 2.24**.

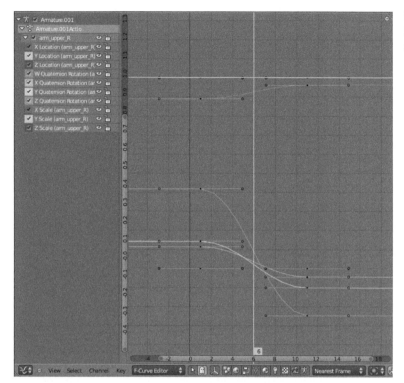

FIG 2.24 Expanding the Object to Show the Individual Animation Channels.

Initially, there appear to be six curves winding through this screen, each with a different color. What do these represent? Three of them show the change in scale, three show the change in location, and four (?!) show the change in rotation. That's right: four. For technical reasons, bones use a four-axis rotation system called Quaternions. If you've not run into this before, just get used it. That's the lay of the land in character animation.

If you were doing the math while reading the previous paragraph, you may have noticed that we see six curves, but have ten properties to account for (x, y, z location, x, y, z scale, w, x, y, z rotation). Recall that we only rotated the arm bone, so the location and scaling don't actually change.

Disable the W, X, Y and Z Quaternion channels by un-checking their line items on the left. What remains? The two flat lines shown in **Fig. 2.25**. That's your first lesson in F-Curves. The location and scaling values do not change (i.e., they are not animated), so their curves are completely flat. The F-Curve editor shows changes in values, over time. No change equals no up or down variation across the timeline. Think of it as a "flat line" in medical terms for those values: they're dead. No activity.

The value for all the location channels is 0.000, so all of the F-Curves for those channels are flat lines, situated at 0.000 on the vertical axis. That's why you see only one curve for all three values; they overlap precisely.

FIG 2.25 *Un momento de silencio, por favor.*

In the same fashion, the default scale value is 1.000 (not 0.000), so all three scaling curves flat line perfectly at 1.000 on the vertical axis.

That's lesson number two: the vertical axis in the editor represents the actual value of that animation channel at that point in time. Time is represented from left to right. In fact, the F-Curve editor is just a big timeline with animation values along the vertical axis.

To get back to the animation itself, re-enable the rotation channels (W, X, Y, and Z Quaternion), and get rid of the location and scale channels by un-checking them. They don't change anyway, so we're not going to deal with them. For a shortcut, you can build a selection of the channels by **Shift-LMB** clicking on them, and then hitting the **V-key** to make them visible (**Shift-V** makes them invisible).

Since the F-Curve editor deals with changes over time and how quickly those changes occur, we need some kind of visible feedback of what we're doing beyond the abstract curves. Of course, once you've been doing this for a while, you kind of get the hang of what results will be produced by certain modifications to the curves. For now though, we've enabled what's called "ghosting" on the armature. The ghosting controls, shown in **Fig. 2.26**, display ghosts of your armature within a specified frame range. It's akin to the "onion skinning" that traditional animators can do on a light table.

I've used the **In Range** option, because I know that I want to show the ghosts for Frames 1 through 11. In the figure, each of the ghostly arms represents the position of the animated arm on each frame in the range. You could use the **Around Frame** option for longer works so that ghosts are created for a certain number of frames around the current one. Also, you could choose to show ghosts only on frames that have set keys by

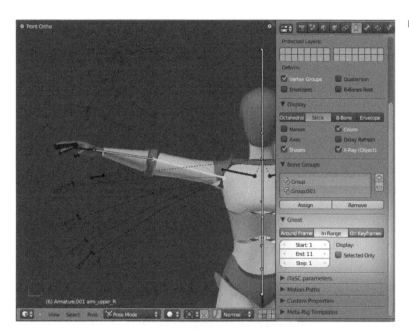

FIG 2.26 Ghost the Armature.

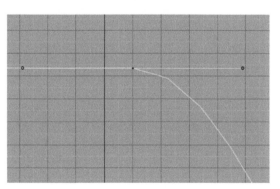

FIG 2.27 A Single F-Curve Point.

choosing the **On Keyframes** option. This ghosting will let us see how changing the F-Curves affect the animation. We can see that with the default F-Curves for this simple piece of animation, the ghosts are closer together at the top and the bottom (i.e., the beginning and end). This is the "ease in/ease out" principle. Tightly spaced ghosts mean slow motion, while more loosely spaced ones mean things are moving more quickly.

Each key value in the F-Curve editor is bordered by two handles. **Fig. 2.27** shows a close-up of a single F-Curve point. The center dot, which is solid, is the key value itself. The small circles that live at the ends of the gold lines are the handles. To move the key—which will change its value if moved vertically, and change its location in time if moved horizontally—you simply RMB-select the center dot and press the G-key, just like everywhere else in Blender.

41

FIG 2.28 Selecting Points in the Editor.

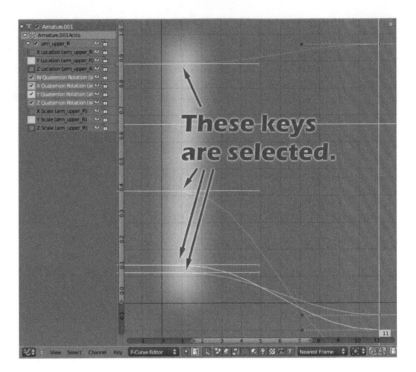

Let's move the key for the start of the motion from Frame 1 to Frame 3. Remember that the whole key is actually made up of the values from each of the four rotation curves, so you will need to select the center dot of all four of them. You can either build a selection with Shift-RMB, use the B-key and border select the lot, or use Alt-RMB to select all visible keys on that frame. Be sure to select only the dots that rest along the vertical line for Frame 1. When you select all four, the editor should look like Fig. 2.28.

Pressing the G-key puts the selected points into move mode. We don't want to change the values themselves, but just the frame that they rest on. Time is represented by the axis along the bottom, so we want to move them horizontally. If we were moving an object in the 3D view and only wanted it to move on the left/right axis, we would hit the X-key once it was moving to constrain that motion along the x-axis. That holds true here as well. So, if you've pressed the G-key followed by the X-key, the four selected points and their accompanying handles will be moving only in time. You can see the results on the ghosted armature in real time as you do it.

The ghosts become fewer and farther apart, which makes sense. We're telling Blender to make the same motion happen not from Frame 1 to 11, but from 3 to 11, two frames less. Thus, the motion happens more quickly, resulting in fewer ghosts (less frames), which are further apart (because distance shows velocity). This was just a demonstration though, so we don't

want to keep this transformation. If you've clicked the Left Mouse button (LMB) to accept the move, use the Z-key to undo it. Otherwise, just RMB to cancel the move.

Really though, we're not working in the F-Curve editor to change the frame number where any particular key resides. That's stuff we can do much more easily in the Dope Sheet later. The F-Curve editor is for playing directly with the Ease In/Ease Out properties of a motion.

By selecting either of a point's handles, you can change the shape of the curve. Take a look at **Fig. 2.29**. I've selected the right-most handle of a curve point. In the second part of the figure, I've pulled the handle further to the right and upward. Notice how the curve on both sides of the point has changed. Before, the curve peaked *at* the key point (i.e., the channel's value was never higher than the key value), but now, the curve peaks *after* the point. This means that after the animation hits its key value, instead of starting to go back down, it continues to rise a bit before falling. In terms of the 3D view, this would be seen as a bone (or object) hitting its key, and then overshooting it in the next few frames.

In the last part of the figure, the handle has been returned roughly to its starting position, but this time, moved very close to the actual point. Notice that when leaving the key point on the right and heading toward the next key value, the curve now has almost no "curve" to it at all.

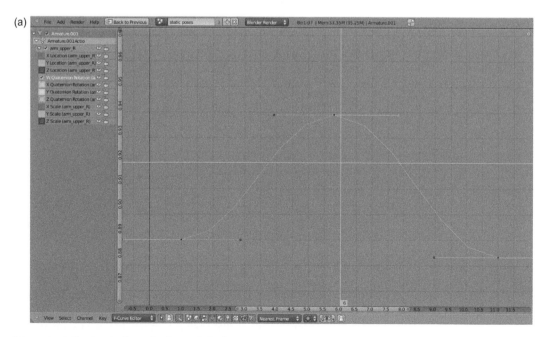

(a)

FIG 2.29 (a–c) Changing the Shape of a Curve with Handles.

(b)

(c)

FIG 2.29 (Continued).

Lesson three of F-Curves, which is kind of the opposite of the first: the steeper the slope of the curve, the faster the channel value is changing. Absence of slope (flat line!) means no change or no motion, and a steep slope means fast motion. A steep upward slope means that the value

represented by the channel is getting larger, quickly. A downward slope indicates that the value is getting smaller.

If you understand that, you'll get why these are actually curves we are working with, and why changing the shape of the curve changes the resulting motion in 3D. As an object goes from a complete standstill to rapid motion, like our flapping arm, the values start out static and the curve is nearly flat for an instant. Then, as it moves to right along the timeline, the values not only begin to get larger (or smaller), but they do so at an increasingly rapid rate (Ease In) until the middle of the motion. In terms of curves, an increasingly rapid rate looks like a line that curves upward instead of just going upward in a straight line. Past the middle of the motion, heading into the last key, the rate of change begins to slow until it eventually flat lines again when the motion is finished. **Fig. 2.30** shows the curves for the arm motion, with these regions highlighted.

With that in mind, see if you can figure out what we would need to do to make the first part of our action take longer than the second part. Remember that by "first part" we mean in terms of distance, not time.

The answer is to adjust the right handles on the first set of key points for all four rotation curves. You could move each one individually, or you can build a selection of them with Shift-RMB. Unfortunately, border selection does not work with handles. Use the G-key and move them to the right, observing how doing so increases the portion of the curves that looks like the "flat line." Recall that our goal is to have less motion

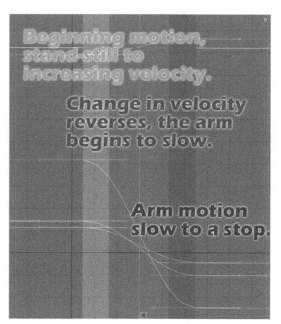

FIG 2.30 An F-Curve's Motion, Explained.

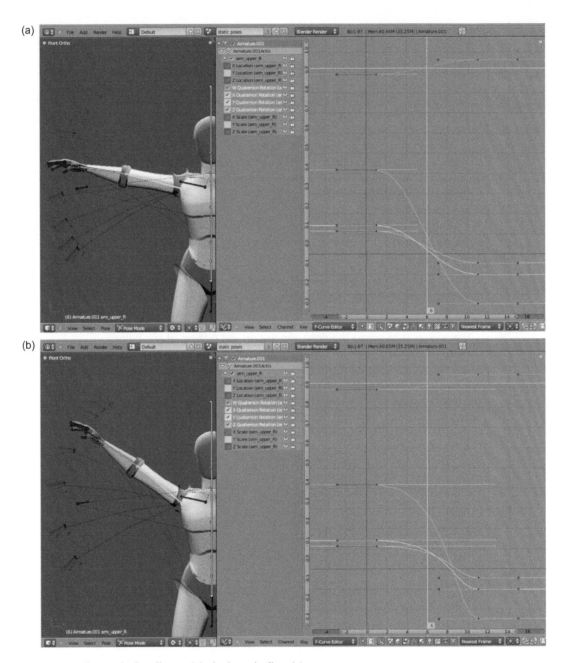

FIG 2.31 (a, b) Changing the Curve Shape, and the Results on the Ghosted Armature.

at first, then more rapid motion afterward. Fig. 2.31 shows the before and the after state. Note the difference in the ghosting on the model's armature. In the second part of the figure, the ghosts are much more tightly spaced before the middle of the action, indicating that motion is

slower there. Notice also how the position of the arm on Frame 6 changes in the figures as we adjust the handles for the key points on Frame 1. If you're following along, you'll get to see the ghosts change in real time as you adjust the curves.

To examine two more functions of the F-Curve editor, take a look at the file *hot_stepper_02.blend*. Once again, we have a simple motion. This time though, there are three keys: foot back, foot forward, and foot back again, shown in **Fig. 2.32**. If you were to play this action back in the 3D view, the foot begins slowly, reaches its highest velocity around Frame 6, then slows to a stop on Frame 11, where it reverse direction. The process repeats, accelerating until about Frame 16 (you can see the slopes of the curves reverse here) where it slows. Then on Frame 22, it comes to a full stop.

Let's say that this motion is Junot kicking something hard, and that her foot should rebound off of it. If that's the case, we don't want her foot easing into the wall. It should slam it at full speed. That is, after all, how you kick things. Afterward, it should rebound with almost equal speed, only doing an ease out when it returns to rest on the ground. In the world of curves, this means that the slope of the line going into the wall—which is represented by the middle key point—should remain constant or even get faster (steeper). After it hits, it should rocket right back out. The lazy arcs at the midpoint of the curves in **Fig. 2.32** aren't going to cut it. If you

(a)
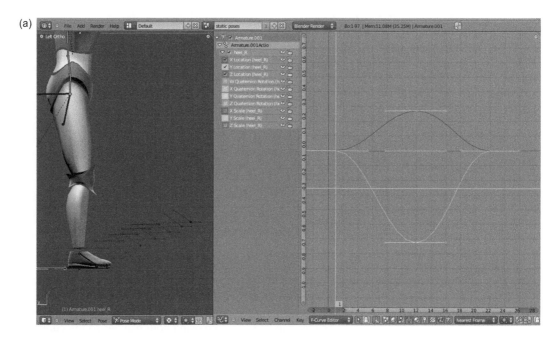

FIG 2.32 (a–c) A Smooth-Out and Back-Foot Motion.

(b)

(c)

FIG 2.32 (Continued).

have already played with the curves and handles though, you might be
wondering how you are going to get rid of that nice curvey curve. Moving
either handle ends up moving both handles so the curve always stays
smooth.

However, if you select one of the points, which in turn selects both handles, then use the V-key, you'll see a menu like the one in **Fig. 2.33**. Up until now, the handles in our example have been automatically aligned and "clamped" which means that they won't go past the minimum or maximum value that the point represents. When we changed the curve slope in the previous example by moving the handle up and to the right, we "un-clamped" it. We want to be able to move the handles freely and make them come to a point at the key. The best way to start this style of handle-editing is to change the point to the **Vector** type.

NOTE: You can also adjust handle style from the Key->Handle Type menu on the F-Curve header.

Let's set all of the handles for the center column of key points to vector style. Using the B-key, border-select the three points in the middle of the curves, press the H-key to bring up the menu, and choose **Vector**. The handles pop right into position! **Fig. 2.34** shows the result.

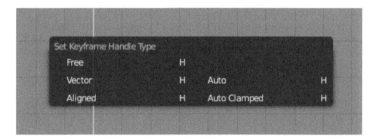

FIG 2.33 The Handles Pop-Up.

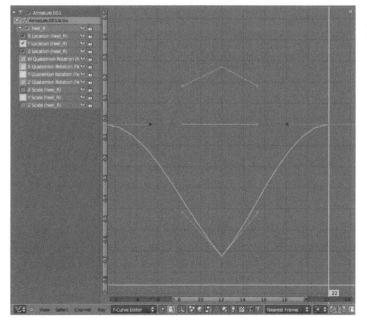

FIG 2.34 Handles on the Center Column of Key Points Changed to Vector.

FIG 2.35 The Kick with Adjusted Incoming Handles.

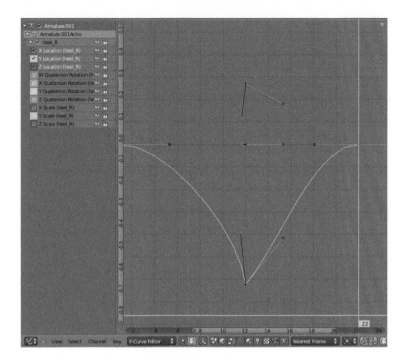

If we really want to provide some pop to the kick, we can make the incoming curve even more drastic by individually selecting the left handles of the center points and making the curve grow steeper as it approaches the key. Doing so yields something like Fig. 2.35, and motion in 3D that continually accelerates into the strike point of the kick.

The last technique to learn with F-Curves mirrors one of Blender's modeling functions. To add points to a curve, you select the curve and **Ctrl-RMB** click in the workspace. The new point appears wherever you clicked, and the curve is adjusted to take it into account. In Fig. 2.36, a new point has been added to both the Z and Y location curves. Using Ctrl-RMB to add new curve points always adds the point to the last-selected curve.

You might be wondering why you would want to add curve points directly in the F-Curve editor. The answer is that in general, you won't. Ctrl-RMB clicking in the F-Curve editor is really adding a new key frame to the animation, and there are usually better places to accomplish that sort of thing. If you're trying hard to fine-tune a curve though, and just can't seem to get it to happen using only the handles of the existing points, adding an additional point can sometimes help. It is also quite easy to generate "noisy" movement this way. By selecting each curve in turn and Ctrl-RMB clicking several times kind of randomly, you can create motion that violently bounces around. Not the best thing for character animation, but it can be great for moving a camera in an earthquake. Fig. 2.37 shows this kind of ugly curve.

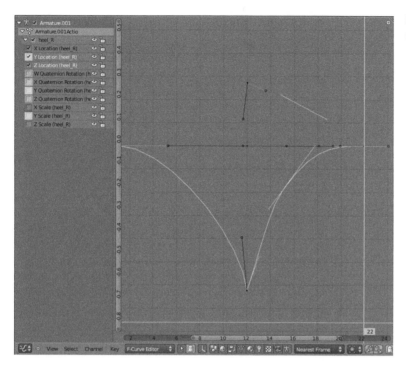

FIG 2.36 A New Point on the Curve.

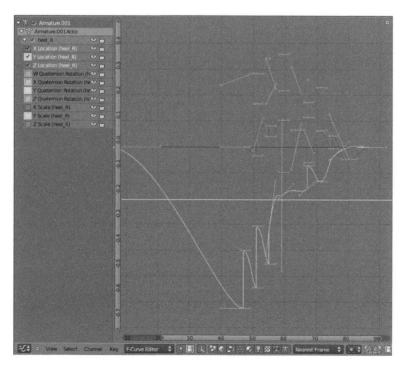

FIG 2.37 Noise Created by Adding Random Points to the Curves.

The Dope Sheet

The Dope Sheet gives you more information than the simple vertical bars that represent keys in the main Timeline window, but less than the morass of curves and handles that quickly populate the F-Curve editor. This makes it ideally useful for organizing and timing your animation. In fact, the term "dope sheet" actually refers to a physical piece of paper in traditional animation that contains all of the information that a cameraman would need in order to properly layer, sequence, and shoot the animators' work. **Fig. 2.38** shows the Dope Sheet editor with a thirty-frame animation sequence of Junot walking.

Much like the F-Curve editor, animation channels are displayed on the left and the work space on the right. In this case, you get one channel per bone to make things easy. Of course, you can expand a bone channel to display all of its individual animation properties (x, y, z location and scale, and w, x, y, z rotation) by clicking on the expansion triangle that goes along with the bone name, but I find that if I'm going to be fine-tuning things at that level, I'm usually better off in the F-Curve editor anyway.

The name of the object, in this case *Armature.001*, is shown at the top, and the whole tree of bones can be collapsed and hidden by clicking the triangle control beside it. The dope sheet shows animation for all

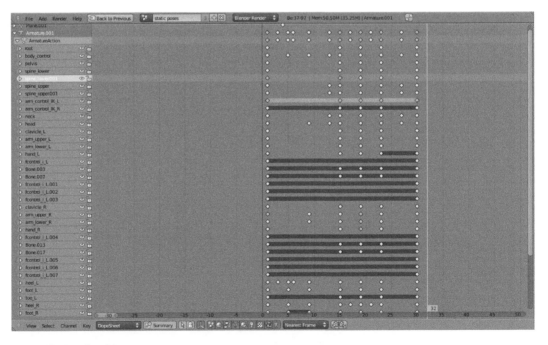

FIG 2.38 The Dope Sheet Editor.

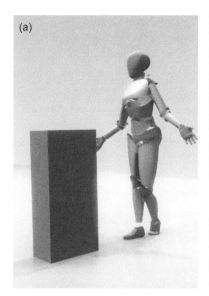
(a)

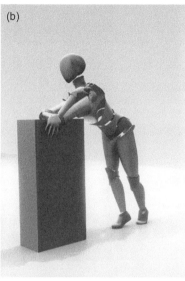
(b)

FIG 2.39 (a, b) Standing to Leaning.

available objects by default, but this can be filtered with the different buttons on the header.

The diamonds in the work space are the key frames. The selected keys appear in yellow and the unselected in white. Several of the channels have darker regions between the keys. This darkened area indicates that the keys have the same values on both sides. In other words, the keys are identical, but separated in time. The effect in 3D is that no animation occurs on that particular channel. This "hold" indicator is displayed in orange for selected keys.

We don't want to start with something this complicated though. Let's open the file *leaning_down_02.blend* to learn to use the dope sheet. **Fig. 2.39** shows the two poses in the example, with the dope sheet in **Fig. 2.40**. The action takes place between Frames 1 and 25, as you can see in the dope sheet by the placement of the key diamonds. If you remember, this means that the action takes place in exactly one second ($25 - 1 = 24$; 24 frames = 1 second).

You'll notice in the figure that the dope sheet still shows a number of objects besides the character. That's fine if you're trying to coordinate and manage the keys of several objects at once, but when you want to focus on the keys of a single object, it can be annoying. In particular, you don't want to hit the Select All command to, say, delete the animation for this object and accidentally end up selecting and deleting animation for *all* of the scene's objects. Let's switch the Dope Sheet to the **Action Editor** view. On the header, change the menu that currently reads "Dope Sheet" to "Action Editor". This view only shows the available keys for all channels of the selected object, and shows the current animation for that object

FIG 2.40 The Dope Sheet.

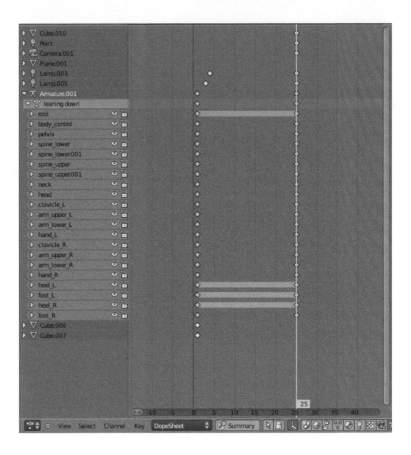

as a linkable Action that can be duplicated, removed or re-linked just like other library data in Blender. **Fig. 2.41** shows the same animation in Action Editor view, which is what we'll be using for the rest of this exercise.

One of the things you should notice when examining the figure is that the channels labeled root, heel_L, foot_L, and heel_R all show the dark bar between their two keys, indicating that the keys are for the same values. If you're following along, LMB-click and drag in the editor workspace between Frames 1 and 25. Doing this moves the current frame marker as you drag, playing the animation back and forth in time with your motion. This is known as **scrubbing**; this is a quick way to preview your work when you actually begin to animate. As you scrub, keep your eyes on the feet and note that, just like is indicated in the editor, the heel bones stay put as does the left foot bone.

Right now, the action takes 24 frames. If we want to make it happen faster, there are a number of ways to tackle this in the editor. The easiest way to do it is to select all of the keys on Frame 25, press the G-key, and move them around. The good news is that unlike in the F-Curve editor, you're not

going to screw up the value of any of the keys by moving them along the wrong axis. In the dope sheet/action editor, you can only change the timing of keys, not their actual values. The even better news is that you have some new selection methods to learn that are unique to this editor.

Sure, you could use the B-key and border select, but that's old hat. You will run into many times when you select a key, and then think to yourself "Hmmm. I'd actually like to select all of the keys on this frame instead." With any key selected (simple RMB), pressing the **K-key** selects all other keys on the same frame. Also, Alt-LMB clicking on the key will select all others in the same frame, just like the Graph Editor. This is one of the reasons we're working in Action Editor view in the dope sheet—using this control in Dope Sheet view would select every key on this frame for this and every other available object. While that might be useful behavior at some point, it's not for us right now.

Another way to select keys has its roots in the animation work flow. If you look back at **Fig. 2.38**, you see a bit of a mess of keys, and that's just a simple walk cycle. Finished animation on a complex project can look ten times more cluttered. While you're working, you might decide that you need more space between the keys on Frame 45 and Frame 62. Your actual animation might extend off the edges of the screen, say, out to Frame 500 or so. In order to add space, you need to select everything from Frame 62 and up, and then move it. To do this, you position the current frame marker in the timeline and **Ctrl-RMB** click on one side or the other to select. In this mini-example, positioning the current frame on Frame 50 and Ctrl-RMB clicking the right of it selects every key to the right of the marker. Then, you just use the G-key to move them a bit, opening up some space. Alternatively, you could have used Ctrl-RMB to the left of the current frame and selected all keys from Frame 50 and down.

In our working example here, you just need to position the current frame marker somewhere between Frames 1 and 25, then Ctrl-RMB click to the right of it. Doing so selects all of the keys on Frame 25. It would have selected keys even further forward in time if we had anything there to select.

Using the method of your choice (B-key, RMB, and K-key or Ctrl-RMB), select the column of keys on Frame 25. Your options for moving those keys are just as varied. Of course, you can be lame and press the G-key. That will work for simple transformations, but the dope sheet has more powerful tools available.

Pressing the S-key will scale the keys in time. The pivot point for the scale operation is the current frame marker. Scaling "up" (move the mouse up or right) causes the key selection to expand away from the current frame marker. Scaling "down" (move the mouse down or left) pulls the keys in toward the marker. **Fig. 2.41** shows the effect of positive scaling with the current frame marker in three different places. Note that this scaling behavior works just like it does in the 3D view. The closer a key is to the

FIG 2.41 (a–c) Scaling Key Frames in Time.

FIG 2.41 (Continued).

pivot point, the less it will transform. If the marker is on Frame 1, a key is on Frame 2, and another key is on Frame 10, and you scale "up" by 2, then first key will end up on Frame 3, while the second one ends up the whole way over on Frame 19. That sounds weird, but if you play with it a few times you'll see that it's quite organic. And don't worry that "scaling" will change any of your poses in the 3D view—we're only scaling the frame numbers that the keys fall on, not the values of the keys themselves.

The other new method is called **Extend**. It uses the **E-key** as a shortcut, although it doesn't really bear any relation to Extrude in the 3D view. Extend works a bit like the Ctrl-RMB selection method in that it takes into account on which side of the current frame marker your mouse falls when you use it. It takes the entire current selection and puts the portion of it on the mouse side of the frame marker into Grab (translation) mode. This means that even if you have all of the keys in the editor selected, pressing the E-key will release only a portion of them for movement. It can be handy if you have a carefully crafted selection of keys and want to add or remove time from the animation without ruining your selection state.

With those methods in mind, we're going to do some quick and dirty timing adjustment without ever learning to animate. With the same file (*leaning_down_02.blend*) open, place the current frame marker on Frame 14. This is just about the center of the animation. When we played around with the "kicking" keys in the F-Curve editor earlier, we were able to adjust the

timing of the midpoint of the animation because we actually had a key there. We don't have one in this example, so let's add one.

Hovering your mouse over the workspace in the dope sheet editor, press the **I-key**. A small menu pops up like the one in **Fig. 2.42**. It asks you to which animation channels you would like to add a key. Select **All Channels** from the menu. Blender adds a keyframe to each of the available animation channels, right on Frame 14. Note that the 3D view does not change with the addition of the keys. The keys that were added represent the exact animation values that were present in the channels on Frame 14. **Fig. 2.43** shows this new column of keys.

FIG 2.42 The Keying Menu.

FIG 2.43 A Whole New Column of Keys.

This column represents the "halfway" point of the action. Test time: if we move that column of keys to the right, say to Frame 22, what do you think this does to the action? The answer is: it takes the character a lot longer (almost the whole time) to reach its halfway point. Then, it completes the rest of the action in only 3 frames. The result is an action that begins lazily, but finishes with a snap.

Finally, what if we wanted to have the character execute half the motion, pause, and then resume? There's no reason to really do this with a whole body character—unless things are very cartoony or someone has a freeze ray—but the technique is valid for smaller parts of anatomy.

If you recall from earlier sections, the dark bands in the editor represent areas where the keys on either side of the band are identical, resulting in no motion. So, we want to create a second set of keys that are identical to the new key column we just made. The same Blender key command that accomplishes duplication elsewhere works here too: **Shift-D**. Use Shift-D with the center column of keys selected and move the new set of keys off to one side. If you adjust the two new columns to fall close to the one third and two thirds points of the animation, you'll get something like **Fig. 2.44**. As I mentioned, this is a silly use of the technique, but you get

FIG 2.44 Duplicating Keys Creates a Hold.

the point. You can alter your animation drastically by duplicating, moving, and deleting (X-key, of course!) keys in the dope sheet editors. In fact, by selecting keys in different channels and moving them around at random, you can make mincemeat out of the original animation!

And that's the sad truth. By messing around indiscriminately in these editors, you can do your work a pile of damage. If you ever find yourself getting tired of working and feel the urge to "just push some keys around," resist with all your might. You'll do more harm than good.

So, with a little knowledge of the available tools and character controls under your belt, it's time to dig into what you came here for: not animating.

Wait, what?

Right. We're not going to animate next. We're going to plan. It's not glamorous, but it's necessary.

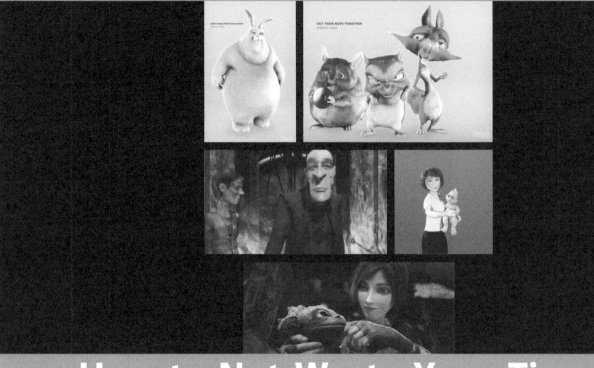

How to Not Waste Your Time

A few simple facts follow:

1. It can take a week to produce ten seconds of decent animation if you know what you're doing.
2. If you finish your animation only to find out that it just doesn't work, you've wasted a whole week.
3. Spending a little bit of time in advance to make sure that you're animating the right thing is worth it.

Resources

I'll lay it out right now: don't bite off more than you can chew. In terms of resources and needs, you already have Blender, which was free. I assume that you have a computer available, of course. The only other resources you're going to need to mine in order to do some animation work are time and concentration. Obviously you'll need time because, well, things take time to do. More importantly though, you're going to need concentration. Animating isn't the easiest thing in the world, and you'll do much better if

you can approach it with a clear head and no worries. Forget the tortured artist shtick—give me someone who is on the ball.

In order to keep this within a reasonable scope, we're going to limit ourselves pretty drastically. We'll be animating a single character, in a single shot, within a simple environment. And it's going to be short. Maybe fifteen seconds, tops. While you work through this book, you can choose to do the exact project that I'm working on, or come up with one on your own. A good choice might be to follow the book once with my project and then branch out once you're more comfortable. If you want to do your own from the beginning, try to stay within the guidelines I've just expressed.

Concept

Even if you're only doing a small animation to learn the craft, it's worth it to put some effort into concept. I've seen demos that feature nice character work, but in the end, they are just a character running and jumping from platform to platform, perhaps dodging obstacles. In music, we call such works *Etudes*, and it only means that the piece was one made exclusively for learning. You wouldn't play it in public.

There is no reason that you can't incorporate the basics of storytelling into even your shortest works. What makes a story? A beginning, a middle part, and an end; a conflict and a resolution; and a symbiosis of character and plot. It doesn't have to be grand, and in fact that would be a detriment to what we're doing here. Think small. Jokes and gags work well.

Within the parameters that I've just mentioned, here is what I came up with for the practice project:

> *A person strolls up to a pedestal, upon which sits some kind of fancy bauble. The pedestal is carved with the words "Do Not Touch". The character considers this for a moment, holds out his hand, and touches the bauble. Horns and sirens go off, and the person slinks away, looking guilty.*

That very short description satisfies the various definitions of the "story" we just gave. **Beginning:** strolls up. **Middle:** considers and touches. **End:** slinks away. Or to do it another way, **Conflict:** Do I touch or not? **Resolution:** Yes I do, with consequences. It packs a lot into the space. If staged properly, it could be funny. If we wanted to make it even shorter, we could change it in such a way that after touching the bauble and shrugging his shoulders, the person is about to stroll off when the bauble explodes into confetti (if we want to stay with funny) or nasty wet bits (if we want to go an entirely different route). As including the "slink away" ending gives us an acting opportunity that we wouldn't otherwise have though, let's keep it.

But how do we know if it's too long? Remember that we want to keep things under fifteen seconds; ten, if possible. Act it out, using a stop watch.

FIG 3.1 A frame from the Live Reference.

Or you can count if you're able to keep a steady beat on the second. Do it a couple of times to make sure that you're not rushing things to come in under time.

So now we come to the tough part, both for you and for me. I've taken a video of myself acting this out. It's shameful, really, but later it can be used for reference. If you have the stomach, check out the video called *Live Reference* on the web site. **Fig. 3.1** shows a frame, so you can decide if you want to risk seeing the thing in full motion. Obviously, we won't be using that for rotoscoping or even for posing purposes—I'm not nearly dynamic enough for it to look good when animated. What it is good for though is in watching how long it takes me to cover a certain amount of space in the allotted time and how my weight shifts when I do different things. There is an absolute pile of physical information contained in video footage of a person doing almost anything.

Thus far, we have a concept and a live reference. Before we dig in any further, let's talk for a moment about character design.

Character Design

We're about to be hit with our first two principles, smack in the face: **appeal** and **solid drawing**. "Appeal" has to travel over a lot of territory—realistic to wildly cartoonish, angelic to demonic, and beautiful to hideous. Perhaps, better terms would be "charisma" or even "attraction."

Some of the characters from recent open movies are shown in **Fig. 3.2**. A few have appeal, but a few don't. Top left shows the cast of *Big Buck Bunny*.

FIG 3.2 (a–e) Characters from Big Buck Bunny, Elephants Dream, the Beast, and Sintel.

The characters are carefully designed and full of personality. Each has something interesting about their looks. That interest attracts us. Below that are the characters from *Elephants Dream*. Personally, I find them a little less appealing, like something you've seen in a depressing film that you wished you hadn't. To their right are the characters from *The Beast*. They're not as carefully designed as the others, and while the baby is certainly creepy, it's hard to say that it happens in an interesting or attractive way. The last one on the bottom is from *Sintel*. The design is clean, but it's kind of generic. It's not *un*appealing, but it doesn't do a whole lot to interest me either. Your mileage may vary.

Don't feel bad if you are having trouble coming up with an appealing character. It can be incredibly difficult. Think about how many animated feature films come out every year whose characters have no appeal whatsoever. It's quite a few. Just take a look at the rip-off animation genre—the films that drag along clinging to the shoelaces of titans (look for *What's Up: Balloon to the Rescue* for a particularly appalling example). Generic character design. Almost zero appeal. And those folks are professionals. Ahem.

Do your best. Study the people who do it successfully, and their designs. Heck, outright copy them if it's just for your own work. A funny thing happens when you ape a master for long enough. If you have any kind of talent of your own, you'll start to recognize things in their work as you recreate it, and you'll learn from it, just by studying and copying. Eventually, you'll see those same things pop up elsewhere, and they'll start to inform your own work. You won't be copying anymore, but creating your own stuff.

Once you have a good design (or one for which you've run out of resources, like I did with *The Beast*), it's time to execute. This is where "**solid drawing**" kicks in. Again, know your tools and do your best. If you're working toward a production goal, like a full short, you'll want to put as much time as you can into properly executing your vision for the character as a 3D model. If you know you're not up to the task and have more important goals in mind (i.e., animation), perhaps you can get someone else to do it. There are some people who are good at designs and ideas, but terrible at seeing them through to production. The opposite is also true. I worked as a production artist for many years, and while I can create my own works from scratch if need be, I work best when putting my steady hand to refining and executing the designs of others.

As we're going to concentrate on animation in this book, the characters are minimalist. They will serve the study, but are obviously unsuitable for a full production.

With characters and concept in hand, we'll start to actually plan what's going to happen and how it will look.

A Brief Interlude on the Subject of Composition

When we introduced the principle of "**staging**" in Chapter 1, we indicated that it was mostly about composition. Composition simply refers to how things look within the frame of the camera. How they are organized, using a number of criteria. That organization's purpose is to direct the eye of the viewer. With only a single character and a very plain set, our composition is going to be rather straight forward, but let's talk about some of the different tools you can use to strengthen the composition of your own projects.

Contrast and Focus

Simply put, the art of directing the viewer's eye lies in paying attention to what stands out. It directs the viewer's focus and tells them what is important in your shot so that they can continue to follow your story and understand what is going on. This is often achieved through "**contrast**." Fig. 3.3 shows a plain field of red cubes. It is unremarkable in all aspects: nothing stands out.

The first method of injecting contrast into your shot is adjusting "**color**." Fig. 3.4 shows the same scene, but with a bit of contrast applied via color. Your eye immediately flies to the yellow block.

This is a ridiculously simple and obvious example, and one that is used point-for-point in a large variety of "I'm an individual!"-style t-shirts and posters in which the entire field of view is covered with identical objects/ characters, with a single one set in a different color. In practice, you don't want to be this obvious about it. The best direction is the kind that is strong enough to actually get the viewer to focus on what you intend without them ever noticing that they've been deliberately directed.

FIG 3.3 Zero Contrast.

The other side of the effects of contrast, like color, is looking for contrasts in your shot that you had not intended. Let's say that you're doing an animation of a couple having a conversation while walking through a museum. You had just grabbed a bunch of random artsy images while making the textures for the museum's paintings. Most of them were fairly drab and fit well with the muted colors of the museum, but one included some bright strokes of red. As you design the scene, you probably won't notice how it stands out if you're not thinking in terms of composition and the different types of contrast. However, when finished, that red flash could steal the viewer's eye from the intended focus of your shot while it was on screen. So, you're not only working with contrast on purpose, but also tasked with identifying places where the shot's focus is diffused or completely stolen by accidental contrast.

Back to the example, **Fig. 3.5** shows contrast by **size**.

FIG 3.4 Using Color for Contrast.

FIG 3.5 Contrast by Size.

The larger block draws your eye, obviously. Keep in mind that it doesn't matter what the actual size of the objects in question are. What matters is the apparent size of things as composed within the shot. You could have an extreme close-up of something small (e.g., a foot in **Fig. 3.6**), which looks large in comparison to something else in the distance, even though we know that they are not. The apparent size—how it appears in the shot—is what's important. Besides contrast, it is also related to another aspect of composition: something that takes up more space on screen will draw more attention.

Fig. 3.7 shows contrast by organization. Once again, the focus is clear. Remember that when we're talking composition, what matters is the actual patterns presented on the 2D screen. It's not so important where the objects or contours are in the 3D space as compared to the final face that they present to the camera. The second part of the figure shows this by displaying a silhouette of the same image. The contrast by organization is still present.

FIG 3.6 Apparent Size Is What Matters. © 2009 Makoto Yamashita.

FIG 3.7 (a, b) Contrast by Organization.

FIG 3.8 Contrast with Lighting, and Depth of Field Thrown in as a Bonus.

Finally, in a shot reminiscent of the staging example from the first chapter, you can show contrast by lighting. **Fig. 3.8** also demonstrates depth of field, which defocuses certain parts of a shot. We won't be dealing directly with either compositional lighting or depth of field in our production, but they are included here for the sake of completeness.

Please keep in mind two things for all of these techniques. First, these demonstrations are fairly wild exaggerations. You would not want to go this far in your own work. It's what is known as "beating the viewer over the head." Very few people like to be beaten in such a fashion. Second, these are not only positive examples to show you what to do, but negative examples as well. You have to be attuned to all of these aspects of your shots so that you don't accidentally introduce competing points of focus.

Long Shots, Medium Shots, and Close-Ups

You shouldn't just be placing your camera at a random distance from the characters in your scene. Although the boundaries between them are sort of gray (i.e., where does a medium shot end and a close-up begin?), it makes sense to think about how you want to show your character. When you want to introduce your subject or show full body action, the **long shot** is appropriate. **Fig. 3.9** shows Junot with a pedestal in a long shot. Use a long shot when you need to show your character's entire body. This could be a shot that shows the person walking for the first time; so the viewer can get a sense of character from the way that they walk. In a long shot, the character should take up as much of the frame as possible, without any portion of their body being cropped out (i.e., don't "cut off their head" at the top of the frame, etc.).

A long shot can show two characters meeting, any full body motion that must be followed but that would carry the character out of frame in a closer shot, or any motion in which you want to emphasize the entire body such as acrobatics, fighting, and dance.

FIG 3.9 Junot in a Long Shot.

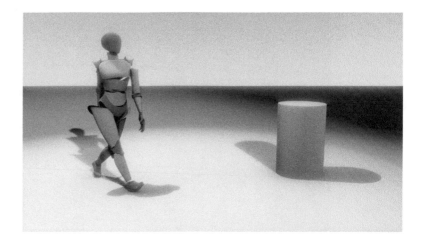

FIG 3.10 The Medium Shot.

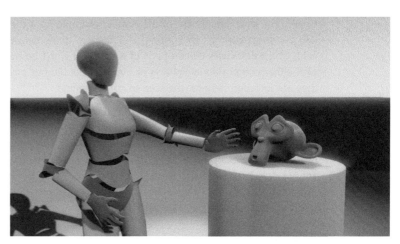

Next, we have the medium shot. This one is good for stationary characters, or when the focus will be on their upper bodies and faces. If it's not so important what the feet are doing, don't show them. The medium shot usually cuts off the character below the waist, and although you can crop them above it, you would risk the hands going out of frame if the character uses any kind of body language. Fig. 3.10 shows Junot after she has approached the pedestal. Both are still included in the shot, but as we strive to put the tightest crop possible on everything important, we are drawn into a medium shot.

When Junot eventually touches the bauble (played in this example by world-renowned teapot stand-in Suzanne), we might choose to use a close-up (Figs. 3.11 and 3.12). Close-ups show fine detail, such as a character's face or some bit of action with a hand. Be careful not to push in too closely though—a standard facial close-up shot will still include the top of the character's head, as well as the beginning of their shoulders. Fig. 3.12,

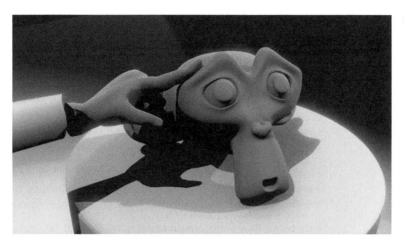

FIG 3.11 Junot's Hand on the Bauble.

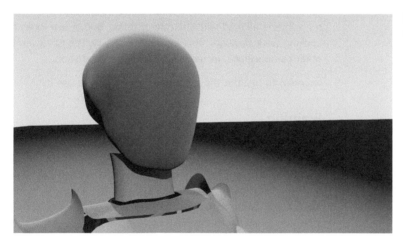

FIG 3.12 A Thrilling Facial Close-Up.

Junot's head shot is kind of boring due to the fact that Junot (and Meyer and Smith) has no face. You'll notice that the final animation has no close-ups of the missing face for exactly that reason.

Among the variety of other shots, you might find the very or extreme long shot useful. It does not fill the frame with the subject like the standard long shot. In fact, the subject in the very long shot might be rather small. The point of a shot like this is more to show the environment, giving the viewer an overall picture that says "All of the stuff you're about to see takes place *here*." For other less-used shot types, Google or a complete book on photographic composition will be your friend.

This is pretty simple stuff, but you'd be surprised how many people go into a project without even considering it. Using a shot distance that is inappropriate to the action is almost as bad as letting unintended contrasts steal your composition's focus.

The Rule of Thirds

When beginning photography or CG, most people's instinct is to place the subject of their work, be it a still-life material or a character, in the center of the screen. It makes sense, no?

It turns out that it doesn't. As you compose a shot, the major lines that the objects make on screen should fall along a grid that divides the camera into nine equal parts. Take a quick look back through all of the shots in this chapter so far, and you'll notice that the focal point falls on one these sections.

Fig. 3.13 shows one of the previous shots, with a grid of thirds superimposed upon it. Major lines in your image should be close to the ones indicated. Important points should fall on the intersections.

Let's take a look at how much better using the grid can make your shots. Fig. 3.14 shows two crops of a lighthouse shot. One has the horizon splitting everything in half, and the lighthouse dead center. The other finds the subjects aligned with the rule of thirds' grid. It just looks more natural. Looking back through this chapter, notice how the rule even informs the other compositions, including the close-up head shot.

No need to belabor the point: the Rule of Thirds. Use it.

Framing

Depending on the set and (virtual) location of your work, it may or may not include framing. Framing is the use of elements in your composition that literally build a frame around your shot. Fig. 3.15 shows three digital paintings of a forest at night, each framed differently. In the first, we see a low horizon and a large tree climbing and blocking the left side of the shot, continuing onto the top as well. If we were to place a character

FIG 3.13 Contrast by Light with the Rule of Thirds Grid.

FIG 3.14 (a, b) Same Picture Shown with and without the Rule of Thirds.

FIG 3.15 (a–c) Trees at Night, with Three Different Framings.

somewhere in the shot, it would be best to put it around the one-third point on the ground, closest to the tree. We'd also do well to have him looking to the right, out of the portion of the shot without a frame.

The next image shows a woodland path, with trees creating a full enclosure above and on the sides. With the color scheme, it provides an ominous backdrop to whatever action will occur. With a morning or daytime palette, it could give a cozy, indoor feeling. Finally, we see another night time shot that uses a mock wide-angle lens for a curved horizon. The tree line curves away in the opposite direction, providing framing only on the sides. The entire composition focuses the attention on the sky, even though the majority is taken up by the ground and trees.

Even if you are not going to use framing deliberately in your work, you need to be aware of it so that you don't accidentally tell a different story with inadvertent framing than you'd like to tell with your subject.

Object Location and Orientation

Here's a dirty little secret about photography, film making, and CG: shooting things as they are in real life can produce poor results. When two people speak with each other in real life, they usually stand at least a yard

FIG 3.16 A Shot Framed for Conversation.

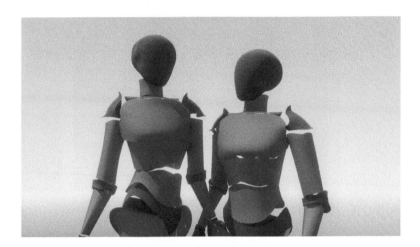

apart, and face each other directly or slightly off angle unless a third party or a group is involved. To effectively frame a conversational medium shot between two characters, you have to drop the real-life notion off a cliff. Fig. 3.16 shows such a shot. The two characters will appear to be having a normal conversation, even though they are way too close together and are oriented at a wide angle to one another. It looks fine, because this is what we're used to seeing on screen.

The benefit is that we get to make a tighter shot with them closer together; from their orientation, we get to see their expressions more clearly. They are "cheating" toward the camera. Go back and take a look at Figs. 3.9 and 3.10, ostensibly of the same scene. In order to make the medium shot look better, I've raised the pedestal a decent amount. Television and film productions use this technique constantly, making shorter actors stand on platforms to make close or medium shots with other actors appear more natural. Yes, it's cheating, but if it makes the shot work, it's okay. If you find yourself fighting and fighting for the perfect camera angle, don't forget the fact that you might only be able to get it by moving something other than the camera.

Storyboarding

With all of these composition rules and techniques floating around, it's time to tackle the storyboards. Storyboards are an extension of the planning process, as it's much easier to fiddle around with composition, posing, and placement when you're dealing with thirty second sketches than when you're in 3D. If you have a strong vision and some projects under your belt, you could probably skip storyboarding on a very short study like this and be fine. We're not going to do that.

NOTE: For storyboarding, I usually just use a pencil and 3" × 5" index cards. For more elaborate projects where I'm also building color into the composition at the storyboard stage, I'll use a digital painting tool like

FIG 3.17

ArtRage (www.ambientdesign.com). Using index cards allows you to easily remove, insert, or replace individual images, or rearrange them to try different things. The storyboard images in this chapter are scans of my index card sketches.

Let's take our story breakdown from earlier in the chapter and covert it into storyboards, using our newfound knowledge of composition.

> *A person strolls up to a pedestal, upon which sits some kind of fancy bauble.*

Our first shot should include both the character and the pedestal. The character is walking, and we'd like to see their whole body. This and the presence of the pedestal, indicate that we should begin with a long shot, shown in **Fig. 3.17**.

Notice how both the pedestal and the character appear on the vertical one-third lines of the frame. The horizon sits on the lower horizontal third. I could have set it up so that the horizon hits the upper third mark, but I felt that the character would have more contrast (and thus a greater focus) when set against the sky than against the ground.

To get the character to actually stroll up to the pedestal, I use two more storyboards. Whether or not you break things down to this level of detail—I did each footstep here—is a personal matter. Do you like to draw? Can you draw well? Would a drawing of each step actually help you later? If you answered "no" to any of these questions, you'd probably opt to just do a first board and a last, skipping the in-betweens. If this had been a longer project, I probably would have skipped them too.

> *The pedestal is carved with the words "Do Not Touch". The character considers this for a moment, holds out their hand and touches the bauble.*

The next sentence in the mini-story is just a statement of fact, telling what's on the pedestal. It shouldn't break the flow of action, as long as we can fit it in somewhere else. I decided that I'm going for "funny," and so I have to determine whether having a close-up of the "Do Not Touch" will be funnier before Junot touches it, or afterward. With index cards for storyboards, this

FIG 3.18

FIG 3.19

type of experimentation is trivial to accomplish, so I just draw one now. It's nothing more than a close-up shot of the pedestal, shown in **Fig. 3.18**.

As I was drawing this, I made two more decisions. First, I realized that it is much easier from a production perspective to create a sign stuck to the pedestal than to model words carved into it, as I had initially noted in the story. Second, "No Touchy" is funnier than "Do Not Touch." So I've changed that too.

I also decide that once the character reaches the pedestal, they should do an "appraising" pose, where they lean back a bit and regard this interesting thing they've come upon. **Fig. 3.19** shows this pose. As you can see, we're still in a long shot, and I'd like to close it up to a medium shot so I'm not wasting all of that space behind the character. I could just cut right to it, or have the camera zoom in, but I'd prefer not to.

It's kind of strange to cut from one way of holding a shot to a completely different one without some kind of transition. I don't want to zoom the camera simply because I'm picturing this study as one with "fixed" cameras; that is, ones that do not move—purely a personal choice. It would be nice to be able to cut to something from the long shot, then cut back to the medium shot. So, it seems like this would be a good place to insert the pedestal close-up. The sequence will go as follows: **Fig. 3.19** (long shot), **Fig. 3.18** (close-up of sign), and then the as-yet-unrevealed medium shot. As a bit of a cinematic trick, and also to make it clear that the character

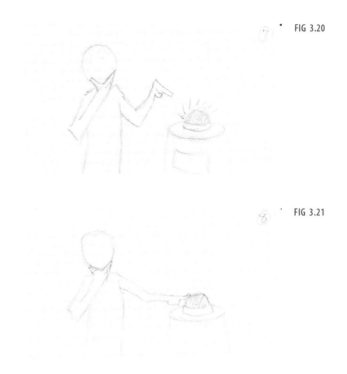

FIG 3.20

FIG 3.21

knows what's going on, I insert a new storyboard before the close-up that shows the character bending over in an exaggerated fashion to read the sign. Now, the close-up not only works as pure information for the viewer, it also shows them what the character is "seeing" when it bends over.

In **Fig. 3.20**, you can see the scene recast as a medium shot. I may or may not need to adjust the height and position of the pedestal and the ground to duplicate this next series of storyboards in 3D; but if I do, it's fine. Remember: cheating is okay!

After a brief moment of consideration in **Fig. 3.20**, Junot goes for it. I designed this storyboard and the next one (**Fig. 3.21**) to work like a flip book, splitting the difference between a single moment of a crucial action. You can flip back and forth between them and it looks animated! What fun. Notice that I've also started to build in some of the keys and cues to "reality" in this storyboard: Junot's finger bends backwards a bit as it presses the bauble. What is the bauble anyway? I haven't decided at this point. It's not relevant. It's just something smooth and shiny that you're not supposed to touch. Google "MacGuffin."

Maybe there's a brief pause here. Maybe not. I can play with it later when I compile this into a mock animation called a "**story reel**." Either way, the next thing that needs to be put down on the storyboards is the appearance of the horns and flags. We're going a little silly with this, so

I decide to just have them pop right out. Where were they before? Yeah, I'm not sure. Shouldn't Junot have noticed them? Agreed. However, she didn't, and hopefully that will add a little bit to the funny side.

I'd like to have Junot really fall backward, flailing wildly when the alarm actually goes off. In a medium shot, she'll be gone in an instant; so we have to switch back to the long shot. In this case, we're not going to use a transition shot. How do we get away with that, as it can be kind of jarring? Well, we'll make the cut to the long shot correspond exactly to the first blare of the horns in the soundtrack. It will almost be like the blast of sound knocked us back at the same time as Junot. So, the horns go off, and we get Fig. 3.22. Notice the arms drawn in several positions to indicate the rapid action.

She stumbles backward and lands in a crouch. Then, she raises a bit and walks backward out of frame, with her hands raised in a kind of nervous karate position (Fig. 3.23).

The whole time, the horns are blaring and vibrating, the flags are wiggling, and the emergency-style lights are spinning out from behind the pedestal. So, is that the end? It's the end of the action as I've described it; but now, we come to one of the reasons why we create storyboards. When we visualize in our head how it will all play out, we're constrained by the power of our mind to hold a picture clearly. In fact, we're also constrained by the fact that it's an internal visualization. In order to "view" it, we must already

FIG 3.22

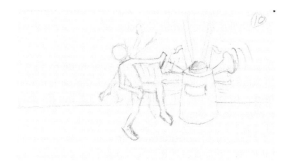

FIG 3.23

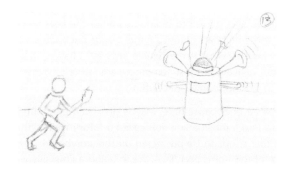

FIG 3.24

be engaging our brain's processing power to generate the picture in the first place. From an analytical standpoint, our mind is "otherwise occupied."

Moving the story from your head onto paper (or screen) forces you to encode the story in a different fashion. Perhaps, something you thought would work just doesn't when you draw it. Also, once you've drawn it, you can look at it much more objectively than you could look at the version in your head. It frees up some brain power for other activities. For example, as I see the next storyboard with the pedestal all by itself (**Fig. 3.24**), several new ideas occur.

First, I can try to do something simple but funny with the way the pedestal's alarm system turns off. It will probably be animation, but nothing of the complexity of full character animation, so I'll maybe get to add another couple of seconds to the piece and throw in an additional joke "for free" (i.e., not a lot of extra work). It also strikes me that the bauble itself could be part of the alarm system. It might be a glowing swirly green thing that flashes red when in alarm mode. Depending on how I play with the timing of when it turns red and green, I can perhaps add a little bit more fun to the whole thing.

Finally then, here are the storyboards as I think they'll run (**Fig. 3.25**). I've decided to have the light simply glow as the pedestal is approached, then switch off as soon it is touched, a beat before the alarm actually goes off. Once Junot has left the frame, all of the horns and flags will retract except for one. The last one will give a pathetic little raspberry, and then retract. When all of that is done, the light will chime back on, ready for the next victim.

Once I have the storyboards scanned in, I simply open them with an image viewer and step through them, playing the storyline in my head. This is a quick check to make sure that it is at least working. With the way I've broken the storyboard up, they run like a cheap animation. The video called *The Story Reel* on the web site shows something like what you would see if you were in the room when I was doing this. I've also added a sound effects track (all done with my mouth!), so I can further solidify my timing. When I play back my storyboards in an image viewer, I actually do this to

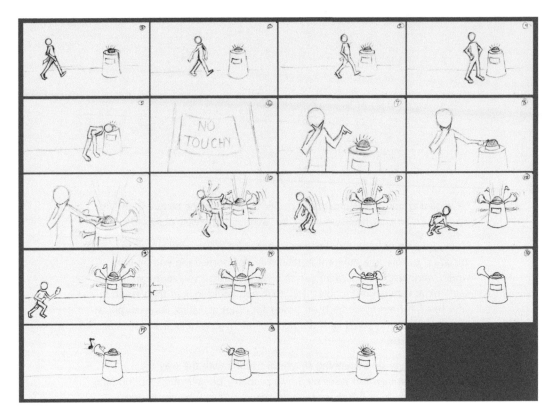

FIG 3.25

help make sure that everything makes sense. If you can't do a coherent one-person soundtrack while stepping through your storyboards, there might be a problem with the choices you've made so far.

Compiling a Story Reel

The next step is to bring the scanned storyboards into Blender and put them into a format that locks in our timing. We'll be using the Sequence Editor to string our storyboards together, sync them to a sound track, and export it as a (very junky) animation.

Before we start to deal with our images though, we need a sound track. Just like the storyboarding process itself provides a manner of checking what was in your head, adding a rough sound track will give the timing of your animation a grounding in physical reality. There are a couple of ways you can go about this. The first is to use your original reference video, if you made one. If your storyboards ended up deviating from this in any significant fashion like mine, you would need to re-record it, keeping in mind the new actions that you've put into your storyboards.

The other way is to make a quick and dirty recording from your computer's built-in microphone. If you don't have a built-in mic, you can almost certainly find a cheap one that will plug into your computer. The odds are that if you have a laptop or even a tiny netbook, you already have a mic at your disposal. Fire up the sound recording application of your choice, hit "record," and act out your shot, making the sound effects with your mouth. Another alternative is to grab an action figure (or a doll, depending on the supplies available in your home) and a block of wood, and then act the shot out with them while making mouth sound effects.

This seems very silly, and it kind of is. If you do it though, you will end up with a sound track that pretty closely fits how the timing of this shot would work out in real life. In the end, you won't be animating to this—you'll be animating so that the timing looks right—but it will make your job much, much easier during the next step.

If you're doing your own project and making your own temporary sound track, give the sound file a relevant name like *sound_track_temp.wav* and save it so that you'll be able to find it later. Is the shame of playing with dolls and making mouth sound effects too great for your fragile ego? Download the file called *my_rough_soundtrack.wav* from the web site, and listen to me continue to make a fool of myself.

We shall now go back to the Video Sequencer, shown in **Fig. 3.26**. This is Blender's default sequencer configuration, and I'm not the biggest fan of it.

FIG 3.26 Blender's Default Video Editing Screen.

From a default Blender scene (Ctrl-N), use the screen chooser at the top to find the entry called **Video Editing**. A quick tour, starting from the upper left and running clockwise: an F-Curve editor window, which I usually turn into a properties window; a sequencer view, set to preview mode to show what's going on at the current frame; and the main sequencer workspace, which looks like a glorified timeline. Below that is an actual timeline window. It seems a bit redundant, but holds some handy playback and start/end frame controls.

For those who have never ventured into the sequencer editor, it is a straight forward video editor. You bring video and audio clips, as well as individual frames, into it, and you can arrange and rearrange them, sync them, fade between them, and basically make a finished video product from the lot.

The first thing we need to do is to get the storyboards into the sequencer. Just like every other aspect of Blender, we can add objects to a scene (in this case, a sequencer "scene") with the **Shift-A** key. The import options for the sequencer are shown in Fig. 3.27. They are: **Scene**, a 3D scene in the current BLEND file; **Movie**, a video file (such as .avi, .mpeg, and .mov); **Image**, one or more images; **Sound**; and **Effects Strip**, which are transitions and special effects that can be applied to other strips.

We'll be choosing **Image**, as we're looking for our storyboards. If you've not dealt with the sequencer before, you may have never selected more than one item from Blender's file browser. It works just the same as selection in any other Blender window. You can find and browse your storyboards from the thumbnail previews and build a selection with Shift-RMB or even the B-key border select. Selected images are highlighted in orange, as shown in Fig. 3.28. It doesn't matter in which order you select the images. They will be ordered alpha-numerically when Blender brings them in.

Notice that I've left the first image (*storyboard0000.tif*) out of the selection, as it was just a warm up sketch. With the selection made, press the **Add Image Strip** button in the upper right of the screen. All of the selected images are brought in and added to the sequence. The result can be seen in Fig. 3.29. The image strip is the purple band in the middle of the figure.

FIG 3.27 Adding Elements to the Sequence Editor.

FIG 3.28 Selecting Storyboards for the Sequencer.

FIG 3.29 An Image Strip.

Take a moment and get your bearings in the main sequencer workspace. We're not going to be spending a lot of time here, but it doesn't hurt to know your way around. The timeline along the bottom of the sequencer view has a unique way of telling time. You'll see that the numbers there count upward normally to the left of the decimal point, but act strangely to the right of it (such as 1.0, 1.1, 1.2, 2.0, 2.1, and 2.2). The number on the left (the whole number part) represents seconds. If you zoom out far enough in the sequencer view, this may be all you get (4, 8, 12…). The decimal part of the number is the frame number within that second. Zoom in a bit and you'll see the entire numbers displayed. So, 1.12 means one second and twelve frames; 5.23 means five seconds and twenty three frames. There will be no frame equal to or above 24, as that puts you into the next second.

This is why you don't see any value higher than 2 after the decimal point at certain zoom levels. Blender is simply chopping off the smaller frame number. 1.1 means one second and ten frames. 1.2 is one second and twenty frames. Personally, I think it ought to stick with convention and show 1.10 and 1.20, but I don't make the rules around here.

Up the left hand side of the sequencer window are the channel numbers. Each channel can hold one or more of any of the various different sequence strip types (image, movie, sound, and effects). The channel stack is exactly that: a stack. You can think of it like an old-style composite camera rig where you build up layers of film and imagery on a board, then shoot the final picture using a camera mounted above everything. Elements that are higher in the stack take precedence. Check out **Fig. 3.30**, which shows two sequence strips with one covering more time in a higher channel that the other. When this is rendered, you will never see the one on the bottom. Unless you do something funky with alpha or blending modes, the camera won't shoot "through" the one on top.

The N-key toggles a mini-properties panel on the right, just like the one in the 3D view. There you'll find things like an opacity control, various ways of dealing with video input, controls to re-link the strip to different source files, and other goodies that we won't be dealing with.

As far the strips are concerned, they come with their own little anatomy lesson. A strip can be selected (RMB), moved (G-key), duplicated (Shift-D), and deleted (X-key) just as you've come to expect. In addition, each of the lighter-arrowed regions on the edges of the strip can be selected and manipulated individually. Using these controls, you can make strips longer and shorter. If you extend a strip past the bounds of its content (i.e., past the last frame of a video, before the first image in a sequence), the strip becomes transparent there. You can see the effect in **Fig. 3.31**. Inversely,

FIG 3.30 Stacking Strips in the Sequencer.

FIG 3.31 Cropping and Extending Strips.

pulling the edges of a strip inside the bounds of its content shows you a little ghostly bar above or below the strip in that region to let you know that something is still there.

Note that when you extend a strip past the beginning or end of its content, it simply uses the first or last frame that is available for that portion of the strip.

With that in mind, what do we do with our image strip? There are twenty storyboards, and if you scrub the timeline over them with the LMB, you'll see that each of the images lasts for only one frame. That's not going to work. First, we need to get the start of the strip exactly on Frame 1. Of the two ways to do it, the first is the most instructive. Using the RMB to select the strip, press the G-key and begin to move it within the sequencer work space. As you do that, you'll notice little numbers pop up before and after the strip. These numbers indicate the current start and end of frames of the strip. Simply move the strip to the left until the first number reads "1," indicating that the strip begins on Frame 1 of the overall project.

The other way to do it is to use the **Edit Strip** portion of the N-key properties panel, setting the **Start Frame** value to **1**. This pops the strip exactly and instantly into place.

A curious user might have tried to use the S-key scale command on the strip to make it longer. It doesn't work. Even if it does, it would probably scale all of the frames equally in time, which isn't what we want to do. We're going to have to adjust the timing of those illustrations individually to make this work.

With the image sequence strip selected and sitting with its left edge on Frame 1, press the Y-key. This triggers the **Separate Images** command (which can also be found in the spacebar look-ahead tool and in the **Strip** menu on the header). Separate Images command splits an image sequence strip into as many little strips as there are images within it. It also pops up a handy tool, shown in **Fig. 3.32**, that lets you set an initial length for all of the new image strips. The default value is 1 (as in 1 frame per image), but I set it up to 12. This means that I'll begin with two images per second (24 frames per second, remember?).

At this point, you can play the result by putting the current frame marker on Frame 1 and pressing Alt-A. It plays, but it's far from good, and the

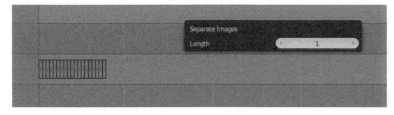

FIG 3.32 Breaking the Image Strip into Parts.

timing is obviously atrocious. If you're not following allow at home, but would like to see what this looks like anyway, watch *Timeless Story Reel* on the web site. We're a long, long way from home, but you know what? That looks like sort of animation. If you've never done this before, seeing your storyboards flung about and playing by themselves might give you a bit of a thrill. I've been doing these sorts of things since I was wee small and still get a bit jazzed when I see a new project move for the first time.

Blindly adjusting the timing of these storyboards would be exceedingly difficult. Fortunately, we don't have to do that. We have our handy rough sound track as a guide. Using Shift-A to bring up the add menu, choose **Sound** this time. Browse to the location of your rough sound file (in the case of the example project, it's *my_rough_sound_track.wav*). Click the **Add Sound Strip** button, and you have a sound added to the work space. Hit the **G-key** (or use the N-key panel) to put the start of the sound at Frame 1. It doesn't matter which channel the sound strip sits in, as there is nothing in it that might obscure the image strips. Fig. 3.33 shows the sound strip in place.

When you first bring your sound strip in, it won't have the fancy amplitude (volume) graph inside of it that you see in the figure. To get this, you must enable the **Caching** control for the strip in the **Sound** panel of the N-key properties. You might also notice in the figure how much longer the sound strip is compared with the imported and separated image strips. We only assigned about ten seconds worth of image strips originally (20 images divided by about 2 per second), and the rough sound track extends out to about nineteen and a half seconds. Recall that we only wanted a true animation project of no longer than fifteen seconds. However, the last four of five seconds is just a bit of business with the pedestal and its horns.

Now begins the somewhat tedious process of matching the image strips to the audio. We won't be sticking with that timing necessarily once we begin working in 3D, but it provides a place to start. When doing this, it's good to

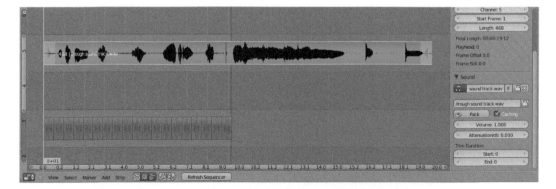

FIG 3.33 A Sound Strip Added to the Sequence.

FIG 3.34 Selecting the Image that Goes with the Sound.

have a solid point in time upon which an image can be stuck. I usually try to find the first real sound that I can positively coordinate with an image. In this case, it will be the "Hmmm?" sound I made that corresponds to the storyboard of the character with her hands on her hips, regarding the pedestal. Had I included actual footstep sounds in the rough track, I would have just started with the character walking. In **Fig. 3.34**, the current frame marker sits right at the beginning of that bit of sound, which you can see on the amplitude graph. The appropriate image is selected from below, and it appears darker purple than the rest.

I could start to pluck these images out of the line up, placing them in another channel right under the sound strip. However, that could get messy and the images could get out of order. Not that I couldn't put them back in order (notice the circled numbers in the upper right corners of the storyboards?), but there's no sense in risking extra work. If I hold down Alt and **Shift** while RMB selecting the target strip, something different happens. Not only is the strip selected, but the handles of any adjoining strips that touch the original join the selection. Using the G-key to move this selection has the effect of moving the central strip, while the two on either side of it adjust their widths to accommodate. This is a neat way of adjusting the location of an image strip in the timeline without introducing any overlap or gaps. However, we would really like to move all of the strips to the right of the target strip, and only have the one to the left stretch. To increase the selection, use either the **Select** menu or the spacebar toolbox to choose the **Select Strips to the Right** command. This should result in the selection state shown in **Fig. 3.35**. Pressing the G-key moves all of the fully selected strips and stretches the one to the left, giving something like **Fig. 3.36**. The target strip is moved until its beginning corresponds to the beginning of the waveform on the sound.

Now we need to have the first three storyboards take up all of the space before this sound cue. Technically, they already do, as you can see in **Fig. 3.36**, but it would be nice if they were more evenly spaced. Let's start by adjusting the relative sizes of strips 2 and 3 (the two immediately before

FIG 3.35 The Image Strips Selected.

FIG 3.36 The Image Strips Moved into Place.

FIG 3.37 The First Three Strips Spaced Evenly in Time.

our last target strip). Once again, you could just select the leftmost handle of strip 3, pull it to the right a bit, and then do the same thing with the next strip over so that they line up exactly. However, there is a simpler way. First clear any strip-selects with the A-key, and then use the Alt-Shift-RMB select combination again. This time, only use it on the leftmost handle of strip four. Only that handle and the one to the left of it are selected. Using the G-key moves the boundary between the two strips, but leaves their outside edges intact. When you've done this to all three strips, you end up with something like **Fig. 3.37**.

Normally, we'd be more careful with where we are sticking the boundaries of these strips, but keep in mind what is going on in the storyboards. The character is simply walking, supposedly at a fairly constant rate. This

FIG 3.38 All Twenty Storyboards Timed to the Sound Track.

means that all of the walking storyboards that we have should be equally distributed within the available time. When we actually get to animation, the odds are that our character's walk will not match the strides taken in the storyboards, but that's okay. Our goal right now is to present the storyboards in a fashion that makes sense, even if it might not be technically accurate.

In fact, the storyboarded walk presented here is pretty unrealistic. If you carefully examine the timeline below the storyboards, you'll see that the first step takes almost an entire second, and the second and third take just as long. In real life, people take a stride about every half second (it has also become a rule of thumb in animation). Obviously, the specific conditions will have an affect, but if you always animate on one step every twelve frames, you will not go wrong. We're almost halving that rate, but once again? Just storyboarding.

Now begins the tedious process of going through the rest of the soundtrack and syncing the storyboard events. It really is a pain, but it's a necessary step.

Fig. 3.38 shows the final state of the sequence editor after I've synced everything to the sound track. On the Web site, the finished story reel is available by the title *Timed Story Reel*.

Aspect Ratios and Resolution or "Mommy, Why is that Man so Skinny?"

If you did your storyboards on 3 × 5" cards, or used the ones provided with the book, you may have noticed that the sequencer preview is a bit squashed. This is because Blender defaults to a 4:3 aspect ratio for rendering, and the sequence preview uses those final render specifications. I'm assuming a certain degree of familiarity with Blender and CG on your part already, so I'll try to keep this usefully brief. A standard 3 × 5" card is very close to the HD ratio of 16:9 (multiplying the card's dimensions by 3 gives you 15:9). So the "old" (standard TV and regular computer monitor) aspect ratio of 4:3 is too narrow to display it properly.

FIG 3.39 (a–c) Choosing the HDTV 720p Preset.

(a)

(b)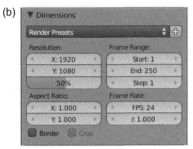

(c)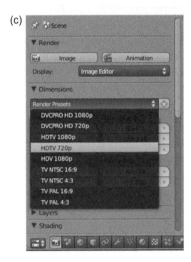

Unless you tell it to do otherwise, the sequence editor takes whatever sizes of video and imagery you've provided and re-samples them to the current render output settings. Bounce on over to the Render properties for a moment. This is why I usually use a properties panel when using the sequencer instead of an F-Curve editor. Fig. 3.39 shows both the default, and the new settings I've chosen.

People have asked me "What's the best resolution and format to render to?" I almost exclusively use the HDTV 720p preset. It generates renders that are 16:9, using 1280 × 720 pixels, at 24 frames per second. Why not 1080p? Two reasons: speed and storage. 1080p has more than twice the amount of pixels as 720p (It does! Do the math!), which takes appreciably that much longer to render. If you have dual quad cores under the hood, that's probably not an issue for you. My desktop workstation is still cruising along with a measly two cores, so that makes a difference to me. This also means that, depending on the content of the images and file format you choose, storage requirements could also double. Storage is dirt cheap, so this isn't that big of a deal. The real question to ask yourself is: Is anyone going to watch my animation in full 1080p? If the answer is "No," why waste the time?

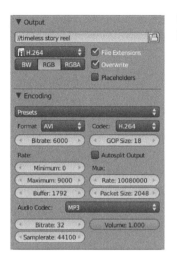

FIG 3.40 The Render Properties, Ready to Go.

Unless you have a compelling reason to do so, I would just stick with the 16:9 ratio. Yes, a lot of folks still have 4:3 monitors, but the world is largely moving to 16:9. From an artistic standpoint, 16:9 better approximates the way that we see the world. The human field of view is a curving horizontal stripe, not a box.

Going back to the sequencer preview, if you advance a frame, you'll see that the aspect ratio has been corrected. It's not exact (15 × 9 versus 16 × 9), but it's close enough that it doesn't matter. With this aspect ratio and resolution decided, make sure to keep it consistent throughout the rest of the project.

Now that the correct render properties are chosen, let's export the current state of the sequencer into an actual animation file. Once again, the presets in the render properties provide some nicely tuned options. You can choose whichever you like, but probably the best to pick right now would be "h.264". Enable audio export as shown in **Fig. 3.40**. Also, find out the last frame number of the last image strip in the sequence. This is easily done by RMB selecting the strip and pressing the G-key. Of course, this puts the strip into Grab/Move mode, but it also shows the beginning and ending strip values right in the work space. When you've noted the ending frame number, RMB or press the Esc-key to cancel the move. Enter the final frame value in the **End Frame** control on the Dimensions panel of the render properties.

Finally, set a path and choose a file name on the Output panel.

Press the **Animation** button, or hit **Ctrl-F12** to start the animation. As the renderer is merely re-sampling a single image on every frame, as opposed to actually rendering anything in 3D, it goes very quickly. You'll see it go by in slow motion on screen. When it's done, find the animation file that was created, and double-click it to play it back in the media player of your choice.

Hopefully, you should have a nicely timed storyboard-based animation with your rough sound track playing along. This product is called the **story reel**. It is your first real indication of whether or not the choices you've made so far are going to work in an actual animation. In a sense, the story reel is a very rough, low frame rate animation. All that we're going to be doing is replacing it with more drawings (done by the renderer, not your hand and pencil) at a much higher frame rate.

Preparing a File for Animation

In a large-scale project with numerous and/or complex shots, we would create a master scene file with all of the necessary assets linked in from separate Blender library files. That allows you to make changes to assets like a character model that might be used in several places in a production without having to go through and update every single file individually. For our animation study though, we're only doing a single three-camera shot. There's no need for multiple files and the library and linking system.

Find the file *character_base_03.blend*. Use your file system tools (Copy-Paste on Windows and Linux, Command-D duplicate for Mac) to duplicate this file, and give it a new name. This will be the file in which you actually do the animation. It's always a good idea to work from a duplicate of your production plateaus, no matter what your industry. In this case, we have a completed character model and set in the file. Let's pretend that it's considered "approved" by everyone in production (which admittedly is just you at this point), so it's wise to keep a clean copy of it somewhere in case something stupidly catastrophic happens during the next phase of production.

Open the duplicate file. I'll be using the pieced Junot character for the study, but if you're following along, you can use whichever one you like. The skinned version of Junot is on layer 11, while the pieced version is on layer 12. Meyer is found on layers 1 and 2. Smith only has a skinned version, which can be found on layer 3.

On Acting and Animation

It's important to note that which character you choose should affect the eventual animation. Meyer and Junot share a rig; so in theory, their animation should be entirely interchangeable. Smith's rig is functionally the same as the others but proportioned a little differently. Animation done for him would be applicable to the others with some tweaking and *vice versa*. In practice though, it will not work. If the animation is entirely generic and pedestrian, it would be "fine." But if you try to infuse some character into the work, it's going to come out differently mapped to a different body. Yes, the motions themselves will be the same, and it still might work as a piece of animation, but it's going to feel different.

Finished animation is a complex interaction of a number of influences. It is affected by the animator's familiarity and facility with the character's controls (solid drawing!), the efficacy of the tools themselves (does Blender rox or suxor?), the ideas that the animator is trying to convey (have you really thought about this?), and finally the feedback that the animator gets as they work with the character. It is the last point that would make animation created for one character feel different on another. If you're paying attention, you *will* animate a female character differently than a male one. You *will* animate a *cartoonishly* proportioned character differently than a realistic one. Or least, you should. Hopefully, it breaks down with even more granularity than just male/female and cartoon/realistic.

Your real goal when animating isn't just the creation of fun moving pictures. You are Acting. Oh yeah, I put a capital "A" on that. Because that's what we're shooting for: the animation you produce is a performance of something that lives in your imagination; however, instead of it being pumped through your own body and face, it is translated by very technical means to be shown on a virtual body and face. Sounds weird, but it's the truth. So, it's almost like you're putting on a suit and acting in very slow motion. If you donned a wacky sports mascot outfit, you would no doubt make different performance choices than if you wore a Nun's habit. The character on screen should be your suit, and that suit should influence your performance.

Back to the file itself. The ground, the pedestal, and the accompanying paraphernalia are already modeled and appear in all five of the character layers. The same goes with the lamps. I've used a simple lamp setup that's good for general outdoor usage: a sun lamp with no shadows, and a shadow-only buffered shadow spot lamp. Extra illumination is provided in the World settings through Environment Lighting and Ambient Occlusion. Mist is added so that the back end of the ground plane fades gently into the sky, which is a simple Real Blend of pale pink on the horizon to a blue zenith. **Fig. 3.41** shows a render of the whole thing, and the world settings can be found in **Fig. 3.42** if you're interested.

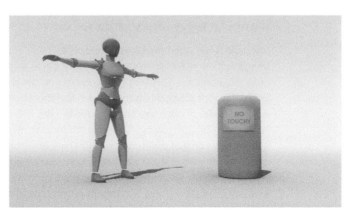

FIG 3.41 The Scene, Rendered.

FIG 3.42 World Settings.

Please feel free to build your own set and props if you feel like you need practice. However, if you want to do it because you feel it's "cheating" to use someone else's stuff, I refer you to my earlier comments regarding cheating in 3D. Cheating is what we're all about! Do you think that the animators at Pixar want to model the room and characters that they'll be animating? Of course not. It would be ridiculous. Okay, I realize that almost everyone reading this book probably does, has done, or will do all of their own work from sketches to modeling, to surfacing and lighting, to animation, to render optimization, and to video editing. Think of this as a nice little break where you get to just be an animator for a while. I'm your production staff, so have at it!

Using the N-key, open the 3D view's properties panel and locate the **Background Image** section. We're going to use the story reel as an animated background image for reference. Speaking of references, you can also open the reference video of myself acting this silliness out in real life (which is increasingly hard to watch). I prefer to open a reference video like this in a completely separate instance of Blender (you can have a bunch running at once). Why not just open it in another panel of the current scene? The frames that I might want to examine in the video won't necessarily correspond with the current frame in my animation, and I don't want to have the video spooling through out of sync with my work. If you have two monitors, this is an ideal way to put it to use: main monitor for workspace and second one for reference items. If you're

FIG 3.43 Setting the Story Reel as Your 3D View Background.

working on a laptop or only have one monitor, you'll have to de-maximize the second Blender instance and arrange your screen appropriately to use it. You may decide it's too much grief, in which case you can just forget about it.

We won't be using the story reel in the background the whole time—mostly just during the initial blocking. **Fig. 3.43** shows the N-key settings for bringing a video in as your image background. Note that the **Axis** control has been set to **Camera** so that the image only shows when we are in camera view. This will automatically keep it out of our way when we are working later. The other changes from the default import settings are **Auto Refresh**, which keeps the background movie in sync with the current frame, and the fact that **Transparency** has been reduced to 0.0. This makes the background image "full strength" which will be perfect for our next task.

Before we can do anything else, we need to position the camera in a way that approximates the perspective in the storyboard. RMB-select the camera, and go to Frame 1 if you're not already there. Analyzing the top, the side, and the front views, take a quick guess about a camera location and orientation that would approximate the one seen in the first storyboard. With Numpad-0, jump into a camera view to see how close you came.

If you have never matched a camera perspective to a drawing or photo before, here's a tip: you can adjust the camera even from camera view.

Aligning the camera's perspective to the one in the storyboard in camera view will be best accomplished in wireframe mode, so use the Z-key to bring up the wires. The three things you will be adjusting as you do this are the camera's actual position (G-key with the camera selected, MMB-click once you're moving to dolly in and out), the rotation of the camera (hit the R-key twice to enter free rotation mode for easy aiming), and the camera's lens angle. **Fig. 3.44** shows the Camera properties.

Blender defaults to an angle that approximates a 35-mm lens, typical for basic photography. You can go way down to 15 mm for extreme foreshortening, or push it upwards—50 mm is about as far as I usually go—for a telephoto lens that "flattens" the subject. **Fig. 3.45** shows those three different lens settings, with the camera itself pushed in or pulled out to keep the same basic framing. In the end, you don't have to

FIG 3.44 The Camera Properties.

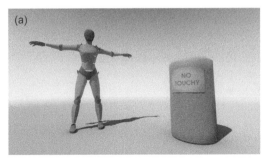

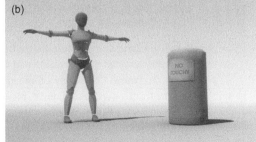

FIG 3.45 (a–c) Different Lens Angles for the Same Shot.

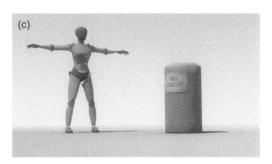

FIG 3.45 (a–c) (Continued).

FIG 3.46

make what's on your screen look just like your storyboards. They are only a guide. Once you're in 3D, you need to do what works in 3D. In fact, you might even find that you can't recreate certain things from your storyboards once you actually have to construct them and make them fit. It's easy to draw things out of perspective, but much harder to really make it happen.

One problem that I immediately ran into was the poorly drawn perspective in my long shot storyboards. See in **Fig. 3.46** how the top of the pedestal is visible, but the horizon is in the bottom third line. The only way to accomplish this once you take it into 3D is to have the ground slope sharply downward as it moves away from the camera.

So it comes to a tradeoff. If I put the horizon on the lower third line, I can't see the top of the pedestal. If I position the camera high enough to see the top of the pedestal, it completely changes the way that I had intended to set the character off against the sky. Looking ahead in the storyboards, I see that it is only when I switch to the medium shot that seeing the top of the pedestal becomes important, so I go with the first option. The composition of the long shot wins out.

With that issue settled, we need to build two more camera angles, one for the close-up of the sign, and the other for the medium shot. You can match these yourself by adding new cameras, advancing to the proper frames and setting their positions, or just jump straight to the next chapter where we have a complete working file ready.

Basic Posing and Key Framing

We're about to begin our first steps in character animation. Because you're just learning the basics, we're going to begin with the pose-to-pose method. We'll talk about it more later, as well as straight ahead animation, but the reason we'll be using it now is that it allows us to break the process down into nicely digestible nuggets. Instead of tackling every aspect of animation at once, it lets us first concentrate on crafting the poses themselves.

Regardless of whether you're working in stop motion, computer graphics, or traditional animation, it all boils down to a series of poses. Whether an artist is drawing them on clear sheets to be layered and shot by a camera, or a computer is generating interpolated poses between poses that you've created, each frame of an animation finds the character in some pose or another. The visual strength of those poses will be your first component of a good animation.

Tradigital Blender
© 2011 Taylor & Francis. All rights reserved.

When deciding exactly which poses to create, think about your goal: to create a series of strong, dynamic "drawings." If it's done right, we should almost be able to go back later and choose certain frames from our work that would be perfectly suitable as action panels in a comic book. This means that we are shooting for the extremes and points of contact in our initial posing. Whatever the character's motion, we want to choose for our pose the instant in time when their body is most extended (or compressed), and their skeletal structure shows the most tension. In terms of physics, we want the moment that expresses the highest degree of stored energy. As a part of that, we also want the moments of greatest weight. When a character touches something (a bauble with their finger, the ground with their feet), we want to capture the moment during which their weight is most heavily expressed.

Of course, deciding which poses to include in your storyboards eventually falls to your intuition once you are more experienced. The rules presented here are meant to get you started, not lead you the whole way through every animation project that you do for the next 10 years. As you gain more experience and confidence, you should rely more on your own gut for this very subjective activity than to any set of hard and fast rules.

First Pose: Walking

Let's begin in the traditional fashion of animation education: walking. Walking is a neat study for animation because you can get a decent walk with only a few poses. Not a great walk, mind you, but it will move, look nice, and be exciting. Walking also introduces some hard core physical constraints:

- A person's stride can only be so long
- A foot that is planted on the ground must stay there until lifted (no skating!)
- A person must be properly balanced

The pose of the character walking that was chosen in the storyboards is no accident. It is the starting point for making your character's walk. Note in **Fig. 4.1** that the character's legs are at their most extended point—it is the extreme pose of the walk.

Let's head into Blender and build this pose.

As we mentioned before, you should work from a copy of the *working set* file, in case you royally mess things up. I've called my working copy *chapter 04 scene.blend*, but you can call yours whatever you like. First though, a little more prep. The file opens to the animation screen, which has been altered as I indicated in Chapter 2. Still, the 3D view is a bit cluttered for animation work. I like to only show my character model, their skeleton (i.e., animation controls), and any geometry with which they might have to directly interact. In this case, that means only the ground. To get rid of everything else, you could add the items in question to another layer

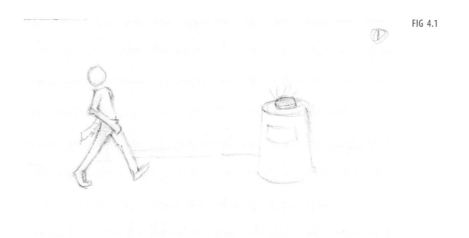

FIG 4.1

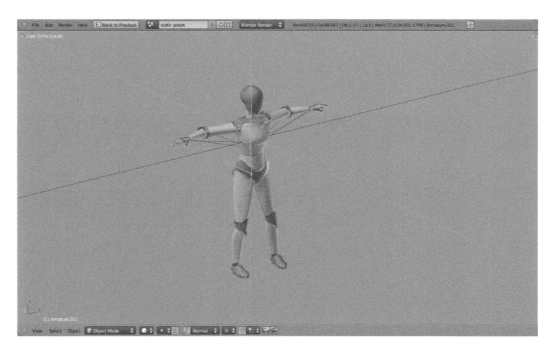

FIG 4.2 Local View. Note the Lack of Layer Buttons on the 3D Header.

and work from there, or you can use local view. From a side view use the B-key to border select all the parts of the character, the armature, and the ground. If you are in pose mode on the armature, you'll have to leave it with Ctrl-Tab in order to select multiple objects. With those items selected, hit the \-key (backslash, located above the Enter key on most US keyboards). Blender puts the selected elements into a temporary layer, leaving you with the clean working area shown in **Fig. 4.2**. From

there, I generally hit **Shift-Spacebar** with the mouse over the 3D view to make it fill the screen. Almost instant super-clean, full screen work space!

Your tools are still easily available from the spacebar toolbox or the T-key toolbar on the left, and necessary properties can be toggled with the N-key. Use the MMB to rotate the view for a moment. The odds are that it's not rotating around your character. To correct this, RMB select only the armature and press **Numpad-Period** (the decimal on the number pad). This forces Blender to realign its view rotation and scaling pivot point to the selected object.

Deep breath and let's actually build the pose.

Go back into pose mode (Ctrl-Tab) on the armature and choose a side view (Numpad-3). RMB select the bone that extends backwards from the base of the spine. If you recall from our lesson about the character's controls, this bone moves the entire upper body, leaving the feet planted in place. Using the G-key, move this down so that the knees flex like **Fig. 4.3**, as though the character was beginning to squat. This first simple move will actually determine a lot about the eventual walking animation.

The body of someone taking long strides will travel up and down more than someone taking tight, controlled strides. In fact, how far we move the

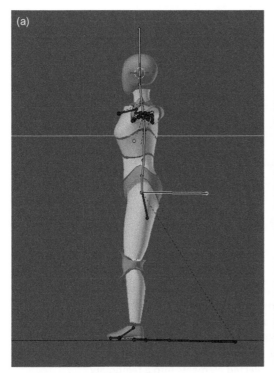
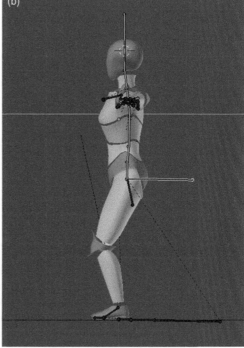

FIG 4.3 (a, b) Junot's First Step in Posing.

body downward in this step determines, in conjunction with the actual length of the character's legs, how long of a stride they can take. A prim and proper character will exhibit only a small degree of vertical travel: their steps will be tighter. A wacky cartoon-based character will probably show a lot of vertical motion in the body. The stride length, combined with how many frames a full stride takes, will determine how much ground your character can cover during the course of your animation.

But how much vertical motion is enough or too much for what we're doing now? If you're using Junot, you'll probably want to keep the amount small. I'm thinking of giving her a sophisticated, sassy stride. She'll tend to glide more than bob. Note in the figure that I've marked the center of Junot's head with the 3D cursor (LMB), and after I've dropped the upper body, she has moved about a quarter of the height of her head. The vertical travel of a real person walking like this will be even less, but we need to give it some life.

If you're using Meyer, you might want to put a little more vertical travel into it. Not much. Don't move it more than half the height of the head. All bets are off with Smith. He's way out of human proportion to begin with, so he will be able to visually withstand a lot more abuse relating to how you move him.

Fig. 4.4 shows the left foot control selected. It's the bone extending backward from the heel of the left foot. The rotation and location of this

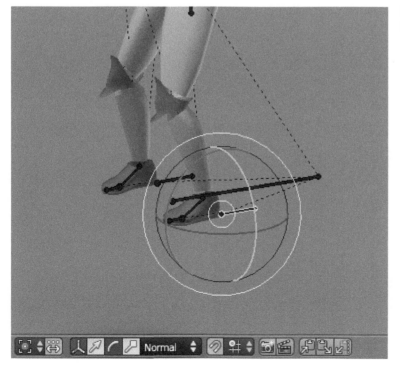

FIG 4.4 The Left Foot Control Selected.

control determines the orientation of both the foot and the rest of the leg. You might have to rotate the view off-axis in order to select it, as seen in the figure. If you don't have the rotation manipulator enabled and set to **Normal** mode, do so now with the header controls highlighted in **Fig. 4.4**. As we mentioned in Chapter 2, this will give us easy access to the bone's local rotational axes.

Back in a side view, hit the R-key and rotate the foot control so that the foot and toe face upward at almost a 30° angle, as seen in **Fig. 4.5**. Hit the G-key to begin a move and reset the back of the heel against the ground.

(a)
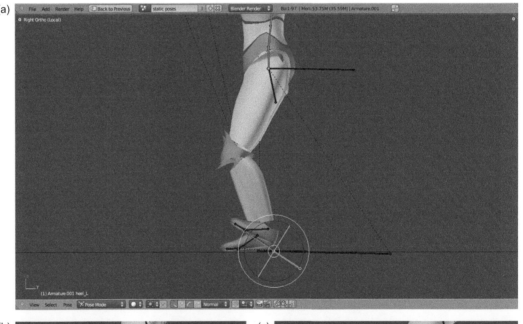

(b)
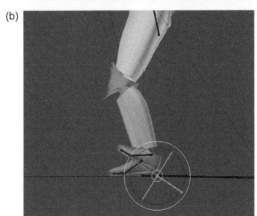

(c)

FIG 4.5 (a–c) Rotating and Moving the Foot/Leg Controller.

It may have pulled away from it during the rotation. Then, move the whole foot forward until the knee "locks" into place and the foot itself begins to pull away from the bottom of the leg. That is actually just a tad too far, but when dealing with IK limbs like this, the easiest way to locate the extreme pose is to actually find "too far" then back away from it slightly. Do that. You can see the result in part c of Fig. 4.5.

Looking at the figure objectively, it appears that it's not a very long stride. She's going to have to hustle to make it from the edge of the screen to the pedestal to match the timing of the storyboards. When we have the other leg positioned, we'll take a few measurements and figure out exactly how far off we're going to be.

On the other leg, we don't select the main foot/leg controller. Instead, select the bone within the foot itself. Fig. 4.6 shows the bone selected. Rotate the bone about 20° counter-clockwise to achieve the second half of the figure. This bone lifts the heel while leaving the toe's contact point intact.

With the right foot in this position, we can grab the main foot/leg controller and move the foot backward. Use the same technique as the other foot to determine how far to move it. Go until the leg "locks" and then back off a little. The result can be seen in Fig. 4.7. None of the motions with the right foot should have pulled it off the ground, but it's worth checking anyway.

Keep in mind that we're only working from a side view. There are more things to consider from other angles, and we'll come back to them in a moment. Right now though, we're going to do a quick experiment to see how long it will take our character to walk from off camera to the

FIG 4.6 Bending the Foot.

FIG 4.7 The Right Foot Pulled Back.

FIG 4.8 Measuring the Stride Length.

pedestal. An easy way to measure distances in Blender is to add an Empty object, move it, and examine the 3D header's transform information display for the appropriate numbers. To do this, I place the 3D cursor where Junot's rear heel would fall if she flattened her foot, and add an Empty with the Shift-A menu (remember to leave pose mode first!). Then, I simply move the Empty to the left until it reaches the same location on the other foot's heel, as shown in **Fig. 4.8**. The 3D header shows the total

distance moved along the *y*-axis (0.8420 units). This is Junot's stride length, assuming that we use the same amount of vertical travel for her upper body throughout the walk.

Now that we've positioned the feet and seen how the knees lock into place when they've gone too far, it's easy to understand how lowering the body and pelvis more can allow a longer stride, even with the same leg length, and how giving even less travel necessarily tightens the walk.

To figure out the rest of the problem, we'll have to leave local view (\-key) and revert the 3D view from full screen (Shift-Spacebar) so we have access to all of our controls. In pose mode from a top view (Numpad-7), grab the large root bone for the entire armature. This is what you'll use to do your gross initial positioning for your characters. I avoid moving armatures in object mode, just in case there is some aspect of the animation and rig that doesn't "like" it. From that top view, I move the entire character via the root bone until it disappears from the camera view in the upper right of the work space, as shown in **Fig. 4.9**.

Notice as I've done this that I've also rotated the entire character clockwise and payed attention to exactly where I'm moving it. The approach that the character takes in the storyboards is pretty much directly from left to right across the space. We can mimic that in 3D, but if we think about staging from the previous chapter, it would be nicer to "cheat" the character toward the camera a little so that we don't get a perfect profile shot. So,

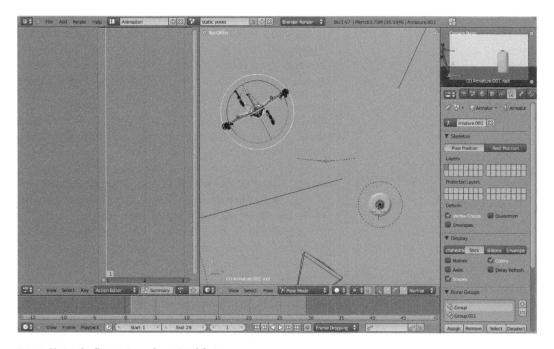

FIG 4.9 Moving the Character into a Decent Initial Position.

from the camera's perspective, Junot will move from left to right, but also from just slightly behind the pedestal as it relates to the plane of the camera's view. In the tiny camera view, her hand is still in frame, but when she's fully posed for walking that won't be the case.

All we have to do now is to hit the G-key again, move her to an approximate location near the pedestal and examine the 3D header for distance information. In my file, it's about 3.64 units. A simple bit of math (3.64/0.84) indicates that it will take her just under four and a half strides to move from off camera to the pedestal with this stride length. We mentioned in the previous chapter that people generally walk at about two strides per second, so this gives us a time of about two and a quarter seconds (54 frames) in which to accomplish this.

Going back to our story reel, we find that the character in the boards stops and regards the pedestal some time between frames forty-five and sixty-seven. Despite our earlier misgivings about the timing of the walk in the storyboard, we've hit it just about perfectly! There's nothing like some math for a morale boost, I always say.

Back to actual animation. As we mentioned just a moment ago, this isn't even half the pose. To keep working on it, I could clear the movement and rotation of the root bone so that Junot lines up properly with the side view, but there is a better way. You won't always have your character posed at 90° to one of the main views. The Number pad view buttons provide a simple way to align the current view to the selected object. Just hold down the Shift key with the appropriate object (or bone!) selected, and the view is aligned for you. In this case, RMB select the root bone and hit **Shift-Numpad-1**. This gives me a perfect front view of Junot, regardless of where and how I've placed that root bone in the scene. Later on, when she moves away from the root bone, we might choose to align the view to some other bone, but for now it works.

The first half of **Fig. 4.10** shows our pose so far from the front. Clearly, there are some glaring issues. First, no one walks with their footsteps falling in line with their shoulders. To a greater or lesser degree, everyone's feet pull toward their center line as they walk. In general, the closer to the center line the footsteps land, the more "girlish" the walk ends up. In fact, an exaggerated female strut (or slink) could even find the feet crossing the center line. For Junot, we're just going to pull them close. Notice how in the second half of **Fig. 4.10** I've not only moved the foot to the left but also rotated it counter-clockwise around the z (blue)-axis so that her knee faces almost straight forward.

If you've just tried this for yourself, or gone so far as to move the back foot too, something bad probably happened. The odds are that so far in Blender, you've been working in global space. That means that if you're in a front view and you hit the G-key followed by the X-key, you know exactly

(a)
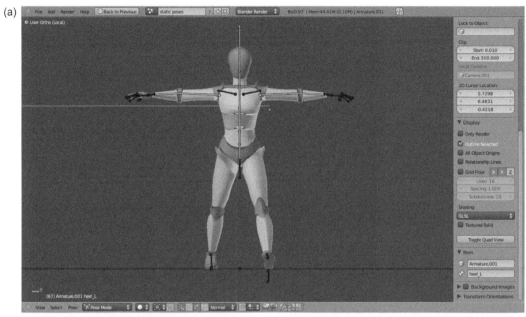

(b)

(c)

FIG 4.10 (a–c) Moving Junot's Foot toward the Center.

what's going to happen. The object in question will be constrained to move only left and right on your screen. If you try the same trick in a custom aligned view like we're working in, you'll get a result you hadn't expected. Your front view is no longer aligned to the global axis, so while tapping the X-key appears to move the foot correctly; when you move the view off-axis, you see that it has not. Due to the exact positioning of Junot in my scene, the foot ended up moving forward as it approached the center line.

The way to avoid this is to change the Alternative Transformation Space (ATS) widget on the header from **Normal**, which is how we were working with bones, to **View**. This way, when you select the foot controller and press the G-key, you can follow it up by pressing the X-key twice: once to trigger that global *x*-axis constraint and a second time to switch it to view-based *x*-axis constraint. That's a lot of words to say something that will only take you a second or two to do once you have the hang of it.

Just remember that when you're working in a custom view alignment, you need to be aware of your transformation space as you press those x, y, and z constraint keys.

If you haven't already moved the back foot toward Junot's center line, do it now.

Moving up the body, let's adjust the hips. The control that protrudes downward from the pelvis allows you to rotate or move the hips independently from the rest of the upper body. Using this control and the rotation widget (making sure the ATS is set back to **Normal** on the header), I rotate the pelvis to follow the legs, that is, the side where the leg is forward rotates forward. I also rotate it counter-clockwise from a front view, so that the portion close to the forward leg rotates up and the other side rotates downward. Fig. 4.11 shows a before and after of this.

That obviously puts the hips contrary to the positioning of the lower spine. As we're working our way up the body, it makes sense to tackle each portion of the spine in turn. Since we'll be using the rotation widget set to Normal mode, having a perfectly aligned view isn't crucial. The widget keeps track of the selected bone's axes for us. Also, it is beneficial to freely rotate your view while posing to inspect your work from a variety of angles.

I'm going to build a curve into the spine starting with the lowest bone and proceeding to the top. The bottom bone will be rotated similarly to the hips, but not quite as much. The goal is get the shoulders either square with the feet from a top view, or even a little bit past it. This is because the right arm will be forward in this pose, to counter the forward left leg. To make that happen, we can't have the shoulders rotated away from center too much. So, using the middle spine bone, we rotate the upper body back toward the way it came and finish the rotation with the upper spine bone. You can see all three stages in Fig. 4.12.

Many rigs will include tools that let you simply pose some portion of the upper body, and the constraints and mechanics of the rig will distribute that rotation evenly among the spine bones, creating a natural curve. We're not using one of those rigs right now for the same reason that you learn how to do basic arithmetic before they let you start using a calculator in advanced Algebra: it's good to be able to do things "by hand" first.

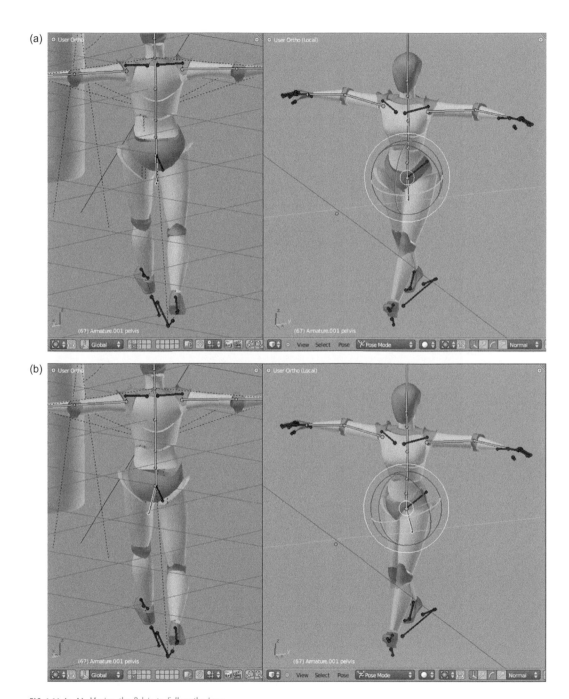

FIG 4.11 (a, b) Moving the Pelvis to Follow the Legs.

(a)

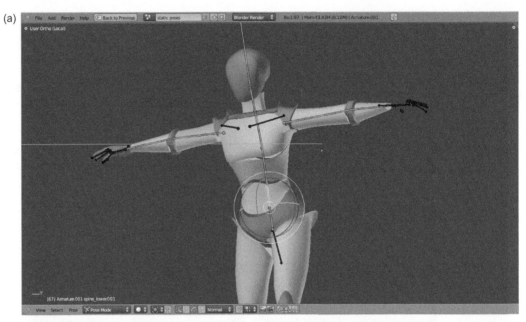

(b)

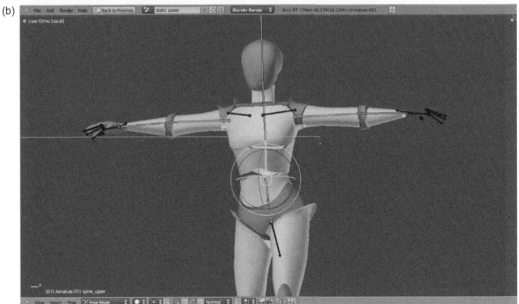

FIG 4.12 (a–c) Rotating the Spine.

Since she's strutting a bit, I've also rotated both the middle and upper spine bones backward a touch to give some arch to her back. **Fig. 4.13** shows the final pose of the feet, legs, hips, and spine. What we've done by twisting the spine this way is to introduce potential energy into the skeleton.

(c)

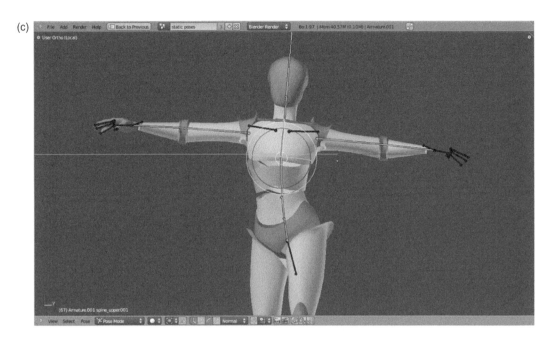

FIG 4.12 (Continued).

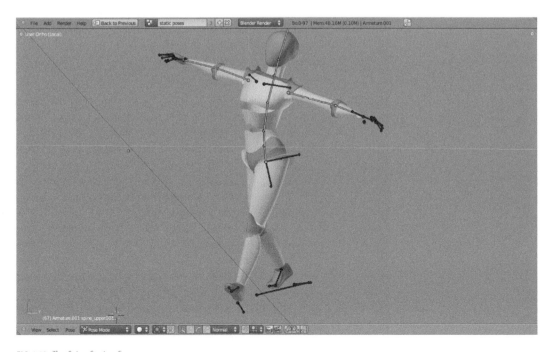

FIG 4.13 The Spine Storing Energy.

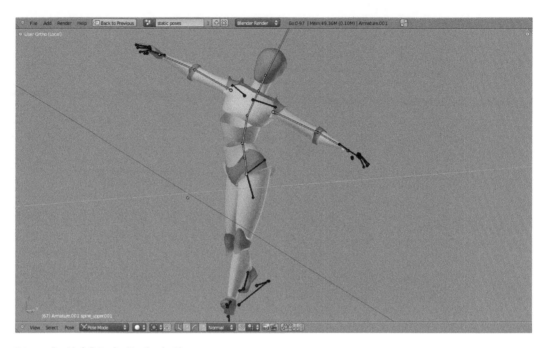

FIG 4.14 Too Much Twist, But You Get the Idea.

The rotations balance each other out, but the character clearly isn't at rest. Depending on how far we wanted to push it, and how exaggerated we wanted the walk to be, we could increase all of the upper body and pelvis rotations to add even more energy. The result, shown in Fig. 4.14, is too much for this, but it's a good demonstration.

Continuing with the idea of building tension (stored energy) into the pose, I rotate the left collar bone back (the left arm will move back) and the right one forward. Not a lot, because collar bones don't have that much play, but enough to enhance the flexing of the skeleton. Finally, I bring the right arm forward, pulling the hand toward the center line, and swing the left arm around the back. Fig. 4.15 shows the arms in place. I usually position arms with the rotation widget, posing each joint by hand. However, if you enable **AutoIK**, which is shown in the tool shelf in Fig. 4.15, you can just grab the lower arm bone, hit the G-key, and pull the whole arm along for the ride. Some animators find this more intuitive, and it is often easier to use this when making a large move than to try to find it by posing the individual bones. However, you will almost always have to adjust the final rotations of bones that are moved with AutoIK. Note that AutoIK is *not* a shortcut to true IK motion. It is a posing tool only. A true IK limb follows its IK calculations throughout its interpolation along the time line. A limb posed with AutoIK will interpolate normally, as though IK had never touched it.

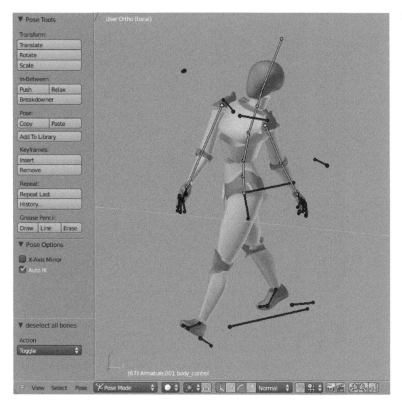

FIG 4.15 Auto IK and Posing.

Proceeding upward, let's do the head and neck. This is another set of bones like the spine where the final pose is an accumulation of the transformations of both bones. So, if you want the head to turn, say, 90° to the right, you would give the neck and head each a 45° rotation in the same direction. In this case, we want Junot to look straight ahead and probably tilt her head back a bit—looking down her nose. When posing the head, don't ignore the character that can be added by rotating around all three axes. Heads can tilt from side to side, and this motion can be expressive.

Finally, we come to the hands. They are easy to ignore, because there is a lot of work involved in creating decent hand poses. In long shots, like the one we're creating, a hand doesn't have to be perfect, but it can certainly add to the look and feel of the overall pose. For this pose, the hands will just continue the motion of the arms. The front hand will be crooked upward a bit, following the curve that the rest of the arm makes. The fingers will be outstretched a little, indicating some tension and the notion that the forward hand is reaching.

To achieve the hand pose in **Fig. 4.16**, the control bones for the first two fingers are scaled up until the fingers "pop" past their straight rest position. Fingers 2–4 are rotated outward a little to spread the hand, and each are then rotated slightly toward the palm. I've done the opposite to the rear

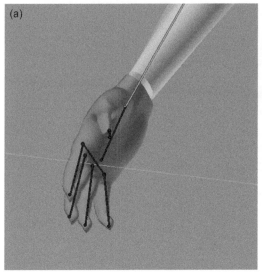
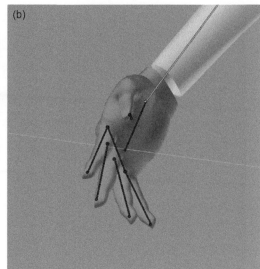

FIG 4.16 (a, b) Before and after Posing the Hand.

hand. While the break of the wrist continues the curve started by the shoulder and arm, the fingers receive a light curl by scaling their control bone downward, and then rotate toward the palm in a relaxed fashion. The fore hand shows tension; the rear, relaxation. As it can be tricky to get the hang of posing hands, you can watch the video *Posing Hands* to see me building this first hand pose in real time.

Fig. 4.17 shows the result of our first round of work on this pose. It is clearly exaggerated beyond how any normal person would walk, but in the realm of animation it will work. In fact, as we've noted before, this level of exaggeration is necessary. While we're talking about the principles (exaggeration!), let's consider a few others while we're at it. Any need for **Squash and Stretch** in this pose? Not really. We're not at any point of extreme weight distribution. **Solid Drawing**: are we doing anything in this pose that radically breaks with human geometry, or just looks plain bad? No. However, it's worth examining the pose again from the perspective of this principle before moving on.

Falling under the "solid drawing" heading would be balance. When I'm creating a pose, I generally give it at least two iterations. The first time through, which we've just done, builds the raw pose. It's possible that during the rest of the posing process certain things you had thought were settled may have become unsettled. For example, leg extension, which is a product of foot placement and hip height and orientation, may need to be adjusted since the hips were rotated. We might be able to comfortably achieve a bit more stride, or perhaps we lost a little, and need to pull the feet closer together. One other thing to check is the character's balance.

(a)

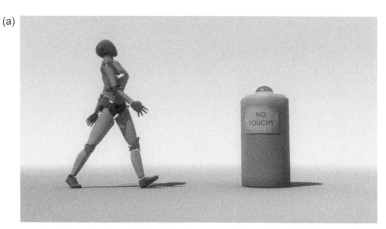

FIG 4.17 (a, b) Junot in a Single Walking Pose.

(b)

Rotate your view and examine the pose from all sides. The character's center of gravity is generally located in the space just below their pelvis. With that in mind, does the overall distribution of weight in your character suit their foot placement and the action that they are supposed to be taking?

Taking a look at Junot's front and side views (Fig. 4.18), you can see that her center of gravity is just slightly forward of the center line between her points of support (heel and toe). However, she is leaning backwards, so that counteracts the forward position. Overall, she appears to be well balanced. In the front view, her center line seems to fall a bit toward the forward leg, which is fine. When you walk, you don't carve a perfectly straight line unless you're in a marching band. Your body tends to cruise along, led by whichever leg is in front.

Obviously, your character won't always be in balance. When they are in control of themselves though (i.e., not tripped, falling down stairs, punched in the face, etc.), they will tend to be in balance.

Looking at the pose in Figs. 4.17 and 4.18, it's clear what's going on even in a still frame. The lines of action are clear. The body is balanced. The pose is

FIG 4.18 Checking for Balance.

FIG 4.19 The Keyframe Menu.

exaggerated to the appropriate level for the character type. Some of the character's attitude is coming through. I'd say that this is a good starting point.

Before we do anything else, we're going to save this pose in a keyframe. Make sure that the character is still completely outside of the camera's view, and set the current frame marker to Frame 1. In pose mode, use the A-key twice to select all available bones. Then, press the I-key. If you've done keyframe animation in Blender before, bear with me. **Fig. 4.19** shows

the keyframe popup menu. It allows you to set keys (i.e., record information in the timeline) for a variety of properties. Depending on which option you choose from the menu, you can record just the location, rotation, or scale of a bone, or even several combinations of them. The options that begin with *Visual* won't make much sense to you at the moment. We'll get into them much later.

For now, just choose **LocRotSize**. We're setting keys for all three properties on all of the available control bones because we don't know what we're going to be doing later. Blender treats everything in the timeline before the first key as equal to that key. So, if you set a Scale key of 2.0 on a bone on Frame 15, and it was the very first scaling key for that bone, Blender would set the bone's scale to 2.0 on Frame 15 and on all frames before it. Likewise, it continues the value of the last key in the timeline out to the very end.

What would happen if we simply said "Bah! I'm not going to key the scale values of the arms. I didn't change their scale on this first pose!"? But, 200 frames down the line, you decide to add some squash to the arms, change their scale to 0.75 and set a key. That key, being the first one set for scaling on the arms, affects all previous frames. Your character develops squashed arms for all frames leading up to that first key.

So it is that when you're blocking out your initial poses, you should key all available properties for all bones. The other benefit of doing this, instead of just picking and choosing certain properties and bones to record, becomes apparent when you glance over at the Dope Sheet. **Fig. 4.20** shows it, set to Action Editor view, after the first batch of keys has been set. The keys make a nice, unbroken vertical column. Later, when we start adding individual keys here and there, the editor can become confusing, and it's nice to have these tall blocks of keys to keep us oriented in both time and space.

In a moment, we'll move on to making some other poses, but let's get Junot up to the pedestal. We've already done the math and know that by taking a step every half second, she'll hit her mark right on time. In order to easily generate the next several steps, we'll learn how to use the **Copy**, **Paste**, and **Paste Flipped** buttons on the 3D header.

Using the bone-aligned views (Shift-Numpad-1 and Shift-Numpad-3) you just learned, set the 3D cursor to the location of the back of the forward leg's heel as shown in **Fig. 4.21**. Our goal is to precisely mark the rear-most contact point between the heel and the ground. This will be our reference for the location of the next step. Since you're setting a 3D location by LMB clicking in a 2D plane (i.e., the viewport), you need to do it from two different angles to set it accurately. Set it from the aligned front view first (Shift-Numpad-1 with the root bone selected), then from the aligned side (Shift-Numpad-3).

Use the A-key twice to select all of the bones in the armature. Then, remove the root bone from the selection with Shift-RMB. We want to copy

FIG 4.20 The Dope Sheet with a Column of Fresh Keys.

and paste all of the posing except for the root bone, which should remain exactly where it is. Forward motion of the character's body will be accomplished solely by moving the foot controllers and the upper body control bone from here on out. With those bones selected, press the **Copy** button on the 3D header (highlighted in **Fig. 4.22**). Advance twelve frames (Up arrow once, followed by Right arrow twice) to Frame 13. Press the **Paste Flipped** button on the header.

Junot assumes the mirror of the original walking pose! That was easy.

If we set keyframes now, she would just be walking in place, like a treadmill. To move her forward, select both foot control bones and the upper body controller that extends from her lower back. In a top view, move her forward so that she is facing the same direction as before, but her rear heel should align with the 3D cursor. Take a look from a regular

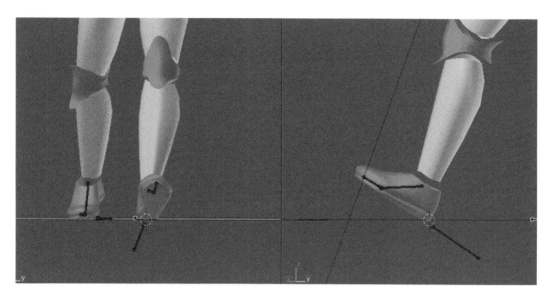

FIG 4.21 Setting the 3D Cursor as a Foot Reference.

FIG 4.22 Moving the Character into Position for the Next Step.

(not aligned) front and side view to position her more exactly in relation to the 3D cursor. **Fig. 4.22** shows how I've done it. Also, rotate the view to make sure that nothing wacky happened during the pose-flipping process. Every now and then it does, so it's worth a look.

If you're happy with the mirrored pose, and Junot is correctly positioned, use the A-key to select all of her bones, then the I-key to create a new column of LocRotSize keys.

Using the same procedure as before, mark the heel of the new front foot (it's now her right foot) with the 3D cursor. Go forward twelve frames in time and hit the **Paste** (not Paste Flipped!) button. We used regular Paste this time instead of Paste Flipped, because this pose should just be a copy of the original one. Strides alternate sides. Junot will jump back to her original position. Simply select the foot and upper body controllers and move her so the rear heel is aligned with the 3D cursor. Select all the bones in the armature and set another column of LocRotSize keys.

Do this once more, using Paste Flipped the next time. This takes us up to Frame 37, and should find Junot near the pedestal. If you like, you can set the animation playback range in the Timeline view to **Start: 1** and **End: 37**, and then hit Alt-A to play it back (the video *Walking Without Breakdowns* shows the result). It looks horrible. That's okay. There's a lot of work left to be done. In fact, we don't even want to see the interpolations at this point. Before we mess with anything else, let's take a break and talk about pose-to-pose, straight ahead, and a hybrid approach that many CG animators prefer.

Pose-to-Pose and Straight Ahead Animation

If you had to animate in sand, how would you do it? Someone has provided you with a tray onto which has been cleverly poured different colored sands that create a picture. Your job is to animate that scene. The only way to accomplish this would be to push the sand around a little at a time, taking pictures along the way. You could think ahead to where you wanted things to go, but you can only approach it one step at a time. If you tried to jump ahead to create some key element, there would be no way to return the sand to its current state before proceeding.

That is the essence of straight ahead animation. You start at the beginning and build each step completely before proceeding to the next. If you were doing character motion of normal velocity in CG, you might generate a pose, advance two frames, generate another, advance two more, and so on. In order to do this effectively, you have to already have some skill as an animator, as you'll be building in things like anticipation and follow through, overlap, and secondary motion as you go. Straight ahead animation is often related to a looser feeling in the final product and is subject to bursts of inspiration.

A pose-to-pose work flow suits computer animation particularly well. Using pose to pose, you go through your timeline building important poses. Then, you go back through and add breakdowns, which are just poses that fall between the original ones and help to guide the interpolation. How many breakdowns you add between keys depends on a number of things, such as how quickly the character is moving (more breakdowns), how widely

spaced the original keys are (tighter key spacing means fewer breakdowns), and how well thought out your breakdowns themselves are. The pose-to-pose approach can be methodical and might lack some of the life of animation produced with the straight ahead approach.

The truth is that most animators pull from both of these techniques. The planning and reliability of the pose-to-pose method is almost a necessity in today's production animation environments, and a well-executed pose-to-pose can be every bit as exciting as a pure straight ahead.

I like to use a hybrid approach, creating key poses and vetting them like the pose-to-pose method, then filling in the gaps moving straight ahead. For most of our animation, we'll be using a fairly strict pose-to-pose interpretation, as you're just learning about the different techniques and portions. For the big, flailing fall-away after the alarm triggers, we'll use a straight ahead approach to get Junot across the frame.

Continued Posing

A common technique for animators is to disable interpolation while creating the initial key poses, and that is how we will proceed. In this way, it's more like creating full 3D storyboards that "pop" into existence on the appropriate frame. You don't have to worry about the ugly default interpolation until after you've solidified all of your poses.

To do this, use the A-key over the keying area work space in the Action Editor to select all of the existing keys. Then, from the Keys menu, choose **Interpolation Mode->Constant** (Fig. 4.23). As we learned when working

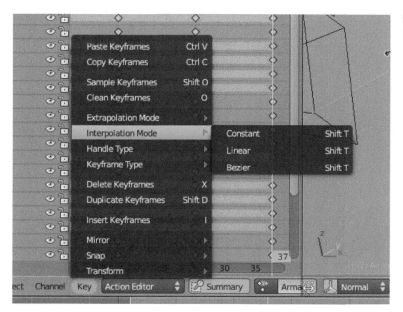

FIG 4.23 Changing to Constant Interpolation.

with the F-Curve editor, normal interpolation between poses happens along a curve, smoothly blending from one pose to the next. Constant interpolation, which we have just applied to our poses, does not do any smoothing. It simply holds the current pose in the timeline until it encounters another key. On the frame of the new pose, it immediately switches to that pose with no transition. It is sort of like making 3D storyboards.

Now, pressing Alt-A doesn't look like someone trying to moonwalk on ice. The motion advances choppily (only one "frame" every half second), but already you can tell if it is going to work or not.

Depending on our work flow, we might go back right now and start adding additional poses between the ones we've just created to help to shape the in-between motion. But our goal right now is to get all of the major poses broken out for the rest of piece.

So, the next pose according to our storyboards (Fig. 4.24) has Junot stopped, leaning back, and regarding the pedestal. Once again, no squash or stretch will be involved, but we have to be careful from an acting and solid drawing perspective to make this pose interesting. The first thing to keep in mind is "How are her feet going to get here from the walk?" We're not going to animate them into place yet, but as we build a pose from the ground up, it would be nice to know if either of her feet should be anywhere specific in relation to their positions in the previous pose.

It's time to get up from your desk (or couch, or wherever you're doing this) and walk around. Find a target that you think you can walk to in five steps. Start with your left foot, and approach the target at a similar angle to what's happening in 3D in our scene.

In my own tests of this (and as you can see in the reference video), what happens is the following: regardless of how you begin or how many steps you take, the foot on the target's side of your body (the left in this case) becomes

FIG 4.24

the "stakeholder." Where it falls determines your body's final distance from the target. After it plants, the other foot (right) does a little catch-up step to drop you into a balanced standing position. So, since our last pose of the walk has the right foot forward, and it will be doing a "catchup," we don't need to be overly concerned with foot placement. We'll just choose something that appears to be reasonable and deal with the interpolation and mini-step later. The only caveat is that the left foot's placement has to be within the natural stride distance we've already established in the previous steps. Ideally, it should be a little shorter, as people tend to slow down as they approach a target when walking. Fig. 4.25 shows a top view of the last step of the walk, with a circle showing the radius within which the left foot must fall.

We should have no trouble placing her left foot within that area. If we needed to push it outside of that radius, then an additional footstep or two would be necessary.

With that in mind, let's just place the left foot and build the pose. The point of doing this kind of pre-analysis is to illustrate that you need to consider these things when animating, or you will end up in a situation where you have 5 seconds of semifinished animation, then you'll get to a section where you hadn't considered something important like this and you have to rework everything up to that point. That's not fun.

The actual pose in our storyboard (04.24) violates one of the precepts of solid drawing. The character's stance is almost perfectly symmetrical. While

FIG 4.25 She Can't Step Further Than This in One Shot.

symmetry might be acceptable in certain circumstances, natural creatures under normal conditions do not strike symmetrical poses. It looks like … a pose. We want Junot to appear natural, so we'll have to come up with something a little different.

Before creating a new pose, I advance about a full second in time (24 frames): sixteen or so for the final step as she slows down, and eight more to bring the right foot into position. Even that amount of time might make the motion appear too fast, but we'll figure that out and adjust it later if need be.

First question then: How do we position the feet? Close together? Parallel to one another or angled in or out? Different combinations of these will provide a different feel for the pose and lend a different aspect to the character. When regarding something mysterious (the pedestal), you can be receptive and curious, or closed off and skeptical, among other things. Junot's walk is confident, and we already know that she's going to ignore the sign and do what she pleases, so let's go with "open and curious plus confident." To indicate this, we'll begin the pose with the feet about shoulder width apart (strong and confident stance) versus having the feet close together (which makes one easily put off balance—it's a weak position). Also we'll angle the feet apart to indicate openness. Fig. 4.26 shows the feet and legs.

Moving up to the hips, we're going to cant them to one side, giving her a bit of sass. We'll also address balance straight away and put most of her weight over her right leg. Note that the hips are titled upward at the right

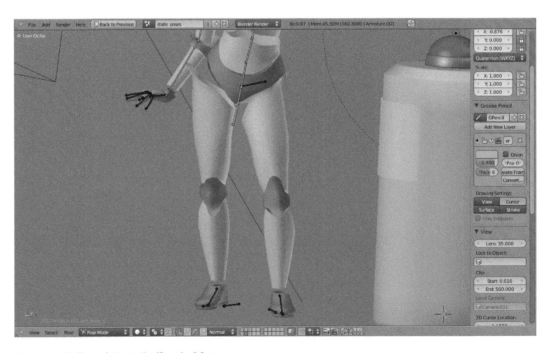

FIG 4.26 Junot's Feet and Legs in Her "Regarding" Pose.

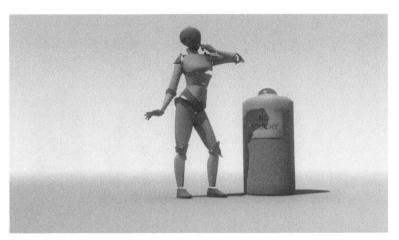

FIG 4.27 Junot and Her Orientation with the Camera and Pedestal.

leg and down at the left—get up and try it yourself to see that it's the natural orientation for this type of stance. These portions of the pose can also be seen in **Fig. 4.26**.

Fig. 4.27 shows the whole body and the pedestal. Notice how I've cheated her positioning so that the camera gets a good view of both the pedestal and her pose. In real life, you would face the pedestal completely, but the principle of staging overrides. She is still leaning back with the spine slightly twisted. This is because she is "regarding" the pedestal—leaning back shows consideration—and to keep some potential energy built into the spine. It's not strictly realistic, but it's not supposed to be. It's an exaggeration! From the storyboards, we know that her next pose will find her bending close to the sign, and the more motion we can provide between here and there, the more alive this will feel. If she were leaning slightly forward in this pose, there would not be as much contrast between it and the next one.

The neck leans back and away from the pedestal, but the head is inclined toward it. This indicates curiosity. Think of the look a dog gives you when it's confused. For the hands and arms, the pose from the storyboard is right out. It conveyed the meaning with what was essentially a stick figure, but it is both symmetrical and lacking in character. To break the symmetry, we'll bring Junot's left hand up to the corner of her mouth to show that she is thinking and put her right hand out to the side and slightly behind her, fingers flared. After looking at that, it seemed a little too twee for her, so I tried something else. **Fig. 4.28** shows the same pose but with the right hand on her hip. I tried it in both ways, and while the one with the hand out and away felt more dynamic to me, the hand on hip seemed more in character and made a better picture. So, I went with the revised option.

These poses were built in the same way that we built the original stride pose. First, the feet and body control bone were positioned, putting the

FIG 4.28 Junot in an Alternate Pose That Was Eventually Used.

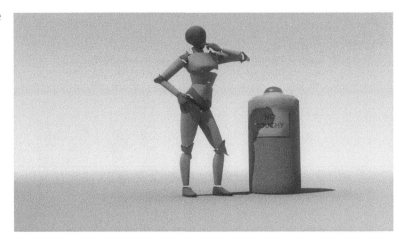

body in the right place. Then, the spine pose was built from the base upward. Finally, the shoulders, arms, and head were manipulated into place. As you adjust the pose, be sure to keep an eye on the overall picture (Staging!). You can get the arm pose right, and the leg pose and the head, but when you look at it altogether, it can look bad. Our goal is to come up with poses that show the character's action and appear dynamic and pleasing within the frame of the shot.

A Note on Working with Constant Interpolation

As you continue to work in constant interpolation mode, keep in mind where in time your actual keys are. If you scrub back through the timeline, see something you don't like and want to change it, make sure that you set any new keys directly over top of the old ones. For example, if we wanted to change the hip placement on step number two, we would set the current frame marker exactly on Frame 25, even though that pose is shown up until Frame 36. The keys that record it are on Frame 25, and that is where you must make the change.

Happy with the pose for now? I was. Select all the bones (A-key twice) and set a LocRotSize key (I-key). This is also a nice illustration of how you need to be flexible when posing and animating. If something isn't working, don't ignore it. The whole time you are working, you need to be thinking about the project from several perspectives at once: the overall large-project view (i.e., does this fit in with the whole thing?), the actual mechanics of what you're doing, the character itself, and lastly, all of the principles. Stay on top of things and work them out as you go.

With that pose recorded, let's proceed to the next. There is no reason yet to deviate from the timing of the storyboards, so find the "bending down" board in the timeline (note that the storyboards should still be showing in the 3D view background) and set the current frame marker to its beginning.

You might wonder why this pose is even here. Clearly, the words on the sign are large enough for her read from a standing position. The purpose is twofold. First, we're trying to make the action work purely as mime. She's reading the sign. How do we indicate that? In real life, you would just continue to regard it and read it in your head. However, in animation, we have to provide some kind of bodily action for the viewer to interpret as "she's reading." The second purpose is to set up the next camera angle. It's a close-up of the sign, and to prepare the viewer for it, we need to direct their attention toward the sign itself. We could use any of the contrast methods that were mentioned in Chapter 3, but we're going to use two

FIG 4.29 Bending Down to See the Sign.

So, with the current frame marker on Frame 25, you would select and alter the hip bone, press the I-key and select LocRotSize. It re-records the key for you, overwriting the old one. Be careful if your Dope Sheet/Action Editor view is zoomed way out and you can't see individual frame numbers along its time line. You might make your change a frame or two off and not realize it until later. Instead of overwriting the old key, you would actually be creating a new one just a frame to the left or right of the original, resulting in an unexpected "jump" in the animation between those two frames.

new methods of direction: motion and character focus. The motion of Junot bending down will cause our eye to follow the fastest moving part: her head. When the motion stops, our eye continues the motion briefly, leading it right to the sign. Also, when we see a character on screen focus on something, it causes us to try to focus on it as well.

So, while this pose is completely pointless in real life, in our animation it serves a number of noble goals.

I won't go step-by-step through the mechanics of generating this pose, shown in **Fig. 4.29**, but you can watch me build it in the video titled *Building the Bend*. Instead, let's examine it in terms of the principles of exaggeration, squash and stretch, and solid drawing. Squash and stretch? Not so much. We actually won't start to put that into key poses until after the alarm goes off, and most of the S&S will show up as extremes later before or after key poses. Exaggeration is certainly here, as no one would really stand like that in order to read a sign. We have greatly exaggerated this in order to provide motion, character and to direct attention. From solid drawing, we can note the aspects of balance and arm placement. In order to balance the leaning upper body, the backside flies out a little and the right arm braces against the leg. The legs also scissor, with the weight shifting from being born on the left to the right. There is no particular reason for this other than to provide some additional action.

With that pose created, I select all of the bones and set a LocRotSize key.

The next storyboard is the close-up of the sign. There are two ways to accomplish this. Both are simple, but one takes longer. The fast way is to add another camera to the scene (Shift-A->Camera), position it for the close-up (use a camera lens value of around 50) and render out a still image. We can add that still to the sequencer much later when we're compiling the rest of our renders into an animation. While very fast, the

downside of this technique is that it will look like a still image. For whatever length of time it is on screen, it will be completely static. The second solution is to similarly add and position a camera, but add the tiniest bit of keyed motion to the camera itself so that the close-up is rendered as a true animation. This will keep it from feeling static.

Keeping a Static Shot Alive

To do this, you can even select and duplicate the current camera instead of creating one from scratch. This will make positioning it easier. Select the single camera that is already in the shot, and hit Shift-D to duplicate it.

With the new camera selected use the Ctrl-Numpad-0 command to set it as the currently active camera. You might also want to rename it to something like "close-up" in the object properties. With the camera object selected (and in camera view), find the starting frame in the story reel of the close-up, and then back up several frames. In the camera properties, hover your mouse over the lens value and press the I-key. This sets a key for the lens value on the current frame. Fig. 4.30 shows the panel. When you set a key on a property like that, the property's background turns yellow. It will be yellow on frames that have a key, and green on frames without a key to show you that the property has been "set" somewhere else. Just like with objects or bones that have been keyed on other frames, if you adjust the value of a keyed property without specifically setting a key on it, it will revert back to its interpolated/keyed value as soon as you change the current frame number.

Scrub through the timeline until several frames past the end of the close-up in the story reel. Over in the camera properties, adjust the lens value just a twitch. Try to pick the smallest value of change that you can actually perceive in the 3D view. Double that amount of change (if you went from 50 to 51, change it to 52) and use the I-key to set a new key for the property. This little bit of change is all you will need to keep the render alive during the close-up.

FIG 4.30 The Camera Properties with a Key Set on the Lens Value.

To continue setting our poses, we need to create a camera for the medium shot. We could continue to pose everything in the long shot, but if the viewer will be watching this from a slightly different camera view, it makes sense to have that same view available while we're animating. Remember that we're playing to the camera the whole time.

To do this, I duplicate the original camera (not the new one that has animation attached) and try my best to frame the shot like the storyboard. The storyboards for the medium shot fortunately don't include a horizon, so we don't have to make the trade-off that we did with the long shot. I decide to put the horizon on the upper 1/3 line, and put both Junot and the pedestal's vertical center lines as close to the left and right 1/3 lines as possible. Junot is still bent down and looking at the sign, so I'm just approximating when I place and aim the camera. It will be easy to adjust the view if I need to after I create the next pose. **Fig. 4.31** shows the framing before creating the pose.

(a)

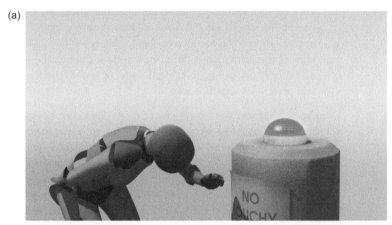

FIG 4.31 (a, b) A New Camera for the Medium Shot.

(b)

FIG 4.32 The Pretouch Pose.

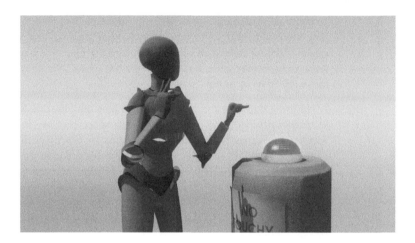

The reason that we're creating entirely new cameras for each angle instead of just animating a single camera to jump around is simple: motion blur. We'll be adding motion blur to our final animation, and the renderer and compositor would see that kind of jump as severe motion and would attempt to blur the frame accordingly. When we go to render the scene after all the animation is done, we can do it through the Sequence Editor and specify our camera cuts right there, or just do the rendering in chunks and piece it all together later.

Fig. 4.32 shows the first pose of the medium shot. We notice for the first time that Junot is a lefty. This is only due to our adherence to the staging principle. If she reaches for the light with her right hand, she will block the view of her body. Actions like this should be performed with the "backstage" hand if at all possible. One other thing I've done is to move Junot from her standing position in the previous pose to better compose the shot. We couldn't do this effectively if we were still in the long shot, but cutting to the close-up gives us an out. We can play with the composition a bit to optimize and no one will be the wiser. Of course, you can't make a radical change—like giving the character a beard after a cut away—but it affords a nice opportunity to tweak the staging.

Take a good look at the figure. It's lame. What's the problem? First, it lacks exaggeration. It's pretty normal. You might actually see someone in a pose like that. The next shot will have her touching the light and leaning back, so this half-way standing pose won't provide a lot of contrast in time. I need to rework the pose to better express the action that's about to happen, as well as to store some more energy in the skeleton. By curving the spine forward significantly, tweaking the right hand's position, and bringing both arms in more sharply toward the center, I create a much more compact visual that brings more stored energy to the skeleton and will provide additional contrast with the next pose. You can see "pretouch pose Mark II" in Fig. 4.33.

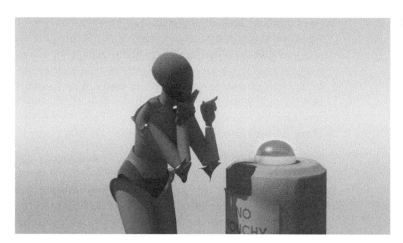

FIG 4.33 A Better Pretouch Pose.

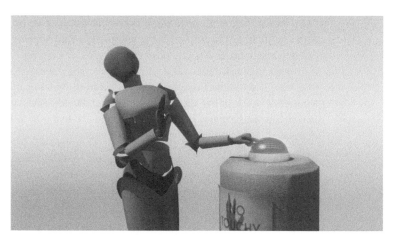

FIG 4.34 The Touch.

The next pose splits an instant in time with this one. Junot goes from the tight, clutching position to the next one quickly, and the two images should be able to function like a flip book. Any time you have a crucial action like this touch, it should be reflected as a before and after both in your storyboards and in your initial posing.

The pose shown in **Fig. 4.34** is mostly a contrast to the previous one. It is open, with Junot leaning back. The tension in the spine is completely reversed. The two most important points in this pose are the head angle and the finger that is contacting the light. The head is pulled back and looking away, as though Junot was anticipating an explosion or some such. The finger tip is bent back to make it obvious to the viewer that her hand is exerting pressure. As 3D elements do not actually ever "touch" one another, we have to be careful as animators to provide accurate cues to the viewer that two items have "real" surfaces that push against each other.

From this point forward, we're going to have two "characters" to animate: Junot and the pedestal's alarm system. If they were going to be directly interacting, like two people shaking hands or fighting, we would have to animate them at the same time in order to keep their actions intelligently in sync and reactive to one another. However, since Junot will not be directly interacting with the animated elements of the pedestal, we can do it serially: finish Junot, and then do the pedestal. We'll tackle the animation of the pedestal effects in a later chapter.

Just like Junot's initial walk, we'll animate her backwards flailing on each step. There is not a storyboard for every step along the way, so we'll have to just make them up as we go along. Sounds like… straight ahead animation! Well, it's really not, but it feels like it as we've been building poses to match storyboards and hit specific timing up until now. We're just going to make staggering poses as they come, and however "long" it takes for Junot to get over to her crouched pose, that's how long it's going to take.

Contrary to every other pose we've done, these should be off balance. As Junot "falls" backward, her body will strongly lead her feet, and they will only catch up on the last pose of the series to keep her from going over onto her back. **Figs. 4.36a through 4.36c** show the poses I've chosen (**Fig. 4.35** is the same pose as **Fig. 4.34**, but from the long shot camera). Notice how each of the three flailing poses show opposite extremes of twisting in the hips and spine. Once again, we're trying to switch between poses with opposing high levels of stored energy.

As it's hard to estimate the timing on this sort of thing, I'm just setting them at one every twelve frames. We can easily adjust the timing in the Action Editor after we have all of our initial poses created.

Junot lands in a defensive, awkward crouch, and her hands and arms raised martial arts-style (**Fig. 4.37**). She has recovered her balance. Thinking ahead to the next step of this process, this would be a great place to add some squash

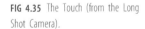

FIG 4.35 The Touch (from the Long Shot Camera).

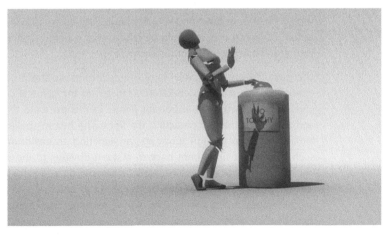

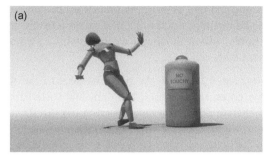

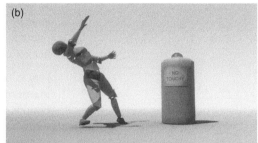

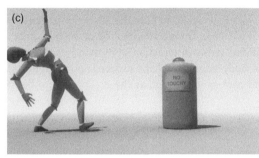

FIG 4.36 (a–c) Three Steps to Fall Back in the Long Shot.

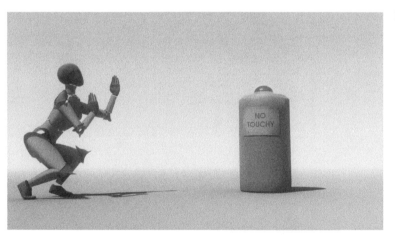

FIG 4.37 The Crouch.

and stretch. She's generating a lot of force stumbling backward, and when she finally catches herself in this pose, we can help to indicate that force by having her first squash pretty heavily for a frame or two before rebounding into this pose. We'll demonstrate that in the next chapter, but just for fun, **Fig. 4.38** shows one way it could look.

We've fallen off from the timing of the storyboards by now, due to our free-form approach to her backwards fall. With that in mind, it's safe to disable the story reel as the background image. You can keep it visible if you like, but it's no longer necessary and will only get in the way.

As we're nearing the end of our time frame for how long we want the animation to be, we try to make her land as close to the edge of the frame as possible without ruining the composition, so we can shuffle her off camera fairly quickly.

Figs. 4.39a through 4.39c show the steps she takes to exit the shot. On the stumbling poses, I wasn't using the Copy and Paste/Paste Flipped buttons to generate poses, so I didn't need to use the 3D cursor technique that we used before when making Junot walk into the scene. I just moved the body and opposite leg on each consecutive pose, leaving the planted foot where it was. For the backward crouching walk, I use the copy/paste work flow again, so I use the 3D cursor to mark the location of the feet. In this case, I'm marking the toe of the rear-most foot, but if you think of it in terms of direction of motion it is really the same (marking the body-side edge of the proceeding foot). I also had to adjust the head and neck on each step, as she is supposed to be focusing

FIG 4.38 The Precrouch Pose, Showing Squash from Impact.

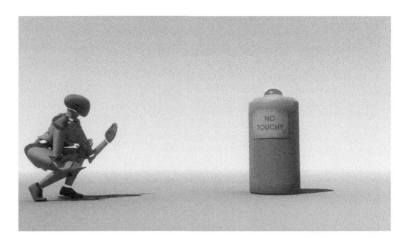

(a)

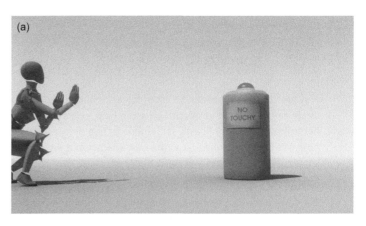

FIG 4.39 (a–c) Leaving the Frame.

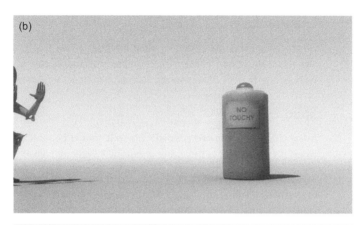

FIG 4.39 (a–c) (Continued).

heavily on the pedestal, and "paste flip" was causing her to look in other directions.

Reviewing the Poses with an Eye to the Principles

Let's go back and take a look at all of the poses we've created, analyzing them from the standpoint of the principles that we've attempted to put into practice. So far, we've only dealt with staging, exaggeration, solid drawing, and to the extent that it hasn't been present, squash and stretch.

Staging

Are the shots composed well? Do the lighting and overall visuals properly showcase the subject? Is inadvertent emphasis placed on any element in the shot?

Exaggeration

Do the character's poses convey their intent in a way that pushes past real life? Are they able to convey the character's attitude, actions, and intentions without the benefit of seeing the face or any actual motion?

Solid Drawing

Is the character balanced properly where it should be, and out of balance when it's called for? Is there any unnatural symmetry (called "twinning") in the poses? Do the character's poses suit its personality?

Going back through the poses then (and making sure to pick the frame on which the pose's keys actually fall), we can re-examine them, hopefully with fresh eyes. If they don't pass on these criteria, push them around a little, keeping in mind what comes before and after.

Playback and Timing

With our main poses in place, let's take a look at the overall timing. It looked "not bad" in the story reel, but things may have changed now that we're actually working in 3D with a real character. Blender allows you to set a frame range, start live playback of the animation in the 3D view that loops over the range, and adjust anything about the scene file and have it reflected in the looping playback. This means that we can watch our animation in the 3D view, make adjustments to the keys and timing, and see the effects in real time.

Before we get too fancy though, let's take a look at what we need to do to get efficient playback. In the Timeline view (Fig. 4.40), change the drop down menu on the header from **No Sync** to **Frame Dropping**. Using "No Sync," Blender plays every single frame of your scene when you press Alt-A, regardless of how long it takes to calculate and draw. Not that it takes that long in most cases, but if it's longer than four hundredths of a second, you won't see playback in real time (24 fps). Switching to "Frame Dropping" tells Blender to just skip any frames that it's calculations have by-passed in time. This provides real-time playback at the expense of smoothness. How many frames it has to drop depends on the complexity of your scene, your display options, and the raw speed and power of your computer. For this stage in production, it is crucial to watch your playback in real time, so it's worth tweaking a little.

NOTE: For a more in-depth discussion of the real-time playback options, see Appendix A.

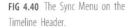
FIG 4.40 The Sync Menu on the Timeline Header.

Make sure that you are in **Solid** view mode, not **Textured**. Textured is pretty, but can be slow. Have only a single 3D view visible on your screen. If you're working in the animation screen and are showing the camera view in the upper right hand corner, change it to something simple like the Outliner for the time being. Even if it is very small, having it showing will force Blender to calculate a lot more information than it should have to. The "tin can" characters of Junot and Meyer are extremely light weight—the fully skinned versions, a little less so. Your computer shouldn't have trouble displaying that in motion at almost 24 fps, but if it does you can select each of the pieces and disable their subsurface modifiers. That will cut the number of polygons Blender has to deform with the armature to 25% of the original.

If you like, select the camera and set its **Passepartout Alpha** to around **0.9**, darkening the out-of-frame regions in the 3D view. Don't take it the whole way to 1.0, as this can make selecting the camera to turn this value back down difficult from a camera view. While you're adjusting the view, use the N-key over the 3D view and find the **Display** section of the controls, shown in **Fig. 4.41**. Enable the **Only Render** control, which hides anything in the viewport that will not render (e.g., bones, lamps, guide lines). Be sure to reselect one of the character's bones before doing this, though, as you won't be able to see them after enabling the setting. Also, disable the transform manipulator (Ctrl-Spacebar) if you have it showing. This will make for a clean display while you check your timing.

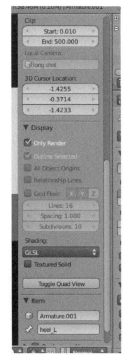

FIG 4.41 Using **Only Render**.

To finish the setup of this stage, collapse the object listing in the Dope Sheet so that only a single line of key blocks shows for the armature. You'll have to switch back to Dope Sheet mode if you're been using the Action Editor. These single keys stand in for the entire column beneath them. If we move them along the timeline, all of the keys they represent will move too, effectively shifting the entire pose in time. Roll the MMB over the Action Editor (or just hit the Home key) so you can see the entire timeline of the animation without scrolling. I don't like how I'm using vertical windows in my animation screen to show two basically horizontal views (the 16:9 camera frame and the very short but wide set of keys), so I duplicate my animation screen and do a bit of rearranging. I call the new screen **Timing**, because it will be perfect for adjusting overall timing. You can see it in **Fig. 4.42**. Notice how I am using the Dope Sheet view and have collapsed Junot's animation into a single line of keys.

Set your Start and End frames properly in the Timeline view—my animation ends around Frame 318. Yours might be different. Hold your mouse over the Dope Sheet and hit Alt-A. Playback begins. Holding the mouse over the 3D view to begin playback will only advance the frame there, while doing it over the Dope Sheet engages playback in all available windows. Just watch it several times before you go poking around. You can see a capture of this first playback attempt in the video *All Poses Raw Timing*. Keep in mind when you're watching this that it's from the long shot camera view, so the poses and placement which were optimized for the medium shot might look a little weak or off. We're working on timing for now, though, so the long view is fine.

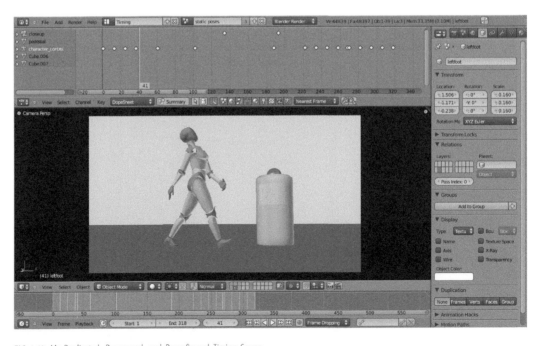

FIG 4.42 My Duplicated, Rearranged, and Reconfigured Timing Screen.

The first thing I notice is that Junot's "wait time" between when she touches the light and when she reacts is way too short. I think it will play better with an anticipatory moment after she touches it in which she can maybe start to relax.

"Oh, it's all right. Nothing's going to-"

To fix that, I note where the current frame marker is in the Dope Sheet when the pose ends (Frame 234), and thereby identify the proper key to grab and move. Moving keys to the left will make that pose happen sooner; to the right, it happens later. I grab the key on frame 234 *and all the ones to its right* and move them about seventeen frames to the right, giving her about 3/4 of a second more of hold time. This looks much better. If you've not worked in animation before, it can be surprising how what are such tiny amounts of time to us in our daily lives can be crucial to the visual timing of something like this.

If you don't want to wait for the entire playback to cycle before seeing it again, you can set a smaller temporary playback range by pressing the P-key while over the Dope Sheet and LMB dragging across a frame range. This sets a temporary playback range (the rest of the Dope Sheet darkens), and you can use it to "zoom into" a moment in time for repeated viewing. Hitting Alt-P removes the temporary range. You can do this during live playback, but the current frame marker won't jump into the temporary range right away. As soon as it encounters the new temporary range during it's natural playback progression though, it will begin to loop over it. Additionally, you can LMB click anywhere in the time line of the Dope Sheet or Timeline view during playback and have the current frame jump there and immediately continue to play.

On the whole, things aren't too bad in the first half of the blocking.

However, the backward stagger is a problem. It turns out that it's pretty hard for me to judge if this is working or not. How does it compare to this sort of timing in real life? We're too far away from the original reference video (egads), so I need some help. I grab a stop watch (your cell phone probably has one, kids) and find my daughters.

"Will you time me while I fall backwards?"

"Are you animating again, Dad?"

"Um, yes?"

"Aren't you a little old to be falling around for fun?"

"Why, yes. Yes I am."

After running several trials, we find that on average it takes me about two and a quarter seconds to cover the same distance as Junot, even though it was not done with not nearly as much style. That gives us fifty-four frames (2.25 × 24) for Junot to fly backwards and hit the crouch. With three interim poses, this would indicate that each should get about eighteen frames of screen time. However, there might be a more effective way to look at it. If we think of it in

Note

When selecting keyframes in the Dope Sheet during playback, you still have all of the same controls available. For example, if you want to select all frames to the right of the one on 234 like the example, you could wait until the current frame marker is approaching the key on 234, then Ctrl-RMB click to the right of it. This selects all frames to the right of the current frame marker. You have to be on the ball, but it's handy.

terms of distance and what's happening, we can use those two and a quarter seconds more dynamically. When the alarm goes off, she will explode backward, maybe covering half the distance in only the first third of the time. Then, she'll slow down, until she eventually falls into the crouch. Looking at the poses, we see that the second interim pose has her about half the distance from the pedestal to the crouch. Fig. 4.43 shows the

FIG 4.43 (a–d) Two Different Approaches to Timing.

(a)
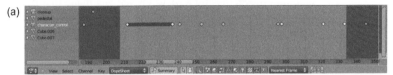

(b)
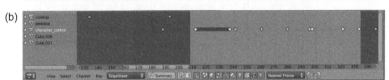

(c)

(d)

two different approaches. When the keys are evenly spaced, the armature ghosting shows that the motion happens at a fairly constant velocity. However, if we "front load" the keys in the available fifty-four frames, we see more loosely spaced armature ghosts at the beginning, indicating rapid motion, with tighter ones near the end.

With the backwards crouch-walk, I simply adjust the timing visually. What looks right? Too fast? Too slow? I ended up spacing it out a bit. When I was finally done tweaking the whole thing, the final key lands on Frame 364, several seconds off from the original. Once again, that's fine. As we do more work and advance in the stages of production, the timing of our animation becomes more accurate. The older estimates don't matter as much.

This last step then takes us through to the Principle of **timing**. There are a number of aspects to it, but the first is in making sure that the overall beats of your work feel right. As we have all of the keys for our poses organized neatly into vertical columns, we can still quickly adjust them later if we find that we need to have more or less time for any particular action.

Coming out of this chapter, we have a series of dynamic poses in 3D that coincide with the ones that were drawn in the storyboards. They (hopefully) exhibit solid drawing, exaggeration, and good staging. We've also created the different cameras we'll need later one. Finally, a first stab has been made at the basic timing between the poses.

In the next chapter, we'll start to add additional poses to the first half of the animation that show anticipation and follow through.

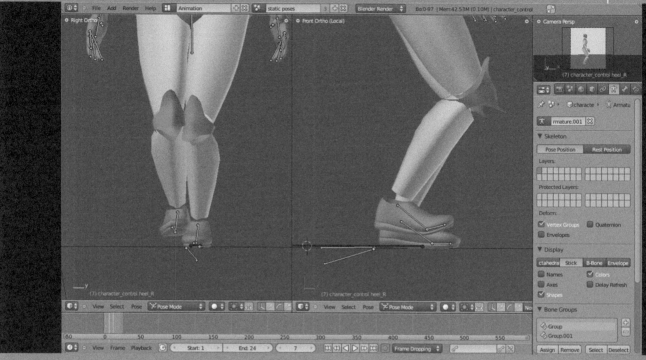

Anticipation, Follow-Through, and Other Interesting Poses

In the last chapter, we kept an eye on our character's balance, among other things. Could their foot placement actually support their center of gravity, given their current motion? Beyond that, did the balance of the character look natural?

In addition to being balanced physically, your animation also needs to be balanced in time. If an action occurs—say, a character jumping across a small gap—that action needs to balanced in time both before and after it happens. In a case like this, it's easy to visualize what we need to do. Before the character jumps, it will coil like a spring, drawing its arms behind it, then swinging them forward to build momentum. The character then flies through the air. After its feet touch down on the other side, its legs will bend to absorb the shock, maybe even taking a step or two forward. The arms will continue forward after the body stops, probably swinging up. The motion before the jump is **anticipation**. After the jump is the **follow-through**. Two more principles of animation are in the mix.

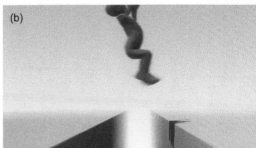
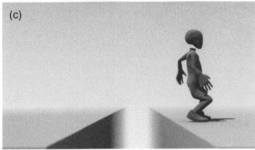

FIG 5.1 (a–c) Three Frames from the Jumping Video.

Fig. 5.1 shows three frames from the video *Only A Jump*. At this point in the book, it will really help to be able to see the videos, so if you've not been looking them up so far, you might want to start. The video shows Smith jumping across a gap. What it lacks is anticipation and follow-through. It looks bizarre. *No one would animate that way!* you might be thinking. But you would be wrong. I've seen countless beginner or amateur animations that use almost no anticipation and rarely have any follow-through. Other times I've seen them included, but far too little. The anticipatory and following actions taken together must equal the main action itself to balance it in time.

The actual jump is a large motion. The entire body is not only moving forward but also being flung into the air. We need some kind of motion to justify it on either side of the time line. Think of the "size" of a motion as a combination of the distance it travels, the amount of stuff that makes the journey, and the length of time that it takes. We could build an anticipatory pose that uses the entire body or just try to relegate it to the character's arms. If it's only the arms, we're going to have to balance that by making the motion larger (covering greater distance) and faster (more velocity) than if we moved the entire body. If we're going to anticipate with the entire body, which has much more mass than the arms, we don't have to make the motion as pronounced. In this case, with the jump being so drastic, we'll use the whole body, moving it a decent amount rather quickly, which will give us the visual energy we need to balance the flying motion.

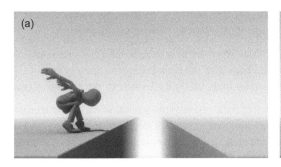
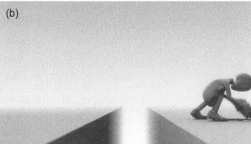

FIG 5.2 (a, b) The Anticipation and Follow-Through Poses.

The anticipation serves an additional purpose beyond the purely physical. It helps to direct the viewer, alerting them to what is about to happen. It is both an anticipation that is necessary from the standpoint of believable physics, and one that assists the viewer in following the action.

The video *Before Jump After* shows the same action with both anticipation and follow-through thrown in. You can see the extreme poses of each in **Fig. 5.2.** I've added some Squash and Stretch in the poses to emphasize the extremity and really pack the energy into the pose. If you examine the piece frame by frame, you'll be able to find it (body squashes and arms elongate), but you don't see it in the animation itself. It just adds to the effect below your level of conscious notice.

This highlights the fact that not everything in animation will be seen. Certain poses will only be visible for four one-hundredths of a second (1 frame). If a character is moving quickly enough (i.e., expending enough energy), you can do things with the model that would never be possible in real life and have them show for only the briefest amount of time. That image won't look strange to the viewer because it will be gone before they realize it. However, done correctly, it can add a new level of dynamic action and energy to your animation.

Let's step through the poses in our whole animation project and determine if, when, and how to add these elements. For now, we'll ignore the walking poses as they are special case. You *could* use the normal rules of animation to flesh them out, but walking is such a common action that we're going to give its own treatment later in the chapter.

Analyzing Your Poses

We're looking for changes of momentum: stops, starts, and rapid changes in direction. The larger the change the more anticipation and follow-through we'll have to add.

Watching the *Adjusted Timing* video from the earlier chapter, I find the following spots where Junot's momentum changes:

- The transition from walking to regarding the pedestal
- When she begins to fall backwards after the alarm
- The transition from falling backwards to the defensive crouch

Note that each of these points in the animation is a time of change in motion. She is transitioning from one kind of motion to another. We are looking for beginnings and endings. One other place deserves a bit of anticipation too: Junot touching the light. It isn't a full body motion, but it is a deliberate, distinct action on her part, and adding anticipation here is directorial: it assists the viewer. A proper anticipatory motion prefocuses the viewer on the hand and arm, giving them a cue that "Hey—something's going to happen here! Pay attention!" It doesn't need to be huge—remember that an anticipation should be in proportion to the eventual action—maybe only a few frames, but including it is important.

The transition to the backwards fall is going to be trickier. It is not a deliberate motion. Junot did not "decide" to start going backwards. She was scared into it. Think about times when you've walked around a corner and come literally face to face with someone. Generally, you jump or twitch (or in my case have a mini-freakout). Depending on how good your memory is of what your body does, you might recall that your nervous system sends a kind of shock into your muscles that causes them to tense at once, propelling you away from "danger." That is what's happening to Junot. Strictly speaking then, this motion shouldn't have any anticipation. It's an explosion of movement. We *could* animate it that way, as though the alarm delivered a shock wave that blasted her backward. That would be a valid approach, and it's probably worth a try. As we're just learning though, we're going to choose a method and stick to it. If you want to go back and try it differently later, then by all means proceed.

What we'll do is provide her with only a frame or two of frightened anticipation. If she had a face, this is where we'd stick a wild-eyed response (in animation terms, that's called a "take"). Since it's going to be brief, we'll have to make the pose rather extreme.

When she finally falls into the defensive crouch, it is the end of the careening motion. We'll need some serious follow through that ends with her hands in the martial arts pose. Follow-through poses have always been a little easier to generate for me because they are often simple physics. How would the masses involved need to move in order to return the character to balance?

Let's go back and work on the first example.

Fig. 5.3 shows the last walking pose and the standing pose, respectively. First, do we need to add anticipation or follow-through? The energy shift is of stopping action (walking to standing still), so we need the latter. Junot is moving at a fairly slow pace—normal walking—but it is her whole body that makes the change. In real life, we ease into a stand still. But this is the world of animation, and we have to liven things up.

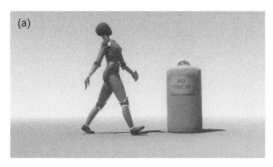 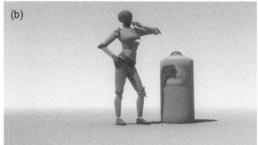

FIG 5.3 (a, b) The Two Poses That will Generate the Follow-Through.

A follow-through that we need here will actually occur between our final pose (standing, regarding) and the earlier one. The resting pose is the one that occurs *after* the follow-through, not before it. So really, when I was storyboarding, I missed two key motions. First Junot walks. Then she begins to stop. There is a follow-through pose. Finally, she comes to rest in the "regarding" pose that actually made it into the storyboards.

For this exercise, let's start with another duplicate of our animation file. The timed constant interpolation steps are pretty good, and again, we'd like to keep a fall back point on hand, in case we completely mess things up. The web site has a file called *chapter 05 scene.blend* to work with as well.

I begin to work on the Animation screen. Junot, her control armature, and ground are shown in local mode in the 3D view (\-key), and the Dope Sheet is set to Action Editor mode. We're still using constant interpolation.

It's often easiest to build a follow-through pose from the final resting pose. To do this, select any of the keys in the column that represents the "at rest" pose. In the sample file, these are the keys on Frame 61. Press **Alt-RMB** on any of the Frame 61 keys to select all of the keys on that frame. Then, press Shift-D to duplicate the keys and move them four frames or so to the left: backwards in time. Click the LMB to accept the duplication and transformation. **Fig. 5.4** shows the Action Editor with the column of keys duplicated and offset. In the figure, the selected column is the new one.

It is on this new frame (Frame 57) that we build the follow-through pose. Remember to exaggerate and use solid drawing techniques. Keep the character in balance. However, this is animation, and we can afford to throw in a little bit of the goofiness. I'm going to try to have her feet stop in place, but have the upper body continue forward just a touch so that when she falls into her final pose it'll be a "Whoa there!" effect, the upper body rubber-banding back into place. Before building the pose, make sure that the current frame marker is on the duplicated, earlier set of keys on Frame 57.

Fig. 5.5 highlights a control on the Timeline view's header. This "record" style button turns on **Automatic keyframing**. We've been setting keys by

FIG 5.4 Duplicating a Still Pose for
Follow-Through.

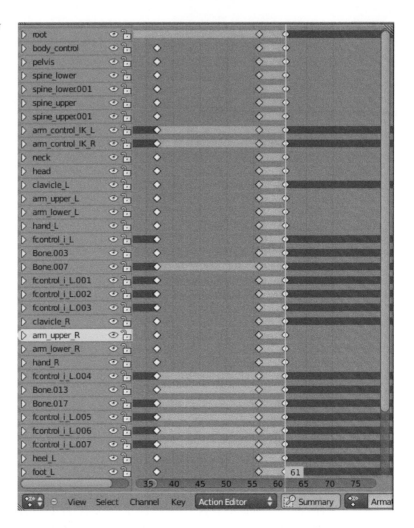

FIG 5.5 Enabling Automatic Keyframing.

hand up to this point, but now it becomes useful to have Blender take care
of that for us. We already have an entire column of keys, and it would be
handy to just have every tweak or change we make on this frame to simply
be recorded without any further intervention. So, enable the button. Once
you do, ensure that you stay aware of it. Any changes you make to anything
in the 3D view will now be recorded in time. This means that if you adjust

the angle of the camera, it will record it as a key, not as the absolute, all-time location and rotation of the camera. This can be annoying however, like when you adjust a camera position and find that it is now animated because it has two different positions in time. To avoid this annoyance, open the **User Preferences**, head to the **Editing** tab and enable the **Only Insert Available** option. This will only place keys for objects (or bones) that already have keys, even during automatic key framing, meaning that only things that you have hand-applied a key to (with the I-key) will receive automatic key frames. Something like a camera that has never been keyed will not receive them automatically even if you adjust its position.

The first thing I do when actually creating the pose is to go into a top view and find out the direction of the character. By toggling back and forth between the walk and stand, the main direction of the body becomes obvious. **Fig. 5.6** shows both poses, with a line drawn to indicate the overall motion. The upper body controller bone should continue along this line as it should follow the body's momentum.

After that, it's a matter of thinking about what might happen if you try to stop that momentum. **Fig. 5.7** shows a more cartoonish approach to this. The pose is inserted *before* the resting pose because the character hits the position and stops, does this bit of follow-through, then returns to the rest pose. It's a nice pose, but in the end I'm not sure how well it fits with the action and character in the rest of the animation. It's kind of goof ball.

To try a different pose, I use the Alt-RMB to select the entire column of keys that represent the pose and move it way off to one side, out of the normal timeline for this animation. This way, I can easily get it back if I change my mind. Realizing that our rest pose is actually the end point of the follow-through, it might be a good idea to generate an additional pose to help us. This new pose should once again fall between the last walking pose and the resting pose, but this time it will indicate the character's attempt to stop moving. We can just duplicate the resting pose several frames to the left again and alter it. In this new pose shown

FIG 5.6 Momentum Dictates the Flow of Follow-Through.

FIG 5.7 One Possible Follow-
Through Pose.

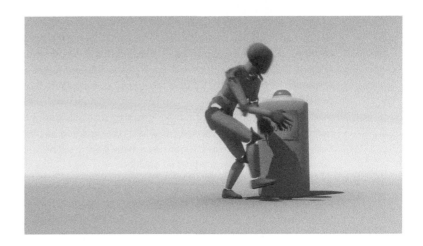

FIG 5.8 The Actual Pose on Which
Junot Tries to Stop Moving.

in **Fig. 5.8**, Junot's left foot is part of the copied pose, in it's final spot. The right foot, however, has not moved from the earlier walking pose. This is because it is really her next "step," and the planted forward foot does not move. To do this, I selected the foot controller in the 3D view and found that the corresponding animation channel in the Action Editor was highlighted. In this case, it is called **heel_R**. I select the key from the earlier column (the last walk pose), duplicate it with Shift-D, and move it forward to take over the key in the current pose's column. **Fig. 5.9** shows the selected key, and where it moves to.

Doing this guarantees that the foot will be in the same place as it was in the earlier set of keys. Then, I adjust the foot's rotation so that it is flat on the floor. Stepping back in time, I see where the next swing of the arms would be and move them accordingly. This isn't the world's most exciting pose, but that is okay for once. It is merely transitional. The next pose we create will show the follow-through. The one after that is our existing rest pose, with Junot considering the pedestal.

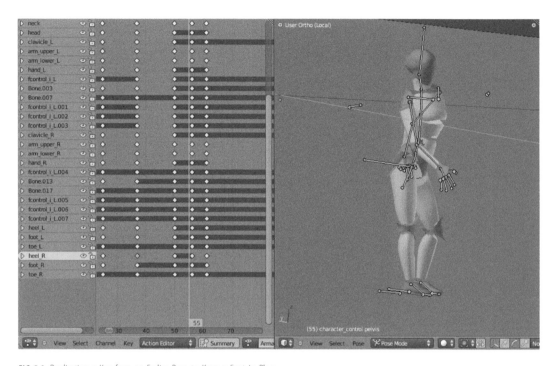

FIG 5.9 Duplicating a Key from an Earlier Pose to Keep a Foot in Place.

The same rules apply to this attempt at a follow-through pose as to the last. Follow the momentum of the body by going backward and forward in time. We keep the upper body controller moving just a little along the main line of action, bend the spine slightly, and pull the arms ahead of the body. The resulting sequence can be seen in **Fig. 5.10**.

Put together like this, the action of Junot coming to a stop, her body pushing a little past it (follow through!), then resolving into the rest pose is obvious. One of the lessons to take away from this is that you cannot always rely on your main poses as a guide to what you're doing. The pose that you think might require some follow-through might actually be the *end point* of the follow through, like it is here.

Let's move on to the anticipation right before Junot explodes backwards. Anticipation doesn't have to get nearly as fancy as follow-through, and you have more freedom. Sometimes, like with the jump at the beginning of this chapter, you need to really watch the physics. Most times, it is just an anticipatory action that draws attention and prepares the viewer for the main action.

Fig. 5.11 shows the "before and after" poses. We need to put an anticipation pose right before the "b" pose. This one is pretty simple. We give Junot a very quick, light movement toward the pedestal to compensate for the upcoming backward motion. It will only show for a frame or two, giving a subtle but useful effect. Although we're showing this pose in the long shot for

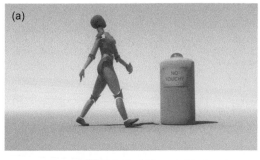
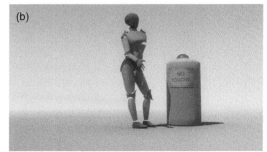
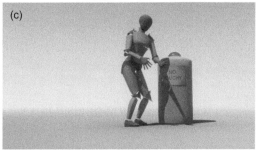

FIG 5.10 (a–d) The follow through after the first momentum change.

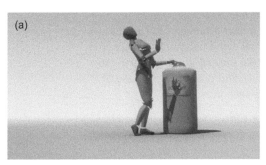
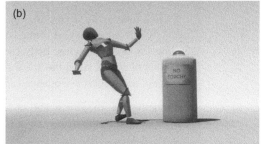

FIG 5.11 (a, b) A Place for Anticipation.

consistency, be sure to build it from the medium shot camera's point of view, as that's where it will be captured in the final render.

I'm going to build the pose only three frames before the first "falling backwards" pose, which comes on Frame 241. So, I duplicate the earlier pose (during the anticipation she won't have moved her feet) and bring the new column of keys up to Frame 238. Keeping in mind where she's headed, some minor adjustments are all that are needed. The goal is to provide motion contrary to that of the action that is about to happen. By noting the differences in the two earlier figures, we can see that the right arm moves the most. So, it should also receive the greatest degree of anticipatory movement. **Fig. 5.12** shows the anticipatory pose.

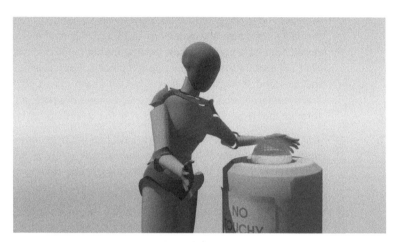

FIG 5.12 Anticipating the Backward Explosion.

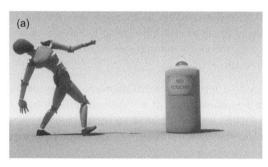
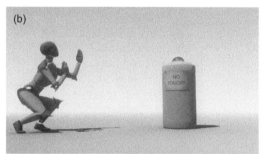

FIG 5.13 (a, b) Before and After Stopping.

If you recall our earlier discussion, this is an explosive, fear driven, almost involuntary action, so the anticipation will be reduced. If Junot had been leaning against the pedestal and actually planning such a movement, the anticipation would have been significantly greater. We can't tell exactly how it's going to look until we release everything from constant to smooth interpolation, but at this point, animation is like a chess game. We're trying to get all of our pieces into powerful positions, with the proper lines showing. If we do that consistently, we'll find that we are in a very good place later in the game.

The last major pose we need to add is a follow-through pose in the transition from the backwards fall to the defensive crouch. Much like the earlier situation, it appears that the defensive crouch itself does not require follow *after* it but *before* it. This is because the crouching pose represents the character once it has regained control of itself, after the initial stop and follow-through. So, we need to add two more poses: a stop, and then some follow-through.

Fig. 5.13 shows the last falling pose and the crouch, respectively. Like earlier, we find the keys that represent the crouch, duplicate them and move them to the left in the timeline.

In this new pose, Junot should be trying to catch her balance. The hips and center of gravity won't be quite as low as the resting pose, and the hands

155

Note

Between this chapter and the earlier one, I took the liberty of altering the pose shown in **Fig. 5.13a**. The earlier way did not appear natural in the least (check Fig. 4.36c to see the difference). It looked like someone posing on an album cover. We want dynamic, but it was just weird. This serves as a good lesson to always have your work under review, but also to try to make your adjustments at the right stage. If I had waited until later when this pose was surrounded by dozens of keys on different bones to create the proper interpolation, replacing it with a completely different pose would cause a significant amount of rework. Doing it now, I only need to create a single new pose.

aren't yet up in the defensive position. This is a transitional pose, so it probably won't have the dynamism and visual impact of one of our main poses. For now, I place this new pose 12 frames before the resting pose. That will give the entire follow-through process, from beginning to recovery, half a second. It might work, or not, but we'll have to wait until we release to smooth interpolation to find out. **Fig. 5.14** shows this pose. It's not our follow through, but represents where Junot is trying to end up.

Think of it this way. Our storyboards indicated an action pose and a resting pose. What we need to have in the animation is an action pose, a pose on which the character thinks they are stopping, some follow-through, and *then* the resting pose.

To take up the energy of her backward fall, the upper body control goes way down toward the ground, continuing its current momentum. This energy applies itself to her legs which bend deeply, push against the ground, and attempt to counter it. The spine also curls forward significantly, and the arms fly ahead as well, each trying to balance her shifting center of gravity. **Fig. 5.15** shows the point of maximum impact. Note that this is not the follow-through.

Finally, in **Fig. 5.16**, we see the follow-through. It's the continuation of motion past the extreme pose of the earlier figure. It is from here that Junot will transition into the defensive crouch. Sometimes doing an adequate follow-through or anticipation study necessitates more than a single pose.

To review, the main rules for building anticipation and follow-through are as follows:

- Actually remember to include them,
- Use anticipation to direct the viewer,
- Make them proportional to the main action,
- Momentum should line up with the main action.

FIG 5.14 Junot's Prefollow-Through Pose.

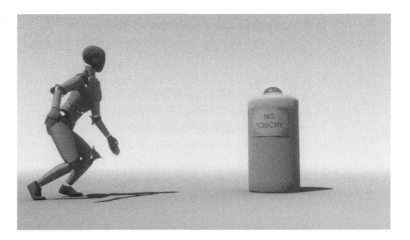

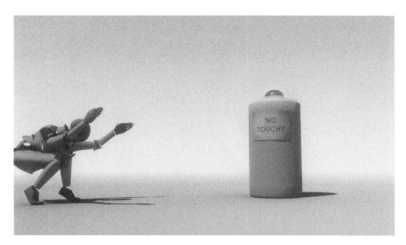

FIG 5.15 Maximum Squashiness.

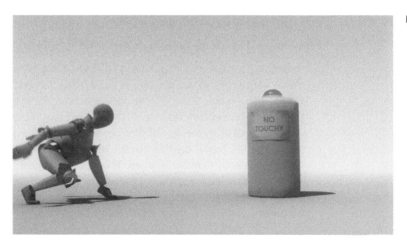

FIG 5.16 The Follow-Through.

Walking

Walking is a very special case of anticipation and follow-through. Every action your body takes while walking is both an anticipation of what it's about to do and a follow-through of what it just did. Fortunately for us, instead of figuring out the physics and lines of momentum every time we make our characters walk, a clear formula and language have been developed in animation for this common activity. Think that formulas are cheating? You would not be wrong. Think that cheating is bad? Then you haven't been reading this book so far.

Fig. 5.17 shows a side view of Junot walking. The first thing to notice is the curve that the head and hips make as they move forward. That's the critical motion we talked about in the last chapter when deciding how long to make Junot's stride. The more up and down motion along the walk, the

FIG 5.17 A Full Stride.

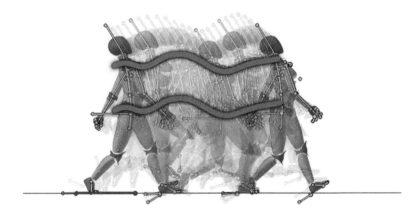

less realistic it will appear. This should also suggest to you that although there is a formula for walking that works very well, it encompasses an enormous breadth of styles and possibilities.

Let's break it down in the order of pose creation.

Step 1: The contact pose (Fig. 5.18), Full stride, both feet on the ground. We've already crafted these poses in the last chapter. For the first stride, they fall on Frames 1 and 13. The hips and head are at about the mid-point of their overall vertical travel. The forward foot touches the ground with the heel only; the rest of the foot and toe pointing upward at an angle. The rear foot is bent so that the toe and ball of the foot touch the ground, whereas the heel is raised. The hips are angled so that the forward leg's side is up. From a front view, the shoulders are angled in the opposite way. Spine twist pushes the upper body in opposition to the placement of the legs, and the arms follow that through.

Step 2: The passing pose (Fig. 5.19), on Frame 7. The body is moved forward and upward until it is just over the forward foot and the knee locks. The trailing foot is brought level with the other foot and raised a bit off the ground. People are generally efficient and will only raise their foot enough to clear the tiniest of obstacles. Don't bring the foot too high. Also, watch out if you have your feet close to the centerline from a front view: you may have to move the raised foot to the side so it doesn't pass through the other leg as it comes forward. The hands, arms, and torso are all more or less along the centerline from a side view as well.

Step 3: The low pose (Fig. 5.20), on Frame 4. In this frame, the head and hips are at their lowest point in the walk. The rear foot has either come off the ground and begun to move forward slightly or the toe is still trailing in its original position. The forward foot is now planted fully on the ground. Arm, shoulder, and spine rotation are just midway between the end and passing poses.

Step 4: The high pose (Fig. 5.21), on Frame 10. The highest point in the walk for the head and hips. The rear heel is starting to come up from

FIG 5.18 The Contact Pose.

FIG 5.19 The Passing Pose.

FIG 5.20 The Low Pose.

FIG 5.21 The High Pose.

the ground. The front foot has yet to actually hit the ground. It should start to angle upward in anticipation of the heel strike.

And that, plus a couple more tweaks that we'll see in a moment, will get you a decent walk.

Before we apply this to the main scene, let's take a look at another sample file that uses the time-honored practice method: the walk cycle. Open *chapter_05_walking.blend*.

To get you started, I've created an initial contact pose on Frame 1. The rear foot has been posed by rotating the foot bone (not the heel). The front foot has been rotated upward by using the heel bone. If you examine the file closely, you'll see that the rear foot is actually rotated off axis a bit in the top view. This is to get the knee to point correctly. There is a helper bone available on a different armature layer, but if we don't have to use it, we shouldn't. Also, note that the forward foot is rotated clockwise from the front view. This is the natural way a foot comes down. You can see the building rotation of the spine as discussed earlier. The head looks forward. Usually, people are focused on a point in space ahead of them as they walk, causing the head to maintain a fairly steady target.

To create the full stride for this walk, use the A-key, select all of the bones in the armature, and then use B-key and MMB to remove the root bone (the long one on the ground) from the selection. On the 3D view header, press the **Copy Pose** button, which is highlighted in **Fig. 5.22**. In that figure, you can

FIG 5.22 All Bones Except Root Selected, and the Copy Pose Button.

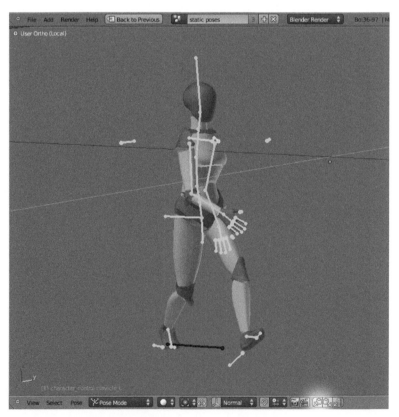

also see all of the bones selected except the root bone. In the Action Editor, move forward 24 frames (to Frame 25) and press the **Paste Pose** button.

Head back to Frame 13 and use the **Paste Flipped Pose** button, right next to the Paste Pose one. This should create the contact pose's opposite. We already did this in a similar fashion in Chapter 3, so it shouldn't be new to you. Frames 1 through 13 are the first stride, and 13 through 25 are the second. Together, they form a full step. We will only need to build one "by hand" and can use the Paste Flipped Pose tool to build the other.

Following the formula from above, we head to Frame 7 to create the passing pose. Bezier interpolation is turned on (as opposed to Constant) in this file, so moving to Frame 7 shows the interpolation. Only a few adjustments are needed. By scrubbing through the timeline with the LMB, find out which foot that is moving backwards. It's supposed to be on the ground because it is bearing her weight, but it's floating a little bit above it. Let's plant it. Select the foot bone (not the heel/controller) and use **Alt-R** to clear its rotation. It may or may not have any in your own work, but it needs to be cleared for this pose. Then, clear any rotation on the heel bone on this same foot. Using that heel control and the G-key, put the foot right on the ground. Make sure when you do this, you are selecting the correct foot! **Fig. 5.23** shows a before and after of this step.

Then, clear the rotations on the other foot, but leave it off the ground. How much? As we mentioned before, just enough to clear some fictional very-well-cut grass. It's okay to angle this foot slightly downward from a side view. Also, view the character from the front and move this foot away from the centerline to ensure that it doesn't pass through the other leg's shin. **Fig. 5.24** shows the before and after on this.

Finally, raise the upper body control bone until the grounded leg locks into place, but not so far that the foot begins to separate from the leg. Select

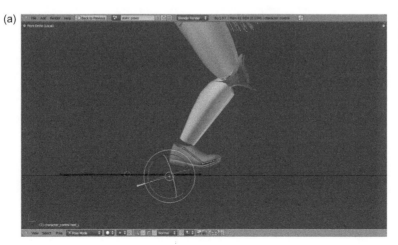

(a)

FIG 5.23 (a, b) Clearing Rotations of the Foot and Placing it on the Ground.

FIG 5.23 (a, b) (Continued).

(b)

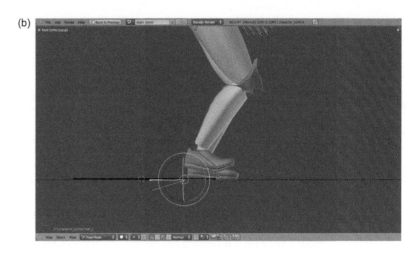

FIG 5.24 (a, b) Adjusting the
Forward Moving Foot.

(a)

(b)

everything but the root bone and set a *LocRotSize* key. With that same selection still active, copy the pose. Advance to Frame 19—the equivalent frame for the second stride—and use Paste Flipped. For now, you don't have to do anything about the arms or upper body. You can refine the arm motion later, but the natural interpolation will do quite nicely for the spine.

Next, we build the Down Pose on Frame 4. Once again, leave the upper body and arms alone. Only a couple of adjustments to the feet will be needed. Clear rotations on the front foot and heel, and move the foot up or down so that it rests perfectly on the ground. Use the foot bone of the rear foot to bend the structure of the foot even further than it already is. With the heel control, rotate the entire foot clockwise in a side view and move it down until the toe touches the ground, as far back as it takes to bring that leg to full extension. **Fig. 5.25** shows a before and after of both feet.

(a)

(b)

FIG 5.25 (a, b) Before and After Adjusting the Feet for the Down Pose.

FIG 5.26 Moving the Body Down.

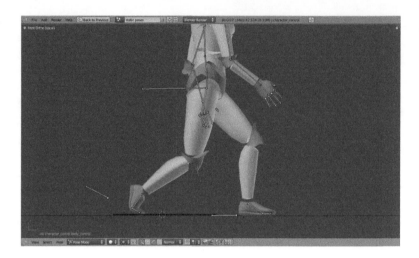

FIG 5.26 Moving the Body Down.

When the feet are positioned, bring the upper body controller straight down until it is obvious that the character is bearing its weight on the flexed legs. **Fig. 5.26** has exactly the same foot positioning as the earlier figure, but the upper body has been moved downward. Again, select all the bones except the root, set a *LocRotSize* key, copy the pose and paste a flipped version 12 frames ahead.

The last one, the Up Pose, takes place on Frame 10. Remove rotations from the rear, grounded foot and place it on the ground with only a vertical adjustment. Move the upper body control upward until the rear leg locks. Move the front foot upward by using the heel bone until that leg *un*locks, and then even a bit more. **Fig. 5.27** shows a complete before and after. Set keys for everything, copy the pose, advance 12 frames, and paste flipped.

You're done. Really.

Set the **End Frame** control on the timeline to Frame 24 and hit Alt-A.

You can watch my render of it (looped a number of times) in the video *Plain Vanilla Walker*.

It's not Pixar quality, but it's amazing how little effort you need to put into this to get something that's at least as good as just about any of the CG kids shows on television. With a little more effort, it becomes something like *Mint Chocolate Chip*. To create this version of the walk, I fine tuned the arm and hand poses and used the 3D cursor to mark and refine the total vertical travel of the hips and head.

Fooling around with the timing by moving the down and up poses back a frame produces something a little weird: *Stutter Velocity*.

If I make the vertical travel more extreme, things begin to get silly, as in *A Bobbin*.

(a)

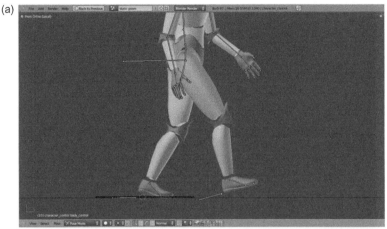

FIG 5.27 (a, b)

(b)

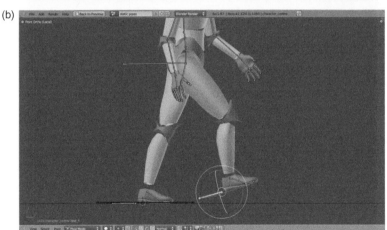

Finally, I can essentially swap the up and down poses for something even sillier. The feet do the same thing as before, but the body moves contrary to the normal flow. I introduce some squash at the bottom and stretch at the top, and we have *Cartoon Walk*. She's going to need a grant to work on that, I believe.

Let's integrate this knowledge into the introductory walk of our animation. You can save this walking animation file for later practice if you like. When you're done with it, reopen the Chapter 5 scene file you've been working with.

Putting the Walk into Practice

Before we start to actually work, we'll need to release the keys in the pose-only animation from constant interpolation back into Bezier. The easiest way to do this is by tapping the A-key twice in the Action Editor to select

everything, pressing **Shift-T** (or using the **Key->Interpolation Mode** header menu) and choosing Bezier. If you're a glutton for bad animation, you can watch the whole thing with raw Bezier interpolation in the video titled *Bezier Nastiness*. We'll work out how to fix all of that in the next chapter, but for now, we need it to provide positioning for the extra poses in our walk.

Clearly, there are going to be differences in technique when working on a character who is actually moving forward as opposed to just doing a walk cycle, which is stationary. For example, if you try to copy and "paste flipped" the foot positions from one part of a stride to another when the character is actually moving forward, it's not going to work. The foot positions are absolute, not relative to anything, so they would paste into the old locations. This means that you're going to have to build every step individually. No short cuts.

The good news is that building the intermediary steps for a decent walk is not that hard when you start with nice contact poses. We already have those, so let's get started.

Make sure that your armature is in pose mode, and select the body control bone that protrudes backwards from the waist. Use the N-key to bring up the properties panel and scroll to the **View** section. Find the **Lock to Object** control and set it to your armature object (the sample file uses "character_control"). When you do this, a selector appears for bones. Choose the "body_control" bone from it. **Fig. 5.28** shows the screen. This locks the current view to always follow the named object, which in this case is the body control bone. You can rotate and scale the view, but not pan it. It's almost like following a character in a film with a tracking shot. We do this so that as the character walks along, it will always be perfectly centered in the 3D workspace.

Now, no matter what portion of the walk you are at, you can select the body control bone, hit Shift-Ctrl-3 (remember the align-view-to-selected trick from before?) and get a perfect side view of the character.

We put our original contact poses on Frames 1, 13, 25, and 37, just like the examples. So, our first additional frame, the Passing Pose of the first step, falls on Frame 7. Use the Action Editor timeline to put the Current Frame Marker on Frame 7. **Fig. 5.29** shows the Action Editor and 3D view. Junot's feet are both off the ground. Following our plan, identify which foot should be on the ground by scrubbing in the timeline (hint: It's the left foot in the example).

We clear the foot bone's (**not** the foot controller bone protruding from the heel!) rotation by selecting it and pressing Alt-R. Now is a good time to double check that automatic keyframing is enabled in the Timeline view. Unlike the example though, we do not simply select the foot controller and remove all rotations from it with Alt-R. Why not? Because

Note

There are ways that a stationary walk cycle can be used for characters who will be walking long distances or for multiple characters in a scene so that you don't have to animate every step by hand. We'll deal with those tools in Chapter 10. For "hero" animation, which means the foreground animation of the focal character, it should be hand-crafted every time.

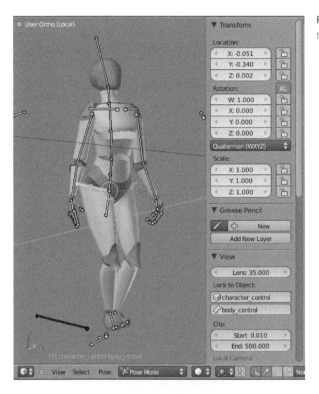

FIG 5.28 Setting up the 3D View to Follow the Body Control Bone.

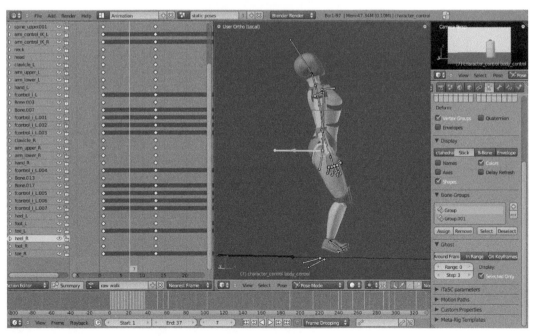

FIG 5.29 The Raw Pose on Frame 7.

our character is not guaranteed to be rotated on any particular axis. If the character is facing 90° from its original orientation, clearing the foot controller's rotation entirely would remove this orientation as well! Instead, we use the rotation manipulator and eyeball it. LMB drag on both the red and green (x and y) orbits and adjust the foot so that it is parallel to the ground. Note that the ground might be slanted a little in this view because of the fact that we're oriented with the body controller bone. **Fig. 5.30** shows the left foot from the aligned side view, parallel to the ground. Do not mess with the blue orbit as this would disturb the direction that the foot is pointing.

With the foot controller (heel) bone still selected, press the G-key and begin to move the foot upward (or down) to place it firmly on the surface of the ground. As you're moving it, give the MMB a tap or press the Z-key to constrain the motion, so it is perfectly vertical. We want to keep the naturally interpolated location of the footstep, but adjust the vertical positioning.

Next, select the foot bone of the nongrounded foot, the one that is moving forward while scrubbing, and clear its rotations too. In the example file, this drops the foot below ground level. Using the foot controller's red (x) orbit, rotate the foot clockwise in the aligned side view until the toe points down at nearly forty-five degrees. Move it upward (G-key, Z-key) until the tip of the heel is just over one-foot length off the ground. **Fig. 5.31** shows the resulting position and orientation.

Finally, grab the body control bone and move it upward (Z-constrain) just until the planted leg locks. It might not be very far. That's the passing pose.

Move back to Frame 4 for the **Low Pose**. Select the body control bone if it isn't already selected and reissue the Shift-Ctrl-numpad-3 command to realign the view. When working with a constrained viewpoint like this, it is

FIG 5.30 Adjusting the Planted Foot's Rotation.

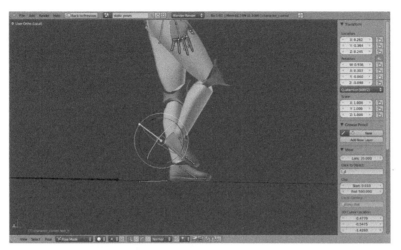

FIG 5.31 Adjusting the Proceeding Foot.

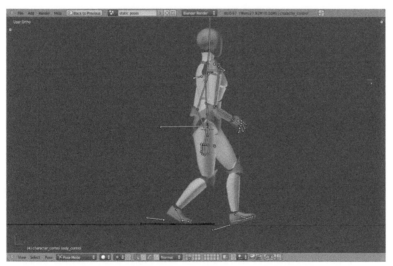

FIG 5.32 The Raw Material for the Low Pose.

crucial to update the view alignment whenever the orientation of the character may have changed. If you forget to do this and start moving feet around with the view out of alignment, you will be in for a nasty surprise when you play your animation back. **Fig. 5.32** shows the starting point for this pose, generated by the Bezier interpolation between the contact and passing poses.

Clear the rotation on the foot bone of the forward foot. Once again, make the foot parallel to the ground by using the red and green orbital controls. Then, bring it straight down (or up) to plant it right on the ground. Using the body control, move the upper body down too, giving the forward leg the kind of bend you see in **Fig. 5.33**. This is the lowest point for the body, and it's your chance to show how the body bears weight on that front leg. Now

FIG 5.33 The Low Pose.

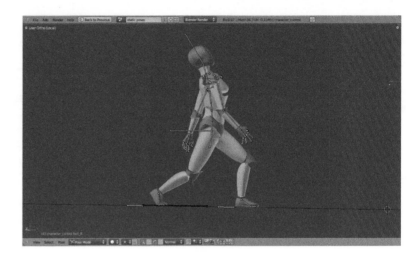

for the tricky part. In the down pose, the rear toe is still on the ground, but the heel has lifted. To get it in the exact same spot as it is on Frame 1, we need to copy the pose from Frame 1 to Frame 4.

You already know one way to do it—the copy and paste pose buttons on the 3D header. Here's another way. Identify the channel in the Action Editor that represents the right foot control bone. It's called "heel_R" in the example scene. RMB selecting the bone in the 3D view actually highlights the correct channel in the Action Editor. Once you've identified it, RMB select that channel's key marker from Frame 1. Press Shift-D to duplicate it. Move it three frames to the right and press the LMB. The duplicated key frame overwrites the one that was already there and snaps the foot into place on Frame 4. Play around with the rear foot's foot bone to lift the heel and leave the toe where it is. You should have something like Fig. 5.33.

Jump ahead to Frame 10 for the High Pose. Fig. 5.34 shows the naturally interpolated starting point. Don't forget to select the body control bone and reorient your view. Make the planted foot parallel to the ground, as you have in the other frames. It should actually be *on* the ground already, as it sits on the ground in both the earlier and following poses. Adjust it vertically only if you have to. The foot itself should exhibit the same bend as the rear foot in the down pose: weight on the ball of the foot, heel in the air. The more pronounced you make the foot bend, the higher the character will travel for this pose. Remember to stay "in character" but still exaggerate a bit.

Select both the body control bone and the foot controller for the forward, in-the-air, foot. Now, raise both vertically until the planted leg locks, but no further. Rotate the forward foot's heel bone counterclockwise until that leg unlocks, and the toe points upward. The final High Pose can be seen in Fig. 5.35.

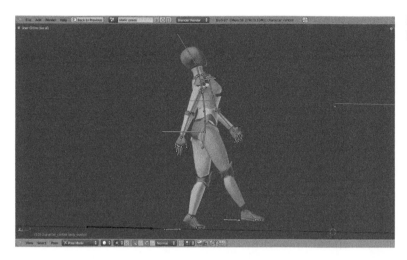

FIG 5.34 The Raw Material for the High Pose.

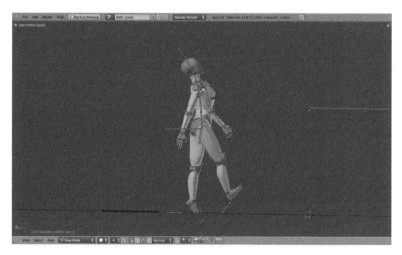

FIG 5.35 The High Pose.

And as far as the basics are concerned, that's it. There's some more we can do to it after we get the whole thing worked out, refinements really, but this is the elemental structure. Now, you move on to Frame 19 to build the next passing pose. Then back to Frame 16 for the low pose and to Frame 22 for the high pose. Do it for the next step, too. Junot takes three steps before she has to do the footwork that brings her to a stop. We'll take care of that later.

When you've done all three steps, it should carry you to Frame 37 if you're working with the sample scene. The Action Editor should look something like **Fig. 5.36**. The keyframes for the feet are selected in the figure. You can see the walk itself in *Simple Intro Walk*. It's a little bouncy, but it works.

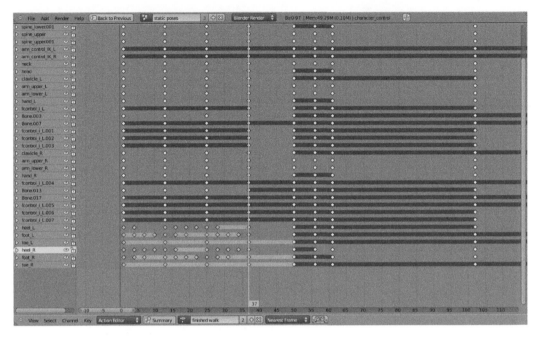

FIG 5.36 The Action Editor with the Different Walk Poses Filled in.

Want to know a secret? The walk you just did along with me was my third shot at it. I didn't like the first two, so I junked them. I didn't mess with the contact poses—they were good. But the exact height that I gave to the high and low poses and the adjustments that I made to the feet didn't look right the first two times. Yes, I could have fought with them, but that's exactly what it would have been: a fight. Sometimes in animation, you're given something that someone else did and you just have to make it work. It can be… trying. If you have the option, it's often better to scrap what you've done and try it again. If for no other reason, you go into it the second time already aware of the problems you'll face.

If you've been following along, you should have a series of still poses that have been released into smooth interpolation. We'll talk about that interpolation in-depth in the next chapter. But for now, you've added poses to flesh out the introductory walk, as well as some anticipation and follow-through poses.

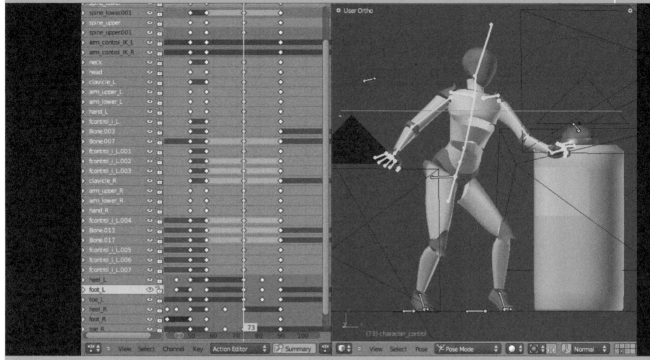

Interpolation, Timing, Breakdowns, and Velocity

So far, we've used the term "timing" to indicate the spacing between our poses. However, when we release our poses into smooth (Bezier) interpolation instead of the constant interpolation we've been using so far, something different happens. You should have already pushed your animation into smooth interpolation in the last chapter when we worked on the walking. If you didn't, do it now by selecting all of the keys in the Action Editor and using either the **Shift-T** shortcut or the **Keys** menu on the header to set them to **Bezier Interpolation**.

Pose Timing and Velocity

Imagine the following scenario, demonstrated in **Fig. 6.1** by Smith: you're laying back on the couch and your shoulder itches. You don't do anything about it for a few seconds, but then you reach across your body with the opposite hand and scratch it. If we were creating poses for this, there would only be two during the initial stages. If we assign a "wait time" between the

FIG 6.1 (a, b) Smith's Shoulder Is Itchy.

itch and the scratch of three seconds, that puts those poses 72 frames apart. When viewed in real time with constant interpolation (*Constant Scratching*), it looks fine. The timing, from pose to pose, is believable.

However, if you release it to smooth interpolation (*Smooth Scratching*), it looks horrible. While the distance in time between the actual poses was apparently correct, the velocity of the transition between them is all wrong. The next chance you get, spend some time observing people in daily life. You'll find that they exhibit two basic types of motion: continuous and discreet. Continuous motions are usually repetitive in nature, such as walking, brushing hair, or scrubbing a window. They are marked by smooth motions of a fairly constant velocity. Discreet actions on the other hand would be someone changing position in their chair, reaching into their pocket for their phone, turning to find the source of a sound, or kicking a pebble on a road. These are one-time actions in which the body is generally at rest, moves, and then stops. If you look carefully, you'll see that most of these discreet actions take place in less than one second. The distances involved aren't great, and neither are the masses. It's just how able-bodied people move.

Back to the itchy shoulder. Do it for yourself. How long did it take from the time your hand started moving until your finger hit the shoulder? It seems to take me about ¾ of a second. So, while there were 72 frames between the two poses in our exercise, the actual motion needs to take place within 18 frames (¾ of 24). So what happens to those extra 54 frames? To achieve the correct velocity of motion, we have to create what is called a **hold**: a period of time during which the character does not move.

The video *Frozen Scratching* shows what this looks like. Still not too good, is it? The problem is that when a real human being sits still, they aren't really sitting still. At the very least they're breathing, which isn't just a motion of the chest. We'll be dealing with the breathing in a later chapter, but that's not all that is going on with a "stationary" person. Hold your arm straight out in front of you and point your fingers. Hold that pose. How well do you do? The odds are that unless you are some kind of yoga master, your arm is going to bobble around a bit.

In contrast, a digital character can hold perfectly still for an infinite amount of time, and in fact will do that unless you specifically force it not to. In traditional animation, you don't have to worry about this so much, because two sequential drawings of the same pose won't actually be identical. The

small differences in line quality and other minor elements introduce enough life into an otherwise stationary character that it still has some life. In CG, we use the "moving hold" to accomplish this. I've seen some animators recommend that you simply have one piece of your character continue to move during the hold and expect that to suffice. I prefer to slightly adjust the entire pose (as appropriate) between the two ends of the hold so that the whole character still feels alive. Unfortunately for us, this kind of adjustment can't be random and only thrown in for the sake of generating a little motion. It needs to receive the same amount of planning and care that your hero-level animation will get. Of course, you have to balance the time that you put into something with the amount of time that it will appear on screen, making sure you don't spend two whole days tweaking the fine points of a moving hold.

Also, keep in mind the point we've mentioned several times before: subtlety. Don't overdo it. If someone is supposed to be resting, we need only the smallest bit of motion to keep things alive. They shouldn't be constantly twitching, jittering, and squirming around. It would look ridiculous.

Let's look at several ways to create moving holds on this fairly simple "scratch" animation. Open the file called "chapter_06_itchy.blend".

Techniques for Moving Holds

In the example file, which can be seen in **Fig. 6.2**, we see two columns of keys. The first, on Frame 1, is the rest pose. The second column, on Frame 72, is the contact point of the scratch. We want to hold the

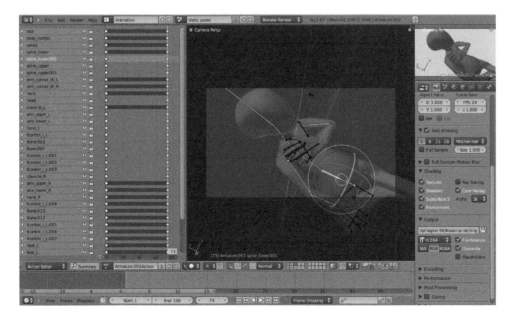

FIG 6.2 Itchy.blend.

FIG 6.3 Inserting Keys Directly in the Action Editor.

first pose until Frame 55, leaving us with an 18 frame transition into the second pose.

The first technique consists of duplicating the first column of keys, then adjusting the pose. Alt-RMB click on any key diamond on Frame 1 in the Action Editor. Use Shift-D, and then slide the duplicated column of keys to the right until they hit Frame 54. Pressing Alt-A at this point shows you the result seen earlier in the *Frozen Scratching* video. It's a completely static hold. To fix this, place the current frame marker on Frame 54. Now, in the 3D view, adjust the pose slightly. It doesn't matter much what you do here at this point, just so it's not large. Of course, subtlety plays better for the moving hold. I've done such an adjustment and created the video *Duplicate Holding*. The reason that we created a new column of keys on Frame 54 instead of simply making a new pose there from scratch is that we wanted it to have a lot of congruence with the initial pose on Frame 1.

Another method involves using only the Action Editor. To do this exercise, delete the column of keys you just made on Frame 54. Place the current frame marker on Frame 1. Now, move forward several frames, watching the motion in the 3D view. If you move up to, say, Frame 14, you've gone about 19% of the way through the motion. With the mouse over the Action Editor, press the I-key to insert a new key. A menu pops up like the one in **Fig. 6.3**, asking if you'd like to insert keys for selected channels or for all channels. Tell it "All Channels." It adds a new column of keys on Frame 14 that represent the exact state of the pose on that frame. Move those selected keys *en masse* over to Frame 54. Now, the first 14% of the entire motion takes place in the first ¾ of the time, followed quickly by the other 86%. The result can be seen in the video called *Key Shift Holding*.

We're going to use one more method, so delete the key column on Frame 54. This last method produces what are, in my opinion, the best results. It also introduces a new tool and new concept. Set the current frame marker to Frame 54. In the 3D view, select all the bones of the character's upper body. With the mouse still over the 3D view, press **Shift-E**. Shift-E triggers the **breakdown tool**. A breakdown is any pose between two others that helps to guide their interpolation. The breakdown tool places the selected bones into a new kind of transformation mode that allows you to quickly find any interpolated pose between the two "bookend" poses. Moving the mouse to the left goes back in time from the current frame, while moving

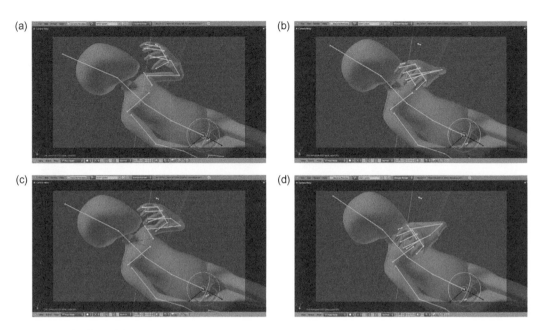

FIG 6.4 (a–d) Possible Breakdowns.

to the right goes forward. **Fig. 6.4** shows a series of poses, all "generated" just by moving the mouse left and right with the breakdown tool active.

While there isn't any feedback for which frame's pose you're currently viewing, you can get a rough idea by where your mouse is on the screen. The leftmost side of the 3D view corresponds to the leftmost key involved, and the right side of the view to the rightmost key. The center of the screen is the exact midpoint blend of the poses. So, using the Shift-E breakdown tool, we could get the same effect as the previous technique (adding keys at Frame 14 and moving them), by placing the mouse pretty near the left side of the view and pressing the LMB to accept the change. With automatic key framing enabled, a new set of keys is created for you on Frame 54 that matches the breakdown pose.

That's convenient—you could use the tool with a maximized 3D view without ever touching the Action Editor—but it's even more powerful than that. The breakdown tool can push the pose past the endpoints. You can try it by removing the new column of keys from Frame 54, then re-activating the breakdown tool with Shift-E. This time, move the mouse cursor past the left edge of the 3D view. The pose continues to change along with the mouse motion. Obviously, if you push it too far (**Fig. 6.5**), you'll get something that doesn't make a lot of sense. But, if you keep it subtle, it will give just the effect we're looking for. The video *Breakdown Holding* shows the result.

We've just added a nice bit of movement to the character with a column of keys on Frame 54, but it would be cool to leverage this tool to provide a

FIG 6.5 The Breakdown Tool Can Go Past the Original Poses.

FIG 6.5 The Breakdown Tool Can Go Past the Original Poses.

bit of anticipation to the arm's cross-body motion. Move the current frame marker ahead several frames of the new column, so it is around Frame 59 or 60. Activate the breakdown tool (Shift-E) and push the pose past the left edge of the view so that the resulting pose has an even more pronounced difference than the first breakdown. The result, which you can see in *Anticipated Holding*, is that you get a moving hold from Frames 1 through 54, then a couple of frames of anticipatory motion that is contrary to the final full motion, followed by the actual action. And you only had to really create two poses from scratch!

This isn't to say that you cannot or should not tweak these intermediary poses— we'll do exactly that in a later chapter to remove the robotic quality—but to demonstrate the ease with which you can use the available tools to begin to fine tune the timing and velocity of your motion.

Fixing Velocity in the Shot

Fig. 6.6 (a–d) shows four poses: the last contact pose of the walk (Frame 37), the stopping pose (Frame 50), the follow through (Frame 57), and the final contemplation (Frame 89). Before we begin to tune the motion's velocity here though, we need to add the footwork. As you've just completed work on the walk in the last chapter, this should be pretty easy to do. The primary thing to keep in mind is that unless you are running or jumping, only one foot can be in motion at a time.

Watch the video *Walking to Standing* for a sense of what this looks like with smooth interpolation but no footwork. The feet just slide along the ground. We need to build the last footstep and get things to work so that the feet move realistically. It doesn't directly pertain to the velocity of what's going on in the upper body, except that we can't really do the upper movements properly until the lower half is finished.

Following the same rules as before, I place the current frame marker half way between Frames 37 (the contact pose) and 50 (the stopping point). I snap the right foot flat to the ground and bring the forward-moving foot up off the ground while clearing its foot-bend. Since this is the last step that Junot is taking before she stops, (i.e. she is coming to rest) the

Note
You actually can do this sort of animation without touching the foot work

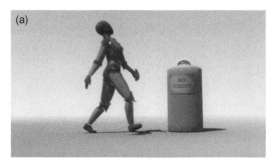
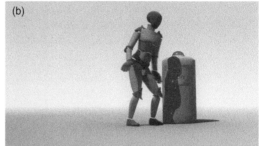
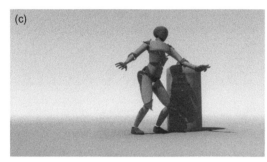
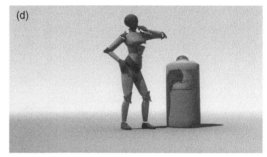

FIG 6.6 (a–d) The Frames in Question.

body will not proceed upward as it normally does at this point in the walk. In fact, it will stay lower than usual, as she will be trying to maintain balance as her momentum shifts. With that middle pose created, it's back halfway toward Frame 37 to create the down pose.

Between Frame 50 and Frame 57, neither foot moves, so we don't have to worry about it. It would be nice to add some follow through in the feet here. This is simply done by rotating the foot bones (*not* the heel controllers) on both sides so that Junot appears to rise up on her toes. This is shown in **Fig. 6.7**. It works along with the upper body pose to indicate that she is attempting to stop her forward momentum.

Now, in order for both feet to move, we need to fit two steps into this space.

The body and feet move differently when we're adjusting our position than when we are walking. There is more side-to-side than up-and-down motion and the feet don't lift nearly so high off the ground, which is to say almost not at all. In some cases, like for a very small adjustment, the heel might only come off the ground and the toe might actually drag.

It probably won't matter from the standpoint of physics or character which foot adjusts first, but if we're thinking about staging, let's do the right (closest to camera) foot first. That way, both feet will always be visible. If the right foot is going to move, that means the left foot stays in place. The easiest way to make this happen is to select and duplicate the left **heel** key from Frame 57 to Frame 73, halfway toward the next pose.

first. It's a little more complicated to set up, but is a nice alternative method of working if your character is doing some fancy motion and the feet are tripping you up. What you do is to temporarily hide both the foot and leg bones (put them on a different armature layer) and the leg mesh as well. Then, you animate the upper body until it looks right. When that's done, you bring the legs and feet back and animate them so that they always keep the body in balance and seem to follow along. This is (for the most part) how we do things in real life anyway.

FIG 6.7 Rising on the Balls of the Feet after the Stop.

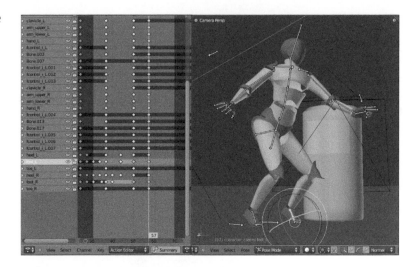

FIG 6.8 Lifting the Receding Foot.

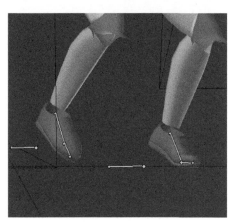

With the current frame marker on Frame 65 then, raise the foot off the ground, then use the right foot's toe control to straighten the foot. This is different than the way we've done it before. While building the normal walk cycle, we would clear the foot bone's rotation to straighten the foot, and then angle it downward with the heel control. The reason that we do it this way is that when a foot moves backward during an adjustment like this, it is usually the toe that strikes the ground first, with the rest of the foot bending to follow. The pose is shown in **Fig. 6.8**. Note how the toe is just barely off the ground.

Advance the frame marker to Frame 73, where we placed the duplicate key from the other foot. This is the frame on which the backward moving right foot has to stop. In other words, it needs to be in its final position on this frame. The easiest way to do that is to duplicate its resting place key, found on Frame 89, and pull it back to Frame 73. Do the same with the right **Toe** key. **Fig. 6.9** shows this procedure in the Action Editor.

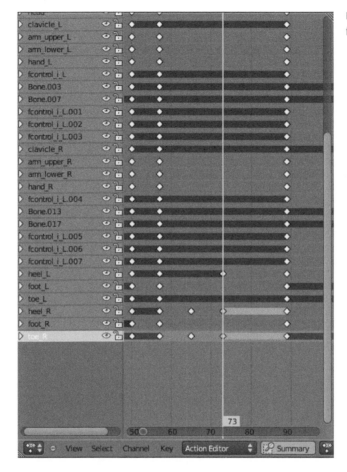

FIG 6.9 Duplicating the Foot Keys from Later in the Timeline.

This effectively causes the foot to stop moving. The last thing to do is to place the frame marker halfway between the left foot's two position keys: Frame 81. Lift and angle the foot the same way you just did for the other one. That's it for the raw motion of the feet. However, if you render that out, you get something like the video titled *Standing with Footwork*. It's "floaty." In animation terms, it means that the velocities are wrong. The character's motion appears to float, as if it is moving in some kind of liquid.

This is bad. The solution? Adjust the timing by moving keys and adding breakdowns, much like we did with the "itchy shoulder" example. Of course, things are more complex here, but the ideas remain the same.

If the legs and upper body all moved in sync and had the same columns of keys, we could do them all at once. However, because the legs and feet have some additional intervening keys to create the two steps, we'll deal with them separately. We may also find that once we've adjusted the velocity of the arms and upper body the leg motion looks fine, and we won't have to alter it at all.

Note: A note about frustration

We're now into the portion of animation where it really becomes judgment calls, and you're probably going to experience some frustration. Relative to the stuff we're about to do, posing was easy. We pretty much know what good posing looks like. But there isn't as much of a language and common point of reference when it comes to critiquing and analyzing flawed animation, which, at this stage, is exactly what we're doing. We're looking at flawed (nonfinished) animation, and trying to decide what to do to it to get it looking good. The principles we've worked with so far, and the ones shown in the rest of this book, can help you along the way. However, at some point, you're either going to be able to see it or you won't.

Just be aware that frustration is normal. Making bad animation is normal. The first skill you'll develop is the ability to know that something is bad. Work at it and do it enough, and you'll start to realize exactly what is wrong with it and consequently, begin to understand what you need to do to fix it.

Let's try using the breakdown tool on the upper body to fix the velocity of the change between the pose on Frame 57 and the contemplation pose on Frame 89. Using the B-key, border select all the bones in the upper body. Basically, get everything but the root bone and the feet. The breakdown tool only affects selected bones, and we want to leave those alone. How long do we want the actual change to take? We already have 31 frames of time in there between the raw poses, about a second and a quarter. Let's knock that down to nearly half: 15 frames. So, position the current frame marker around Frame 73 (89 − 15 = 73) and press Shift-E to trigger the breakdown tool. Remember that moving the cursor to the far left of the window gives you the pose on Frame 57, while the far right of the screen gives you the one from Frame 89.

I move the mouse about 80% of the way to the left, so the breakdown pose will still be somewhere between the two extremes, and not past them. You can see it in Fig. 6.10. Note the new column of keys highlighted there. The little animation that represents this state is called *Breakdown Center*. It's better, but still not right. The limbs float a bit.

Remember earlier in the book, when we assigned a temporary playback range, started animation playback, then tweaked things while it played? This is a perfect time for this technique. In the Action Editor, press the **P-key**, then LMB drag over an appropriate frame range, something like 43 through 95. Press Alt-A, and playback begins in the 3D view. As the new keys that were added for the breakdown are automatically selected, it's easy to move them forward and backward in time. Just hit the G-key while the playback is still running and move them. By moving them between the two end poses (Frames 57 and 89), you can see the results immediately reflected in the 3D view. As I do this, I find that I like the snappier motion created by placing the breakdown keys closer

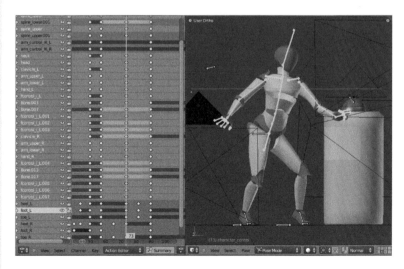

FIG 6.10 Adding a Breakdown.

to the right hand side. Around Frame 78 looks pretty good to me. The result is shown in the video *Breakdown Cheat Right*. As you can tell, this sort of work is highly subjective and will depend on the artistic sense that you develop as an animator by watching your own work and the work of others with a critical eye. The more you do it, the better you will become.

That's a decent result for this stage of the animation. It's still not natural motion, but that will come as we refine it in later chapters. Also, we should remember to go back to our references. Things are starting to get pretty technical at this point, adding and pushing keys and thinking about velocities. Drag out the reference video and watch it again. Do some live observation of your own. How does the motion that you're constructing compare to that? Remember that it doesn't need to (and probably shouldn't) be an exact transcription of the references, but what you see there should inform your digital performance.

With that in mind, it wouldn't hurt to experiment a little with our pose. To do that, we'll take a look at Blender's Pose Library tool. Make sure the current frame marker is set on Frame 78 and that the upper body bones are selected. With the mouse over the 3D view, press **Shift-L**. This adds the current pose to the armature's pose library, which is just a special Action datablock that is used for storing poses. Without changing the frame, press **Ctrl-Shift-L**, which lets you add a descriptive name to this pose, as shown in **Fig. 6.11**. I've called this one "breakdown 01". We've now saved this pose into the library and can retrieve it at will. With that done, delete the upper body keys (X-key) on this frame so we can try a different breakdown pose.

Keeping the upper body bones selected, press Shift-E and this time push the pose past the left edge of the view so that the pose exaggerates past the one on Frame 57. On the first try, we used a pose that was between the references, but it's worth checking to see if maybe one that's outside of the references works better. When you finally press the LMB to accept a pose like the one in **Fig. 6.12**, keys are created for it on the current frame. Playing the animation with Alt-A should produce something like the video *Breakdown Backward*.

It's not nearly as good as the first try, so let's replace it with the previous pose. We could just keep hitting "Undo" until we got there, but as we've saved the original pose in the pose library, it's easy to recall. Press Ctrl-L with

FIG 6.11 Naming a Library Pose.

FIG 6.12 The New Breakdown Pose.

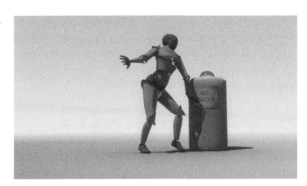

the mouse over the 3D view, and the name of the pose (along with some instructions) is displayed on the 3D header. The pose itself is shown on the armature. If you had more than one library pose saved, you could rapidly cycle through them with the mouse's scroll wheel. As it is, there is only one. LMB click to select it, and it will replace the existing pose.

Breakdowns for Guiding Motion

So far, we've only used breakdowns to control the velocity of an action. They can also be used to refine and guide motion. During the change from "stopping" to "considering" in the animation, the arms simply move from one pose to another. Thinking about the way that we actually move, we sometimes hit intermediary points during an action that aren't strictly between the two endpoints. Take a look at the video called *Two Ways to Point*. In it, Meyer is first pointing upward, then straight ahead. The first half of the video shows a simple shoulder rotation, causing the outstretched finger to describe a long arc. The second half shows another way to do it: the arm first folds in toward the body, then re-extends into the final pose. Depending on the situation and character, either might be appropriate. The important thing is to note that you should not always just accept the computer-generated interpolation between two poses as the final word. There will probably be a more natural way to do things.

Let's add an additional hand-crafted breakdown to make that happen. The "stopping" pose has Junot's arms pushed out in front of her and to the sides to help arrest her momentum. Instead of having her shift directly into the "consideration" pose, we will have her first pull the arms back to her sides, with the elbows bent. You can see both poses in Fig. 6.13 (a, b).

Make a few attempts at doing this yourself, physically. We're off the original reference video now, so it won't be any help here. Observe what you're doing in a mirror, but be careful. Most of us are not the actors that we think we are. This is where diligent people-watching, a strong memory for motion, and YouTube will help you the most. Just remember that references, both their collection and usage, should still be going strong at this point in the animation process.

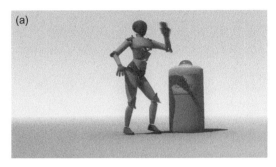 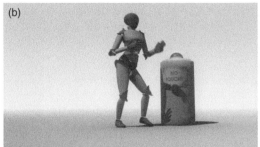

FIG 6.13 (a, b) Junot's New Transition Breakdown.

It is not going to be a resting pose, but one that just guides the motion from the "stop" to the "consider". With that in mind, let's give our original breakdown a few more frames to play with. Hopefully those keys will still be selected. Move them three frames to the left. We take a guess and set the current frame marker five frames to the right of this to create our new guiding breakdown. Obviously, we can move the keys in time after we make them, but you need to pick a place to start.

At this point, you could create an entire column of keys on this new frame, but it's really not necessary. We did that during the first stages of animation just to keep things organized and obvious in the Action Editor. However, we're going to be getting to stages of the production in the next chapter when having too many keys laying around is going to be a hindrance. With that in mind, we'll just key the arms.

On this frame, adjust the arms inward and bend the elbows so that something like **Fig. 6.13b** appears. New keys are only added for the bones that we changed. By setting a temporary animation range with the P-key and watching the live action with Alt-A, I decide to move the original breakdown keys way back to Frame 68 and the new arm pose to Frame 80 to fine tune the velocities. The resulting motion is more complex and appears a bit more natural than the original.

Before we move on to the next part of the action, let's take another look at this one to see if it needs any other gross adjustments. I usually do this by making an OpenGL animation file and letting it cycle over and over on my screen. Sometimes, this results in my eyes glazing over, but usually the longer it plays, the more the flaws and missteps in the motion become apparent. As they do, I note them and think about how to fix them.

In this case, it appears to me that the pelvis and hips are a little dead. They pretty much make a straight line between the first and second pose, even though the feet are moving and weight is ostensibly shifting. Some more motion here would certainly liven things up. **Fig. 6.14** shows the very straight line that the "body control" bone follows.

DJV

DJV is a movie player designed for professional animators, visual effects artists, and film makers. It can play movie files and image sequences. DJV allows you to smoothly do a number of things with your animation playback that you cannot do with most other players. You can play your video in real time forward (duh) and backward, rotate it, or mirror it horizontally and vertically. That might not seem like such great shakes, but viewing your work that way can give you a fresh look at it. By this point in the project, you've been staring at the same overall animation for hours, and probably focusing on your current task for enough time that it's lost its life for you. Watching it in a different fashion can help to snap you out of the trance that you sometimes fall into, letting you notice things that you have been missing.

DJV is Open Source and can be downloaded for free from http://djv. sourceforge.net. It's documentation is pretty sparse right now, and it doesn't support playback for the entire range of video formats that Blender can pump out,

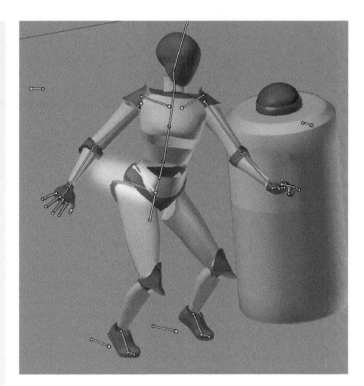

FIG 6.14 The Linearity of the Body Control Bone.

FIG 6.15 Bone Properties for Adding Paths.

186

To show these kinds of lines in your own work, select the bone in question and switch to the **Armature Properties**, shown in **Fig. 6.15**. In the **Motion Paths** panel near the bottom of the properties (you might have to MMB drag to find it), switch to the **In Range** option. Set a start and end frame that will be used for the calculation of the path (I used 57 and 89) and hit the **Calculate Paths** button. The path that the bone follows is drawn in the 3D view, with little dots representing frames. In this animation, I've had to change the setting in the panel from **Tails** to **Heads** so the path is generated from the part of the bone that touches the spine. When you're done with such a path, use the **Delete** button on the panel to remove it.

Placing the current frame marker back on Frame 57, I step through this portion of the animation frame by frame with the right arrow key. I watch carefully what the feet are doing and picture how the weight would be shifting in that situation in real life. Also, I check my reference material to see if something like this is included. For example, on Frame 81, where the right foot is bearing the most amount of weight, I tilt the pelvis bone so the right hip is raised. I do it again on the opposite side when the left foot bears all the weight. Finally, I move the control bone slightly to the left and right (relative to the character) from an aligned front view (Shift-Numpad-1 with the control bone selected) on those same frames and add some dip as well when the body is only supported by one foot.

These refinements aren't full pose breakdowns, but they certainly help to guide the motion between poses. The result can be seen in *Breaking Down the Hips*. The differences between this and the previous iteration are subtle, but meaningful. It's better, and better is good. Of course, if it hadn't been better, we'd want to go with the original. It's valuable to keep in mind that not everything you do to refine a piece of animation will work out like you planned, and, even if it does, the result in real time might not be better than the alternative. So, when you prepare to do something like this, make a reference video of what it looked like to begin with. That way, after you make the change, you can compare the two on equal footing and decide if it's worth it.

That's as far as we're going to go with this particular part of the action. Let's move on to the next one: the transition from "consideration" to the bend over and close-up look at the sign. Remember that somewhere in the middle of this transition, we'll be cutting in for the close-up shot of the sign, so we don't need to be super concerned about what the whole body is doing at the end of this part of the action.

To make this happen, we'll add a breakdown dead center between the two endpoint pose frames (89 and 130) and adjust its location in the timeline as the animation plays (Alt-A) in real time. Just like the last time, place the current frame marker midway between the poses (Frame 110) and select all of the upper body bones. Press Ctrl-E for the breakdown tool. When I push the mouse past the left edge of the view, I find that I like the hyperextension that it gives to Junot's back. It's a nice exaggeration of the pose, and my gut

but if you're looking to add a new and powerful tool to your arsenal and willing to spend an hour or so experimenting, it's a great find.

References

A number of times in this chapter, we find that we're adding new poses and motion that weren't present in our planning or our original references. At times like these, it really helps to have… more references. You can perform them yourself in front of a mirror, but doing it yourself isn't usually good enough. If someone else is around, ask them to do something that will lead to the natural motion that you seek. Don't specifically direct them to do the motion— unless they are a fantastic actor, you'll get their conscious idea of what that motion is

supposed to look like, not what it actually is. If you're working with a team, you'll probably end up getting asked to participate in numerous reference activities by other animators, so don't be afraid to ask back. When working with friends, it's probably a good idea to video the entire interaction so that you're not constantly starting and stopping the camera and directing people. Have some fun. The more natural everything feels to those involved, the better your eventual reference material will be.

tells me that it will look good as our moving hold before the actual transition to the next pose.

I push the new set of keys generated by the breakdown tool to the right until it forces the downward bend to take place in just under fifteen frames. Now, bringing together all of the animation from the very beginning to this point looks like the video called *Half Way Home*. It's still a little robotic, but it's looking a lot better than the first time we released the poses to Bezier interpolation.

We won't be seeing any part of Junot except her hand during the close-up, which can be seen in **Fig. 6.16**. We could decide to either add a little animation to the hand to keep it interesting while it's in frame or just move it out of frame altogether. By using two poses and a few breakdowns, it will be relatively simple to get the finger to point to the first word, then the second.

NOTE: To switch to a different camera select the close-up camera and press Ctrl-Numpad-0.

Before we actually mess with the hand though, we need to add a breakdown between this bending down pose and the next one, where Junot is preparing to touch the light in the medium shot. If we don't add a breakdown, we'll get a fairly long, slow interpolation between the two poses. I add a breakdown that's very similar to the left-most (bending) pose, twenty-four frames (one second) before the next (standing, preparing to touch) pose. This means that she does a moving hold for most of the time between the poses and then executes the stand-up over the last second. We've added several breakdowns in detail now, so I'm just going to give the shorthand for it this time: set the current frame one second before the last pose, Ctrl-E breakdown tool, and pick an intermediary pose that works. In this case, make sure to include the body control bone in the breakdown so that Junot stays crouched.

Dealing with the hand is nothing you haven't done before. Craft a pose like the one in **Fig. 6.17**. I've added an extra, temporary point lamp and used

FIG 6.16 The Close-Up.

FIG 6.17 Pointing to the Words.

Textured shading mode in the display so I can see the word texturing in the 3D view. Position the arm near the beginning of the close-up so it points to the top line of text. Advance the frame a little and make the hand point to the other word. We're only working with around sixty-three frames of time, so we can use a different system for creating our holds. If the arm and hand keys on Frame 130 are the initial pose, we can just duplicate and move them forward one-third of the way toward the end, or about 20 frames. Then, on Frame 150 where we placed the duplicates, we alter the position of the arm a little to give the hold some motion. Then, 20 frames further on, we point the hand to the lower line of type. We copy those new keys and move them on top of the original breakdown keys on Frame 192. On 192, we shift the arm position just a bit to give it some life.

So, we're left with a moving hold from Frame 130 to Frame 150, a twenty frame transition to a new pose, then another moving hold of about 20 frames that takes us into the next breakdown. By setting a temporary frame range and playing the animation with Alt-A, I find out that the two interior key sets need to come very close together for the velocity to work. The result is the frame configuration in **Fig. 6.18**, and the motion can be seen in *A Closeup Hand*. It's simple and to the point.

You should be able to abstract the work flow now. Get your poses right. Do the rough timing. Fix the velocities with breakdowns. Refine the motion with intermediary poses if it makes sense. Notice how each step in that chain relies more and more on your own artistic judgment of what looks right.

Once you understand the process and get the hang of it, it's not that bad as long as you're not doing complex motions that include footwork. So, by the time we hit the medium shot where Junot stands up, anticipates touching the light, then actually touches it, our way ahead is clear. We need to build a breakdown for each pose so that the velocity is correct and also to make sure that the lines of motion make sense. **Fig. 6.19** shows the action editor, with the main poses highlighted in green and the breakdowns—each created with the breakdown tool—highlighted in blue.

FIG 6.18 The Keys to This Sequence.

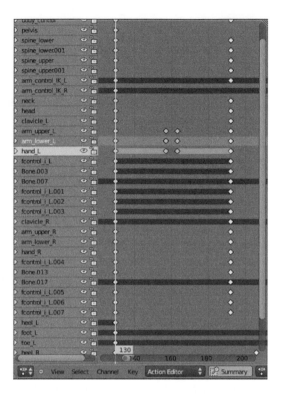

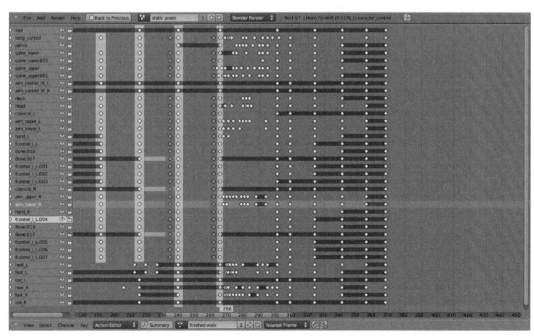

FIG 6.19 The Keys for the Next Sequence of Motions.

There are a few things to note. First, there is some off-camera footwork that happens in order to get everything lined up. While it's not crucial that you spend as much time on it as you normally would, you need to at least make sure that the visible movements of the upper body and legs look right. Second, the breakdown that holds the anticipation falls very near (just five frames) to the pointing pose. This makes the velocity of the actual pointing motion very high. It's like she's building up her courage and then does it in a flurry. Third, the breakdown after the point/touch was created by moving past the left edge of the view, pushing the pose so that the hold has Junot leaning further and further away as though she is expecting something bad to happen. Watch *Point with Breakdowns* and notice what happens to the finger and hand when we do this.

The finger pushes through the light and moves with the rest of the hand. Obviously, that's not something that would really happen. There are a few ways to fix a problem like this, one of which (using IK) we'll tackle in the last chapter of the book. The other way is to simply keep adding breakdowns and keys on the arm so that the hand stays mostly stationary while Junot leans away.

Using both a front and side view (**Fig. 6.20**), place the 3D cursor right at the contact point between the finger tip and the lamp's surface. Proceeding to the last frame where the contact is maintained (Frame 262 in this case),

FIG 6.20 Extra Keys Keep the Finger in Place.

reposition the arm in both a front and side view so that the finger tip falls exactly on the 3D cursor. Placing the frame marker midway between the endpoints (Frame 251), adjust the arm again. Keep going midway between the break points, re-adjusting the arm so the finger and light touch at the 3D cursor. Scrub through that area of the timeline as you do this, working until the finger stays reasonably stationary. It might take only a few extra keys and breakdowns to accomplish this, or it might end up requiring a key on every other frame. Either way, it's okay. You can then see the result in *Stationary Hand*.

You might be tempted to just keep plowing through the rest of the animation, working on the surprise movement and backward jump next. If you'd like to give it a shot, please feel free. Just be sure to work on a copy of your current file. I tried the backwards stumble a number of times using the pose-to-pose method that we're learning here, and it never felt right. It could be that the intermediary poses weren't correct or that my animation skills just weren't up to it. I tried it once using straight ahead animation, and the result was significantly better. The problem with teaching straight ahead animation at this point in the process though is that you're really not ready to learn it. To do straight ahead effectively, you already need to have internalized the lessons you've learned as well as the ones that you're going to learn in the coming chapters. So, we'll come back to this portion of the animation later in the book, when you have the proper tool set to deal with it.

Skipping that then, we come to the backwards, guarded retreat, in Frames 309 through 368. This is a mostly continuous motion, like forward walking, and, while the mechanics are a little different, you follow mostly the same process. Lift the foot that moves, and shift the weight. An OpenGL version of this can be seen in *Exit Stage Left*. There actually isn't a whole lot of breakdown work to do here, unless you want to give the guarding hands a bit of snap. Instead of having them smoothly cycle back and forth in sync with the feet, let's use just two different hand poses.

To replace a part of an animation like this, identify the frame range that will receive new keys, find the correct animation channels, select their keys, and delete. As shown in **Fig. 6.21**, you'll want to keep the keys on the end points so you have something to work with. With the interior keys removed though, you're back to the familiar process of making two poses, then correcting their interpolation velocity with breakdowns.

I've actually kept two of the hand poses from before and spread them out. It was easier than building completely new poses. The beginning hand pose lands on Frame 309, and the first opposing position is on Frame 327. The breakdown is on 321, meaning that the hands switch positions in only six frames, a quarter of a second. **Fig. 6.22** shows the all of the added keys, including the breakdowns. The walk-out with the hand motion changed is called *Guarded Exit*.

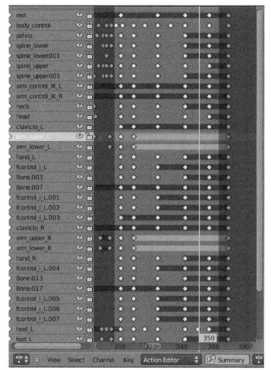

FIG 6.21 Removing the Original Hand Poses.

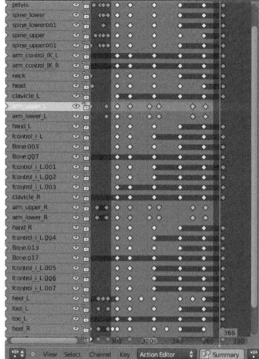

FIG 6.22 New Hand Poses and Breakdowns.

Slow In/Out

One of the other principles of timing, Slow In/Out, is actually taken care of automatically by Bezier interpolation. A quick look at the f-curves (Fig. 6.23) for something like Junot's standing motion makes this clear. As you learned earlier, a steeper slope in a curve indicates higher velocity. The fact that all of the motion curves begin flat, grow increasingly steeper, and then reverse that trend until they stop demonstrates the slow in/slow out principle.

If you need to change the slow in/out characteristics of a particular motion, you could come to the f-curve editor and start messing with the Bezier handles. Of course, there are a metric ton of them there, and you can't select groups of handles with the normal B-key method, so good luck adjusting curves for overlapping keys on a full body motion in this lifetime. Actually, you've already been adjusting the slow in/out motion right in the Action Editor. By adding breakdowns to control velocity, you've been doing exactly that. And, if you needed to, you could control the slow in/out rate rather finely through the careful addition of breakdowns.

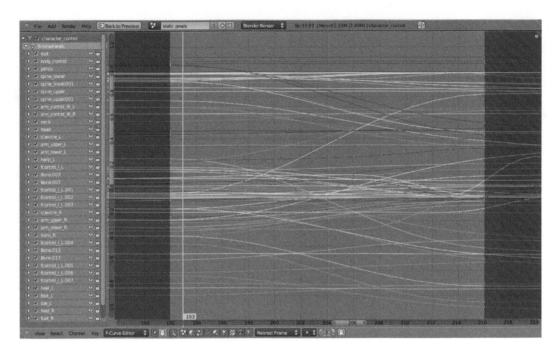

FIG 6.23 The f-Curves for Junot Standing.

For example, if you have two poses like the ones in Fig. 6.24 (a, b) and allow them a normal Bezier interpolation, you get something like the video titled *Just Thinking*.

Let's say that for some reason, we want to lengthen the slow in/out periods within the same time frame. Of course, this means that the motion itself will hit a higher velocity in the middle, but that's the trade off. To do this in the f-curve editor, you would have to make an adjustment like the one shown on a single curve in Fig. 6.25. Note that is only a single curve, while each bone that moves is going to have at least seven curves (three for location and four for rotation). You'll have to do a lot of adjusting.

Alternatively, you can do the same thing with breakdowns. By placing the frame marker at the one-third point between the poses, activating the breakdown tool (Ctrl-E), and choosing a pose to the left of the one-third point, you effectively extend the slow in period. Then, if you place the marker at the two-thirds point, do another breakdown, and this time choose a pose to the right, you extend the slow out period. Fig. 6.26 shows the resulting Action Editor configuration and notes "where" in the timeline the keys were chosen from. To do this more precisely, you could also place the current frame marker a few frames off the endpoints, hit the I-key (right in the Action Editor), add two new columns of keys, and move them inward. The result is pretty much the same. You can see the extended slow in/out periods in *Thinking Slowly*.

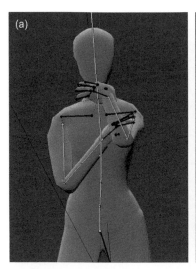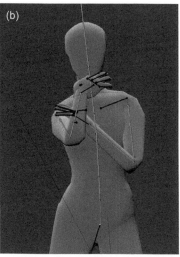

FIG 6.24 (a, b) A Simple Pose Change.

FIG 6.25 (a, b) Changing an f-Curve to Increase the Slow In/Out Periods.

FIG 6.26 Creating Breakdowns to Control Slow In/Out.

The one time that you should probably use the f-curve editor to alter motion is in the case of a rebound. When one object (a ball, a fist) collides with another (a floor, a face), the stoppage of motion does not exhibit slow out. It proceeds at full speed and stops immediately. When something bounces, the motion is completely reversed in an instant. To see how to do this, watch the video called *Bouncing Ball*. Both halves of the video use the exact same set of keys, if viewed in the Action Editor. The difference in motion is generated by the Bezier handles.

Fig. 6.27 (a, b) shows the f-curve editor for each half of the video. Fig. 6.27a is the standard smooth interpolation. You can see how the standard Bezier curves make the ball slow down as it nears the ground, graze it, and then gradually start back up. That's okay if you're a stunt plane buzzing the crowds, but it's entirely wrong for a rebound. The only difference in Fig. 6.27b is that the handles on the curves have been selected and changed to **Vector** with the V-key, then adjusted slightly to provide an even sharper in/out. This produces the instant reversal of motion that you see in the second half of the video.

To summarize before we move on, correct timing is a function of both the distance in time between poses, and the velocity at which the transitions occur. That velocity can be controlled with breakdowns, which are in-between poses that help to guide interpolated motion. Breakdowns are not constrained

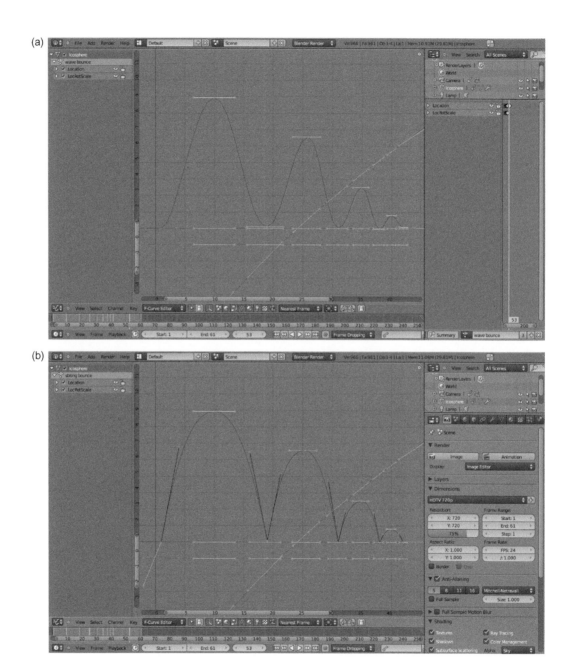

FIG 6.27 (a, b) The Different Handle Styles for a Bounce.

to only deal with velocity but can be used to refine motion, add additional activity, or raise the complexity of the existing action. Breakdowns can be added "by hand," by duplicating and altering existing sets of keys, and through the use of the breakdown tool.

In the next chapter, we'll talk about the principle of overlapping action. Up until this point in our work, any single motion that our character has done finds all of the bones beginning and ending their motions at the same time during an action. When Junot stands, every bone in her body begins the action at the same time, and every one ends at the same time. Likewise, when she reaches out to touch the light, both her right and left arms move in perfect sync with one another. This rarely if even happens in real life. Learning to build that into our animation will loosen it up considerably and push it into the realms of what one might call "decent."

Fine Tuning Motion

Overlapping Action

We mentioned in the previous chapter that our animation was still lacking something important. Even with the proper poses, timing, and velocities, all of the bones within any particular motion were moving at once. That might not sound like a problem, but consider the following example.

In Fig. 7.1, Smith is hurling a ball. If this were done in the fashion of the animation we've completed so far, his arm, body, and legs would all move at once and at the same rates. In real life though, someone who is throwing a pitch like this shows something a lot more like Fig. 7.2. The motion begins with the legs, travels to the hips, up into the shoulder, and finally to the arm. As the pitch develops, the upper arm and hand lag significantly behind the rest of the arm, finally coming forward with a whipping action.

As a real person actually doing this, you don't even have to think about this cascade of motions. Your body just does it. However, since we are generating keys to create motion, we have to notice this and push it into

FIG 7.1 (a–d) A Very Robotic Pitch.

the animation on purpose. The motions of the bones need to overlap each other, instead of happening perfectly in sync.

This brings us to the principle of **overlapping action**. I break overlapping action (often called "overlap") into two categories. The first involves making sure that no two parts of a character move exactly in sync with one another. Due to the way that our brains and bodies function (and really, the very nature of universe), when we reach for something with both hands, the arms neither begin nor end their motion on the same instant in time. It might be close. It might be so close that it feels to

FIG 7.2 (a–d) A More Natural Sequence.

you like it is happening with true simultaneity, but it isn't. The effect of overlap is to force different parts of a bone chain (the arm, the spine, etc.) to move in sequence. For example, if someone falls flat on their butt, a slow motion X-ray camera would capture the impact first affecting the pelvis and moving slowly upward through the spine. Although most of our motions take place in less than a second, we still have to consider this and account for it.

It is this second style of overlap that can really bring your animation to life. Think about two different scenarios, and how they would be animated.

In the first, a character holds a ball at arm's length, then shakes the ball back and forth (Fig. 7.3). The motion is generated by the character itself. It begins with the trunk of the body, progresses through the shoulder, the arm, and finally into the hand, which could snap like a whip. If animating this motion properly, the rotation of the spine would take place a frame or two before the shoulder motion begins, and that before the lower arm, and finally the hand.

In the second scenario, a giant Smith grabs Meyer by the head and proceeds to shake him (Fig. 7.4). When Meyer is animated, the motion will begin with the head, and the rest of the body will follow sequentially.

FIG 7.3 (a–h) Shaking a Ball.

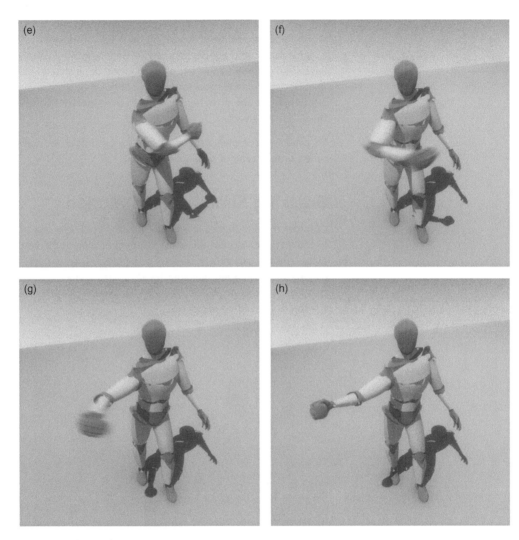

FIG 7.3 (a–h) (Continued).

FIG 7.4 Shake It, Meyer.

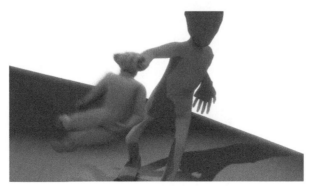

This seems pretty elementary, but it is fantastically important. The way in which force propagates through the body tells the viewer where the force is generated. Some people approach overlapping action by just pushing keys around a few frames left or right in the dope sheet and think that's fine. Not so. You will need to think about the motion that is occurring and tell the viewer about the origins of the forces involved by the way that you break out the overlaps.

It's actually a complex topic, so before we get into it, let's take a look at the other, simpler type of overlapping action.

Breaking Simultaneous Motion

Consider the two frames in **Fig. 7.5**. Junot is holding a box with both hands in the first part and has released it to begin falling in the second. If you've ever done the experiment wherein you hold a piece of paper with two long cuts by the sides, then pull your hands apart rapidly (**Fig. 7.6**), you'll know that no matter what you do, you are not capable of completely balancing the forces exerted on either side.

FIG 7.5 (a, b) Junot Letting Go.

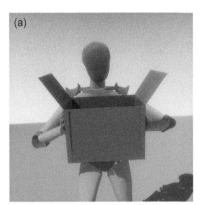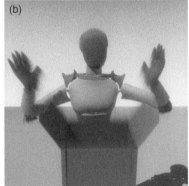

FIG 7.6 Do This. Pull Both Sides at Once. Tearing the Paper into Thirds in One Go Is Impossible.

Doing this in a pose-to-pose work flow is as simple as you would imagine. **Figs. 7.7 and 7.8** show the Action Editor before and after an alteration to break up Junot's "let go" animation. It's as simple as shifting the set of keys that represents one limb a frame or two out of alignment with the others.

In this example, the entire key set has been shifted two frames forward in time, maintaining their relative distance within the set. There is no reason that you have to do it this way, though. You could have moved the first keys one frame to the left and the last ones one to the right. By doing that, the one limb begins its motion one frame before the other and ends one frame after it. This lengthens the motion by two frames. You might be thinking "Two frames? That's less than a tenth of a second!" You're right. It's not something that will cause the viewer to take note of. It's there to add almost subliminally to the illusion of believability we're trying to build.

While it's pretty trivial to do this in the Action Editor, there are some considerations to keep in mind. First, keep it subtle. The more you offset the keys, the looser the animation is going to feel. Take it too far, more than a few frames, and things will start to feel uncoordinated. While the

FIG 7.7 The Action Editor Before.

FIG 7.8 After Breaking Simultaneous Action.

motions of two arms, for example, shouldn't occur in perfect sync, they should certainly be related. Second, don't expand or compress motion velocity too much. You've hopefully already tuned the velocity of your motions. While a couple of frames one way or another won't make that much of a difference, this is a perfect place to make "before" and "after" videos to ensure that what you've done is an improvement.

For some interesting effects, we can apply this simple notion to our earlier introductory walking. As we've keyed it, the legs move perfectly in sync with the arms, that is, forward arm motion on one side of the body begins and ends exactly at the same time as the rearward leg motion. In real life, the leg motion leads the arms by a fraction of a second. So, by selecting all of the arm-related keys over the length of the walk and moving them two frames to the right, we introduce a tiny bit of lag. The difference is subtle, but effective. If you watch the video *Walking In Sync*, you can see three different iterations of this: the raw animation, the arms offset by two frames, and the arms offset by six frames (a quarter second) to exaggerate the effect. Setting it off by two frames starts to bring it to life, while pushing it to six frames makes things start to look silly.

Before we go plowing through the whole animation and sliding keys for different limbs back and forth like crazy, let's tackle the second type of overlap.

Sequential Motion

As we mentioned before, the correct propagation of energy through the character's skeleton tells the viewer where a force is coming from and to where it is headed. Not using this type of overlap leads to the mechanical feeling of the current animation. Even worse though, is using this technique randomly or just flat out wrongly which sends confusing cues to the viewer.

There are two main ways to add overlap to your animation. The first is by offsetting existing keys in the timeline. Do this is fairly quick, and the results can be good. The second method involves adjusting the pose of either a new or existing breakdown by hand. This method requires more thought, but can produce superior results. For motions of the spine and incidental action, I usually use the first method. For arm or high value motions, I generally use hand craft breakdowns.

Let's do a simple example of the latter.

Back to the walk with the recently offset arm motion. Thinking about the arms as they swing forward and back, do they remain rigid? **Fig. 7.9 (a, b)** shows a frame where the right arm is as far back as it will go, followed by the pose several frames later. When the arm begins to move forward, unless you are attempting to keep the arm rigid or purposefully move it in that way, the lower arm should actually fall "behind" the motion for an instant.

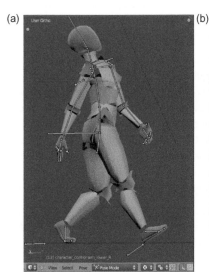 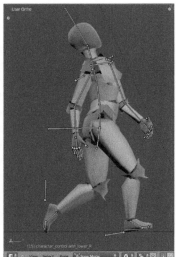

FIG 7.9 (a, b) Frames of Walking.

Just a frame or two. To put it into the terms we've already used, the energy for this action is coming from the torso, passing through the shoulder, into the upper arm, and finally into the lower arm.

The solution is to add a lower-arm only breakdown on the frame that represents the second image. In the example animation, I've straightened the arm entirely on this frame. Automatic keyframing inserts a key here, only for the lower arm. If you want to try out some variations with this technique, a good way to do it is to use the looping walk cycle file from Chapter 4. That way, you can watch your single adjusted pose repeated over and over in a continuous stream. Things to try could be: make the break closer or further from the initial key, watching how it loosens or stiffens the animation. After moving the key, you can always adjust the rest of the pose, too. The odds that simply pushing keys left and right in the timeline will produce truly natural motion without further intervention are pretty low.

Try pushing the lower arm past "straight," actually bending the elbow a bit past the normal human limit. Done so that the "break" in the joint only lasts for (ideally) one frame, it can add a "whip" to the motion, suggesting that doing so could be useful for particularly fast or violent motions. The human eye won't completely register the un-naturality of the pose as though they were seeing it in a still image, but the flexibility will be communicated.

On the other side of the arm swing, the lower arm should also lag by a frame or two when the upper arm begins its backward motion. This is done easily enough, by finding the keyed extreme of the arm pose, advancing a few frames until the arm begins its backward motion, and increasing the bend of the lower arm slightly past the bend in the original pose.

I've worked through the initial walking animation making both of these adjustments to the arms along the way. You can view the results side by side with the pre-overlap version in *Walking with Overlap*. The differences are subtle but significant. Junot actually looks alive now.

You might be getting the idea from working with the lower arm that adding overlaps "by hand" requires a lot of thinking. Indeed it does. You need to consider what exactly is going on in your animation, along with the character's physical situation and state of mind. A lazy character would probably exhibit a lot more of this kind of overlap. Someone who is, for example, power walking would most likely keep their arms rigid throughout the motion. A character holding something heavy would exhibit a completely different set of overlap characteristics. Once you get the hang of figuring out this type of overlap, you might even try building it into your initial key poses and breakdowns, when appropriate.

The other method of generating overlap is to simply use the keys that are already in place and offset them in the Action Editor. **Fig. 7.10** shows two columns of keys that represent the two poses shown in **Fig. 7.11 (a, b)**.

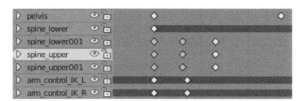

FIG 7.10 Two Columns of Keys.

FIG 7.11 (a, b) Junot Stopping.

Junot is stopping at the end of her walk. Taking the actual motion of stopping into the realm of physics, how does it work? The pelvis stops first. This change flows up the spine, which is flexible. We can simulate this by offsetting the pose keys, one after another, up the spine. To do this kind of thing with the spine, I usually use the B-key to select all of the spine, neck, and head keys with the exception of the pelvis. I move them one frame to the right, and then de-select the lowest one in the chain (*spine_lower* in this case). I repeat that until the Action Editor looks something like **Fig. 7.12**. Notice that in this case, we are only changing the positions of the keys that represent the stoppage of motion.

How much you offset the keys depends on the velocity of the motion and other considerations. How much momentum does the upper body have? A character with something heavy (another person?) on their shoulders would actually have a huge amount of upper body momentum. In general, the more

FIG 7.12 Offsetting Keys for Overlap.

FIG 7.13 Disabling Snap in the Action Editor.

momentum a body has, the longer it will take to stop. The longer it takes to stop, the more spread out the keys will be when it comes to overlap.

The opposite holds true as well. If your character is only making small movements at low velocities, you won't need to have a lot of overlap. You don't want to have your characters whipping all over the place if they're just fixing themselves a cup of tea.

Up until now, every key you've moved around in the Action Editor has snapped exactly in single frame increments. This snap can be disabled by changing the selector on the Action Editor's header, like Fig. 7.13. If you change it to "No Snap," you can position the keys anywhere you like on the time line. Blender only calculates poses on integer frame numbers (no decimals), and you can't place the current frame marker between frames, but the interpolation works properly. Two poses with keys on Frames 1.5 and 2.5 would show the exact middle point of the interpolation on Frame 2.0.

So, if you decide that your entire spine overlap should occur within two frames and offset the keys accordingly within that space using fractional frame numbers, you'll get the proper effect at each of the three frames along the way. Putting them all within the span of one frame is pretty useless though, as you only get the poses on either side. The lesson: if the overlap takes only a single frame for an entire bone chain, split the chain into two parts. Instead of doing what you see in Fig. 7.14 (offsetting all the spine bones within a single frame), you are better off with something like Fig. 7.15, offsetting the upper half of the spine as one piece. Another way to approach this is to adjust your poses on either side of the original key so that the overlapping action is built right in.

Back in the example, Junot goes from this stopping pose into the consideration pose, found on Frame 89. The same thought process applies as the last action, but be careful to consider the action being taken. If you

FIG 7.14 Staggering Keys within a Single Frame.

FIG 7.15 Going Half and Half.

just built the motion up from the pelvis again, you would be wrong. Try leaning forward until you're almost off balance, and then pull yourself back. You do *not* do that last movement from the hips. Do it a few times, and you'll realize that you're mostly flexing the long muscles that run vertically along your back. That contraction pulls your shoulders back first, almost like someone is grabbing you by the shoulders and hauling you backwards. If you do it the other way around (motion running from hips to head), you feel like some kind of puppet.

So on this motion, we take the upper spine key and pull it to the left, back in time, from the rest of the motion. That way, the shoulder motion begins first, and the shoulders lead, just a bit. To add to the effect, you could pull the neck and head keys one frame ahead of the upper spine. This is a fairly low velocity motion though, and not a whole lot of momentum is involved, so don't overdo it.

All three of these overlap exercises might have you wondering "Do I really need to think this way about every single motion for the whole animation?" The answer is "Yes." You really do. It needs to be there, and it needs to be right, or the animation will suffer. However, you must be careful not to overdo it. Under certain circumstances, you might want your character to appear to be made out of springy rubber, but not here. Adding too much overlap will make your character's actions appear floppy. The rule is as follows: keep an eye on the big picture, think about character, and preview often.

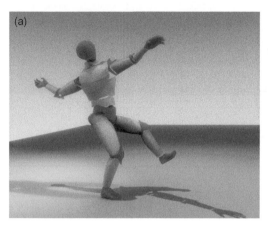
(a)

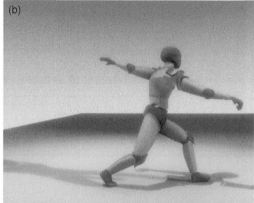
(b)

FIG 7.16 (a, b) Start and End of a Throw.

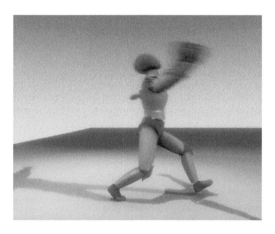

FIG 7.17 A Throw Breakdown.

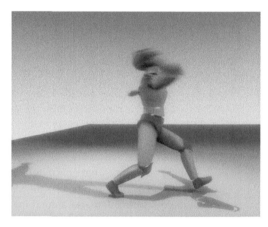

FIG 7.18 The Same Breakdown, Considering Overlap.

Continuing through the rest of the animation that has been done (and still skipping the jump away from the pedestal), we pay attention to both forms of overlapping action, making sure that nothing moves with perfect synchronization, and that limbs exhibit the effects of momentum and force.

The result of adding the overlap can be seen in *This Is Overlap*.

We're not going to do it yet, but once you get the hang of adding overlapping action to your pose-to-pose animation, you can start to build it in earlier in the process. For example, when adding a breakdown between poses in our throwing example from the beginning of the chapter (**Fig. 7.16 (a, b)**), you might do something like **Fig. 7.17**. That's a decent breakdown, but even better would be one like **Fig. 7.18**. Notice how the lower half of the throwing arm already lags significantly behind the rest of the limb.

Of course, you could just do a normal breakdown, but if you're thinking ahead, you can save yourself a lot of time by doing it this way.

When this will really benefit you is when we tackle straight ahead animation in Chapter 9. As you work forward through a sequence, you are forced to build your overlaps in from the very beginning. And, as you gain more experience and confidence with overlap, you'll find that it starts to make sense to build it into your breakdowns (and even key poses!). It requires much more skill, but the end result is almost always better than pushing existing keys around, and it keeps your Action Editor neater too.

Arcs

At this point (ignoring the portion of the animation that we're going to do using the straight ahead method), you have the primary motions for the animation completed. Before we move on to adding secondary motions, let's do a last minute check on the animation we already have.

As we demonstrated much earlier in the book, characters generally move in arcs. This is due both to the nature of the way that living things are built in this world and to gravity. Most characters you animate will have a skeletal structure and use a system of joints, which necessarily results in arcs in the real world. Gravity accelerates freely moving bodies downward at a constant rate, generating arcs.

To show the arcs in your animation so far, select some that could represent the motion of the body as a whole: the head and body control. Find the **Motion Paths** panel of the **Armature Properties**. Make sure that the selector is set to **In Range**, and enter the full animation range for **Start** and **End**. In the demo files, this is Frames 1 through 368. Press the **Calculate Paths** button. The path that each of the selected bones follows throughout the entire course of the animation is displayed in the 3D view. **Fig. 7.19** shows both the 3D view and the **Motion Paths** panel.

We want to see arcs. Nice sloping curves. If there are areas where we see long straight lines or sharp corners, there had better be a very good reason for it. Let's use some of the other motion path tools to examine one of the sharp corners. **Fig. 7.20** shows a fairly sharp point that the head bone makes. Rotating around it, you can see that it still arcs a bit, but it's worth checking out. By enabling the **Keyframes** option on the **Motion Paths** panel, an orange dot is placed along the paths in the 3D view wherever keyframes are located. Then, enabling **Keyframe Numbers** displays the frame number beside each orange dot. This has already been done in the figure.

Having this available makes it simple to identify where the problems might be. In this case, it's Frame 301. To check it, I just scrub in the timeline back and forth around Frame 301. Does the motion look unnatural? What is actually going on there? Here, it seems that what looks like a sharp point in

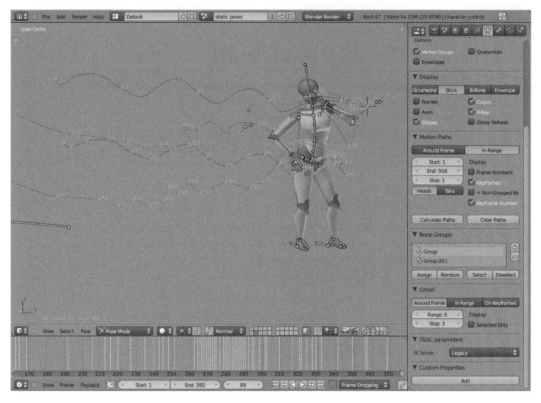

FIG 7.19 Showing the Paths for the Entire Animation.

FIG 7.20 Showing the Keyframe and Frame Numbers on the Motion Path.

FIG 7.21 The Motion Path for Junot's Head.

the path is created because Junot drops into a crouch, beginning on that frame, as she continues to move backwards. That one is okay then, as her head should begin moving downward in only a few frames while her body drops. Sections like Fig. 7.21 can be difficult to untangle. There is a lot of information packed into a very small area of 3D space. Instead of zooming way in and trying to make sense of it (good luck), I usually try to let the animation guide me.

Placing the current frame marker at the beginning of this sequence, I step through it a frame at a time with the right arrow key. Doing it this way, it's pretty easy to keep track of what is what when it comes to the arcs on the screen. An alternative way to deal with this is to switch to the **Around Frame** mode in the **Motion Paths** panel. The **Before** and **After** values specify how far back and forward in time from the current frame to generate paths for the selected bones. Using this mode, you can step through complicated portions of your animation and only display a small part of the whole motion path. As you change the current frame, pieces are added to and removed from the calculated path so that it always maintains the designated range around where you are in the time line. Fig. 7.22 shows this mode.

Once I've examined the head and body control paths, I select those bones and clear the paths by pressing the **Clear** button on the panel. The buttons work for selected bones only. Then, I calculate the paths for the hands. The result can be confusing, so I sometimes do them one at a time. The nice little loops in the path in Fig. 7.23 show that we were doing something right during the opening walk cycle. You'll also notice in the figure that there are a lot more sharp points than on the body control and head paths.

FIG 7.22 Head Motion with and "Around Frame" Path, Showing 20 Frames on Either Side of the Current One.

FIG 7.23 The Hand Path.

A close look at the motion surrounding these points shows that they are not a problem. What we are looking for are sharp angles that occur within the middle of a motion. After scrubbing through the timeline around the identified sharp points, I see that the points indicate places where the hand was in a "hold," and that the motion coming into and moving out of the hold works nicely with an arc.

You can always go back to smooth out arcs and fine tune overlap. By the time you're done with it, the Action Editor can get to be a mess. That's okay, because we're very close to calling this "finished." There's more to do, but the main motions have been nicely timed, posed well, had their velocities adjusted, been broken down if the motion required guiding, been analyzed for needless synchronization, and had overlap built into them.

When we created our poses way back in Chapter 4, we were careful to keep the character in balance physically. In the next chapter, we'll be working to balance the character's main motions both visually and in time with secondary action.

A Second Pass

In **Fig. 8.1**, Meyer is waiting for his grandmother in an Emergency Room. Every few seconds, he glances toward the ER door. If you were drawing storyboards, posing, and animating a sequence like this, you would probably draw several "look" poses for him to use throughout the shot. Mostly, they are just movements of the head and the upper body. Animated just like that, it's a lame performance.

You could follow all the steps we've laid out so far in this book and it would still be lacking. That's because up until now, we've only been concerned with the primary actions: the reach, the walk, the hand movement, and the jump. But what else is going on with the character?

The principle of **secondary action** comes to the rescue. Secondary action refers to the "extra" motion that is happening to the character, above and beyond the main one. Meyer, while he's waiting, might drum his fingers on his leg. He might shift his feet around to get comfortable. If he had a face, he might roll his eyes, or make other expressions of frustration or concern. The video, *Kicking a Ball* is an older animation that I did. Note the twiddling fingers on the character right at the beginning, as he concentrates on what

FIG 8.1 Meyer, Waiting.

he's about to do. That's secondary action. Find yourself stuck for ideas as to what your character should be doing? Find some references. Go to a lobby and watch real people sitting around. Hit up You Tube for some crowd footage. What do the people do? Do they move more or less often than you would think? What do their little actions tell you about them?

Back to our example animation, we find that there are only a few spots where this kind of action would be appropriate: when Junot stands and regards the pedestal and just before and after she touches the light. The rest of the time, her whole body is in motion (walking, stopping, jumping, and slinking), which doesn't seem to afford us any use of this principle. If we make a couple of tweaks to our character structure though, you'll see that there are opportunities. Another aspect of secondary action beyond the deliberate things we might do with parts of our body aside from the main action is the involuntary elements. We breathe. Our characters should too. If we have long hair or wear a long coat, it should move naturally. Note that some animators refer to this sort of thing as overlapping action because of the nature of the motion of hair and long cloth. While it's true that the techniques used to animate such things fall under the principle of overlap, as a part of the animation process they are secondary to the primary action of the character, so I include them here.

Fig. 8.2 shows Junot with a fake head of "hair". Yes, Blender can do actual hair, but we're keeping with the simplified feel of the rest of the model. Also in the figure is a new controller in front of her chest. Moved up and down, it controls breathing. If you play with this control on your own, be sure to note how the breathing deformation is done. When we breathe normally, our stomach pushes out a little, with the ribs expanding forward only the tiniest bit. There is also some lateral expansion. I've seen too many characters that "breath" by puffing out their chest, and it's just wrong.

We'll come back to the involuntary types of secondary action in the second half of this chapter. For now, let's work with the deliberate motion.

FIG 8.2 (a, b) Junot, Now with Hair!

Deliberate Secondary Action

Adding secondary action gives you one more chance to bring out the character. What is their body doing when they are paying attention to something else? What are their habits? Are they nervous? Imperious? These traits will be enhanced by the choices that you make.

In Junot's case, I've gotten the feeling from animating her for a while that she's kind of a goofball. A little bit spastic, if you will. So, while she is looking at the pedestal, what is she thinking about and how will that be reflected in her secondary action? Owing to the fact that I'm a bit of a dork myself, I've decided that she is going to do what I would do: stroke her chin in an overly dramatic fashion, as though to say "Hmmmmmmm! What's this?!"

Checking the timeline, we have from around Frame 90 to Frame 120 to do this. Not a lot of time. Looking at the Action Editor, shown in **Fig. 8.3**, we make sure that no intermediate keys will interfere with us. We need to check the hand and finger bones. Any keys that are found in that frame range will have to be either removed entirely or pushed to the sides if the poses they represent are crucial to action either before or after the new motion. This is a general rule when inserting something new like this. You don't want to be keying along and run into some pose you've set and forgotten about.

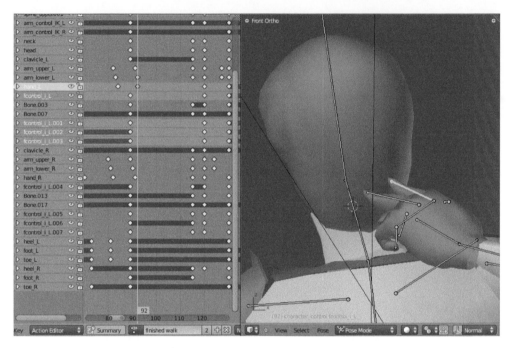

FIG 8.3 The Action Editor and 3D view, Removing Intermediate Keys.

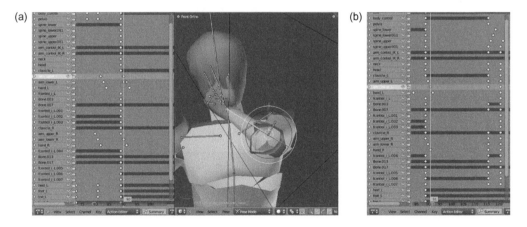

FIG 8.4 (a, b) Reposing the Hand, then Moving the Single-Frame Pose Keys to Match the Original Overlapped Keys.

The last hand key is on Frame 92, so that's where we'll start. On that frame, I adjust the hand into the new pose (Fig. 8.4a). As I do this, I realize that I'm going to have to move the whole arm so the hand can maintain contact with the chin. Looking back to Fig. 8.3, you can see that the arm keys have been staggered by the overlap process, falling on Frames 90 and 91, and not 92. If we just moved the arm it into place on Frame 92, it would give an additional motion that we hadn't planned for.

(a)

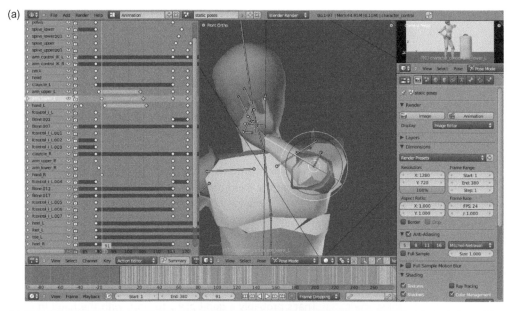

(b)

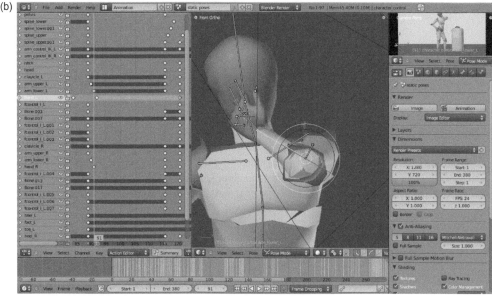

FIG 8.5 (a, b) Changing the Starting Pose and Copying It Forward in Time.

So, we have to go back two frames and position the arm properly. Then, the lower key is moved one frame to the right, taking over the position of the offset original key for that bone. Finally, I duplicate the keys for the hand and both arm bones (**Fig. 8.5a**), and move them to the right until they each take the place of the next key in line (**Fig. 8.5b**). This holds the

arm stationary relative to the rest of the body for this section of time, giving us a good baseline to work with.

It's important to keep this sort of thing in mind when working with an Action Editor that is increasingly full of keys. Before you make any additions or changes, take a look at the Action Editor, how the keys for the bones you'll be affecting are positioned, and what effects adding new keys into the mix will cause. Likewise, once the fingers are posed, I copy the keys for them over to Frame 115 (**Fig. 8.6**) so that I'm working with a consistent baseline.

Scrubbing the frame marker back and forth between Frames 92 and 120, I see that the hand pose holds steady against the chin. That's the starting point. The motion I'm going for will have the hand draw toward the chin, with the fingers and thumb spreading apart as they "slide" up the jaw. An adjustment to the arm, hand, and fingers on Frame 98 gives the pose in **Fig. 8.7**. Then we simply duplicate the keys from Frame 92 and 98 and move them 12 frames to the right. This gives the key configuration also shown in the figure.

That's probably a good place to start, with the hand in first position, then second, then first, and second again and ending in the first. Each is separated by six frames. It provides two full iterations of the motion. Playing it back in real time though (*Double chin*), it shows that the motion is way too fast. It looks like there will only be time for a series of first, second, first.

Changing the keys around to create that sequence yields **Fig. 8.8**, and the motion in *Single Chin*. The middle pose is there and gone before it really registers. A short "hold" to the rescue. For something this brief, taking up this small amount of screen space, and already incorporating some overall body motion, we don't need to concern ourselves with building our usual moving hold. Simply duplicating the keys and covering a few frames worth of time will be sufficient. The result is the video called *Chin Rub*.

FIG 8.6 Making the Fingers Stationary.

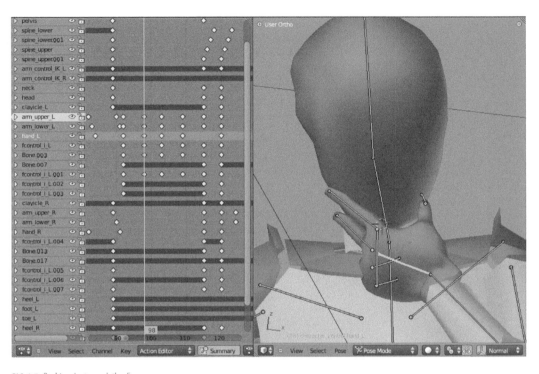

FIG 8.7 Pushing In toward the Face.

FIG 8.8 Before Adding the Hold.

Of course, you should let your time constraints dictate decisions like this. If you have all the time in the world to craft the animation, by all means, make each hand pose individually instead of duplicating the keys like we just did, for both the chin rub and the hold. However, if there's any question as to how much time you will be able to put into any given shot, it might be better to use time savers like this when you can, make a note of them, and then revisit them later if you actually have some time left over.

There are really no chances for exaggeration, squash and stretch, anticipation or follow through with this new motion. It's important to run down the list for yourself though, in case one of them could apply.

Unfortunately, with the compressed time frame, this new secondary action doesn't quite bring out the character like I had hoped. Of course, if I wanted to make this small motion into a character moment, I could decide to slide all the keys in the animation from this point forward to the right by a second or two and really make it work. As it is, I'm content for the purposes of the exercise to let it slide.

What Not To Do

Scrubbing over the timeline between Frames 215 and 235, I look at the less-than-one second amount of animation that represents Junot hesitating before she touches the light. In my initial considerations, this seemed like another opportunity for some secondary action. Upon further review, it appears that that would be a bad choice. First, there isn't much time. Second, both hands are already engaged. Finally, the only thing that might fit—an adjustment of the head position—would throw off the contrasting next pose which has her leaning backward and pulling her head away from the light. So, I decide that there won't be any secondary action there.

It is important to note that what you leave out can be as valuable as what you put in. Not every principle of animation needs to be packed into every single second of a shot. The principles should act as a guide, giving you targets to shoot for, but that guide must be used with a sense of practicality.

Another Example of Deliberate Secondary Action

In the next section of the animation, Frames 240 to 260, Junot has touched the light and is leaning back in anticipation of something bad happening. She has a free hand, which makes this a nice opportunity for secondary action. Fig. 8.9 shows the general pose. Her right hand is held up in a defensive fashion. To augment that, I'm going to have her wave it back and forth slightly.

FIG 8.9 Junot Waiting for the Hammer To Fall.

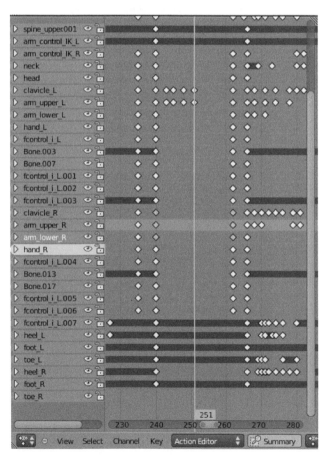

FIG 8.10 The Frame Range for the Movement.

We'll follow the procedure from the previous example. Checking the Action Editor, shown in **Fig. 8.10**, we see that there aren't any keys for the right arm or hand within the specified frame range. That's nice, because it means we don't have to delete anything or do any shenanigans to create a hold across those frames like we did last time.

Doing this movement myself, I try to count how many back-and-forth's I get in a second. (Check out some videos of people waving if you're not a good self-reference.) We only have twenty frames to play with, so this has to be quick. However, unlike last time, we're not working in strict coordination with another element of the character like the face, so we can stand to cheat the beginning of the motion a little if we want to. In other words, Junot can start the "warding wave" a few frames before Frame 240.

I learn two things from doing this action with my own arm. First, I get about six motions in one second (left-right-left-right-left-right). Second, this kind of wiggle wave is mostly accomplished by rotating at the wrist. There is almost no other arm motion involved.

With that in mind, I rotate the hand just a bit on Frame 240 (**Fig. 8.11a**), then again in the opposite direction on Frame 244 (**Fig. 8.11b**). **Fig. 8.12** shows the Action Editor with these two keys highlighted.

Then, I select those two keys and duplicate them twice to make the motion repeat. The result can be seen in *Warding Off Evil*. The motion of waving is repetitive: a cyclical thing like walking. When people do these types of repetitive motions, they are less likely to incorporate holds, and to exhibit the mostly stop-and-go characteristics of regular motion. Because of that,

FIG 8.11 (a, b) The Two Waving Poses.

(a)

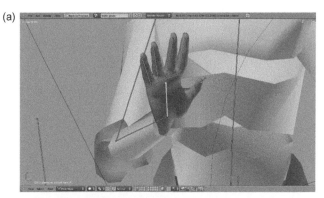

(b)

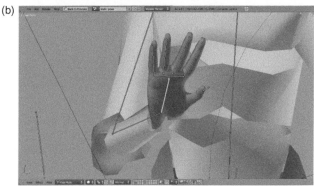

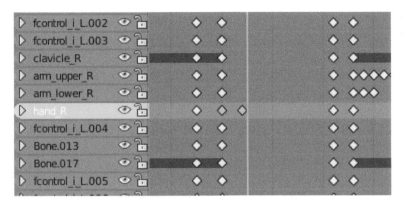

FIG 8.12 The Two New Keys in the Action Editor.

the wave looks pretty good with only these few simple keys. If you were doing this in a very cartoony fashion and wanted to get fancy, you could incorporate some overlap into the fingers so that they lagged the main hand motion a little.

Once again, you don't necessarily have to repeat the exact same keys by duplicating them in the Action Editor to achieve this motion. You could set each one as its own pose within the 3D view.

Two final notes on deliberate secondary action: first, be careful not to completely isolate the motion. For example, a character that taps its foot as secondary action should not just move the foot. Yes, the rig is built so that you can do this, but when you try it in real life, you see that the motion propagates up the leg subtly. Motion in a solid body does not occur in a vacuum. Second, remember that this is *secondary* action. Whatever you decide to do with it should not overthrow the primary action. We're trying to add life and believability at this stage, and not redefine the storytelling and character goals of the animation.

Involuntary Secondary Action

The most obvious type of involuntary secondary action is breathing. If you enable the second bone layer for Junot's controls, you will see a new bone in front of her chest, like the one in **Fig. 8.13**. This bone has been constrained so that it will only move a short distance forward and back. Doing so activates shape keys on her torso that cause her stomach, chest, and back to expand as though she is breathing.

With the right kind of control in place, adding breathing to your animation is nothing more than exercising some basic key framing skills and using a little common sense. Here are some practical notes for animating breathing:

• Breathing is not a pure in/out repetition. Under general circumstances (such as sitting and not doing anything) our breath has a brief intake, followed immediately by an outflow, then a pause. At rest but awake,

FIG 8.13 Junot's Breath Control.

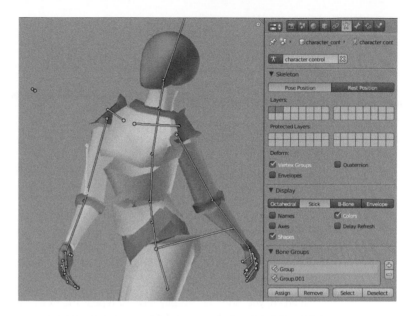

FIG 8.14 Breathing at Rest.

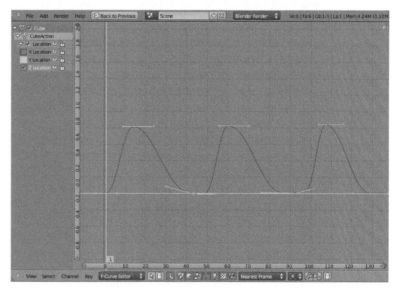

we repeat this cycle about every two seconds. **Fig. 8.14** shows a curve indicating the cycle, with the top of the curve representing a fully drawn (in) breath.

- When working hard (a fast run, lifting something very heavy), we draw a large breath rapidly and blow it out more slowly. The *in* is much faster than the *out* (Fig. 8.15).

- A sleeping person's breathing cycle can slow down drastically, with most of the extra time coming in the "pause" portion (Fig. 8.16).

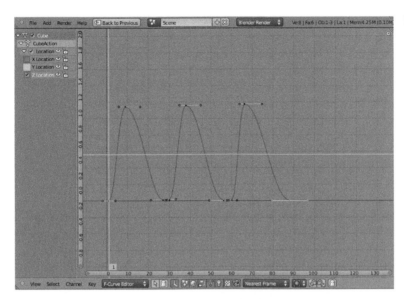

FIG 8.15 Breathing with Hard Work.

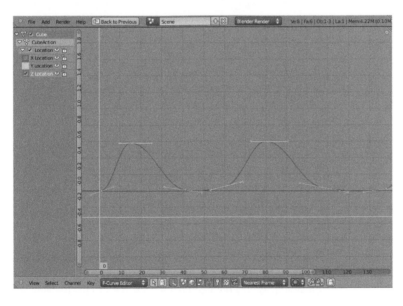

FIG 8.16 Sleeping.

- The only time someone will exhibit rapid in/out breathing without a characteristic pause at the bottom is when they are panicking and/or badly injured (**Fig. 8.17**).
- The size of your character will affect their overall base breathing rate. Larger characters (a wrestler or an elephant), will respire more slowly than a child or a hedgehog.

Analyzing the animation we've done so far, we'll give Junot a standard "at rest" breathing pattern as she walks in. Then, we'll have her draw a fairly large

FIG 8.17 Panic Breathing.

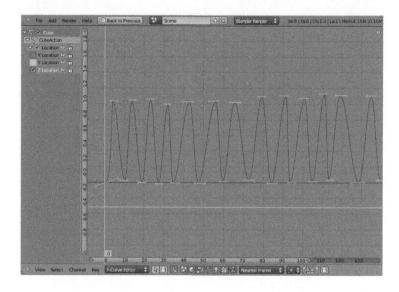

FIG 8.18 Junot's Breath Curve.

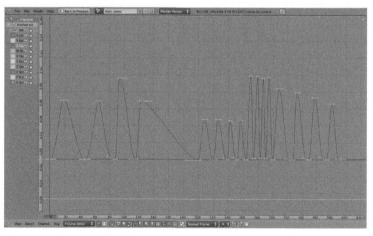

breath and force it out, followed by a no-breath pause as she contemplates the pedestal. While we're zoomed in to the close up, we can ignore the breathing, as only her hand is showing. Back to the medium shot, we have her preparing to touch the light. I'll give her a slightly more rapid breathing pattern than before, because she is anxious, but it will still be shallow, as she is not really exerting herself. When the alarm goes off and she jumps backwards, we drop her into panic breathing. She is completely surprised. Finally, the panic breathing resolves into something midway between "at rest" and "working hard." She isn't truly exerting herself, but she is definitely in fighting mode and coming down off her momentary adrenaline spike.

You might once again be wondering if you have to actually consider all of this stuff. The answer, again, is yes. You do. **Fig. 8.18** shows the entire

F-Curve for Junot's breathing. The first part of the animation, up until the missing section we'll be doing straight ahead, is shown in *Breath In*.

Automating Secondary Action

Let's add one more thing to Junot: hair. Okay, it looks funny, but it's there for a reason. A character with long hair or a long coat or dress, a mane, a tail, etc., has an additional pass of secondary action that will need to be added. If we were to extend Junot's control structure into the hair, it might look something like **Fig. 8.19**. Personally, I don't relish the thought of painstakingly animating that to properly react and follow through along the course of the animation. Not that people haven't done that very thing. In fact, until recently, animating such things by hand was the only way to do it. Even now, the simulations we'll learn about can be so difficult to tame that you might end up doing it the "old fashioned" way out of sheer frustration.

Now, we can get a much more accurate (though not quite as controllable) form of animation by using simulators. Blender includes simulators that can help with secondary action for cloth, hair, and soft bodies (i.e., flab). As we're not using Blender's "real" hair on Junot and her hair is a single mesh blob, we'll use the soft body simulator on it as an example.

First, some general notes about using simulations to generate your secondary motion: when animating characters and other things by hand, the trick is to achieve believability. It's easy to make your character hit a certain pose on a certain frame, but doing the transitions is where the hard work kicks in. Simulations are the opposite. Believability is built in. The simulators are designed to produce accurate results (and by "accurate,"

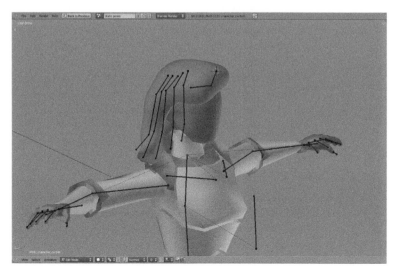

FIG 8.19 Junot's Hair, and Control Bones.

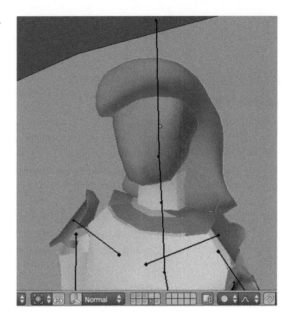

FIG 8.20 Junot's Hair, on Layer 14.

I mean correct for their settings). The hard part lies in making them behave. It will be almost impossible to make hair fall, for example, in a certain way on a certain frame. Instead of performing iterations of changing key frames, adjusting timing, and testing poses, you'll be trying different combinations of simulation settings.

To start working with Junot's hair, switch to Layer 14 in the 3D view (**Fig. 8.20**). As mentioned before, the hair isn't realistic, but in keeping with the style of the character. With the hair object selected, go to the **Physics** properties, find the **Soft Body** panel, and click the **Add** button. This adds a soft body simulator to the hair object. The new set of controls is shown in **Fig. 8.21**.

Like many types of mesh modifiers, the deformation of some simulators can be controlled by vertex groups. In the case of the soft body simulator, we want to prevent the hair on top of the head from moving around, while letting the longer hair in the back do its own thing. You might wonder if it isn't better to just set it up the way it would be in the real world (i.e., all hair follows the same set of rules regardless of its location on your head) and let the chips fall where they may. Remember what we said about simulations though: they are notoriously hard to tame. If dynamic motion of short hair on top of the head isn't important, it's better to not have to deal with it at all.

So, I've created a vertex group for the hair object called **hairbounce**. **Fig. 8.22** shows the group displayed in Weight Paint mode (accessible with Ctrl-Tab). For soft bodies, the portions of the mesh that don't receive secondary motion are red, while the most flexible portions are blue. For example, if you were creating a chubby character and wanted certain

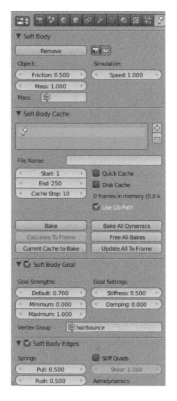

FIG 8.21 Enabling Soft Body Simulation.

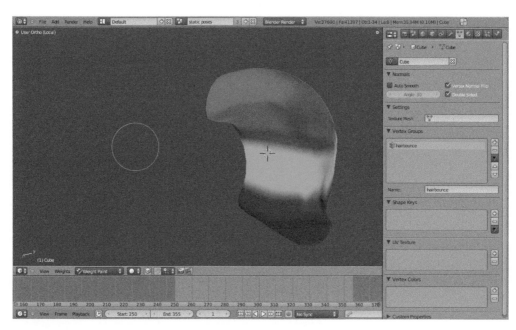

FIG 8.22 The Vertex Group for Junot's Hair.

portions of their body (stomach, chest, etc.) to be driven by the simulator, you would weight paint the whole body red (100%), and then paint blue (0%) onto the areas that should bounce. To use this vertex group, simply choose it on the **Vertex Group** selector in the **Soft Body Goal** panel.

In very simple situations like this—trivial vertex count, collisions not enabled—the simulation can run very close to real time. If you've been using **Frame Dropping** on the Timeline view though, set it to **No Sync** right now. Trying to run simulations in real time with **AV Sync** or **Frame Dropping** enabled will cause a mesh catastrophe, like the one in **Fig. 8.23**. On the **Soft Body Cache** panel, change the **Cache Steps** setting to **1** instead of **10**. With only the default settings for soft bodies, press Alt-A in the 3D view and watch what happens. It should look something like the video *Basic Bounce*. If the top of the hair starts bouncing off the head entirely, then the simulator flat out got it wrong. To try again, just change one of the settings in the **Soft Body Goal** panel like **Default: 0.700** a click up to **0.800**, then back. Press Alt-A again.

When the simulator just seems to get it wrong (i.e., ignoring our vertex group to keep the top of the hair in place), you need to refresh the simulation by changing a setting, like we just recommended above, and rerunning it.

Even when it works here though, the results are basically useless. If you watched the video, you'll see that the back of Junot's hair starts revolving like a gymnast on the high bar and pretty much doesn't stop. It needs two things: much less energy and the ability to actually collide with body parts. Let's deal with the "energy" problem first.

As collision is computation-intensive, I usually try to get the overall motion and feel of the simulation looking right before I add collision. It's faster and easy to test different simulation settings without having to wait for the sometimes lengthy collision calculations.

 FIG 8.23 Crazy Hair!

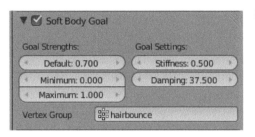

FIG 8.24 The Soft Body Goal Panel.

To work with the settings, you need to know how soft bodies "think." They consider everything in terms of the starting mesh shape, which they call the "goal." On the default simulation, with the Goal panel shown in **Fig. 8.24**, the controls allow the simulation to try to hit that goal shape anywhere from 0% to 100% of the time. Those values are entered on the **Minimum** and **Maximum** controls. With this configuration, and the way we've created the vertex group, the hair in back is going to be influenced by the original shape 0% of the time (i.e., it's blue in the weight paint, and the minimum possible goal value is 0.000 or 0%). If we want to force her hair to actually keep its shape in the back but just move around a bit, we need to raise the value of the Minimum control significantly. Let's try 70%, or 0.700.

The video, *Staying in Shape* shows the result of this change. It's still way bouncier than real hair though. Moving up to 0.9 for the Minimum value tames things down even further. Even with that modification in place though, the hair still has too much life. When someone with longer hair tosses their head, the hair moves to follow, and quickly finds a settling point and stops. Junot's hair keeps bouncing back and forth. The way to control how quickly motion settles in a simulation is with the **Damping** control. Damping values run from 0.0 to 50.0. Using the "Rule of Halves" (which you can learn about in the sidebar), I arrive at a Damping value of 37.5. Now, running the simulation produces the video called *Settle Down Please*.

That's actually a decent result. The hair has some bounce to it, but doesn't ever go wild. It also settles down fairly well. With the actual dynamics worked out, we can attempt to control the result a little better by adding collision.

The hair should be stopping when it hits the neck and shoulders, or the top of the head hair itself if it's flopping up and around. To make this happen, we select the neck, upper body, and "collar" objects and enable collisions for them. This is done for each object individually by selecting it, pressing the **Add** button on the **Collision** panel of the **Physics** properties, and then heading to the object's mesh modifiers panel. The modifiers panel for the neck object is shown in **Fig. 8.25**. Note that in the modifier stack, the Collision modifier comes after the neck's Subdivision Surfacing modifier. This is bad. Every level of subdivision multiplies a mesh's vertex count roughly by four; so with subdivision set at 2 like it is here, the simulator is going to have to calculate collisions against something like sixteen times as

The Rule of Halves
When you have to find a suitable value for a setting whose effects you are not familiar with, you can use the rules of halves. You test the one extreme to see its effect, then the other, and then halfway in between. Using the Damping value of the Soft Body simulator as an example, you would do a test with a Damping value of 0.0,

50.0 (the maximum) and 25.0. Looking at the middle (25.0) result, you decide if what you're looking for is closer to the 0.0 or 50.0 result. If it's closer to 0.0, then you try halfway between 0.0 and 25.0, or 12.5. If you were looking for something closer to 50.0, you would try a value of 37.5 halfway between 25.0 and 50.0. It's up to you how far you want to take this and what you consider an acceptable result. You keep refining your test, moving halfway toward one of your previous results, until you find something that looks good enough.

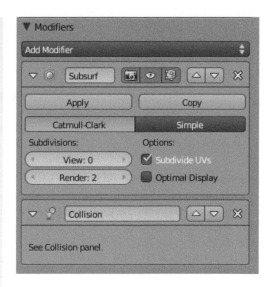

FIG 8.25 The Modifiers Panel for the Neck.

much information. The very simple solution is to use the arrows on the Collision modifier's header to move it above the Subdivision modifier in the stack. This is an important check to perform every time you enable collision for an object. Failure to do so can result in painfully slow calculations.

I repeat this process for both the upper body object and the collar. I could have done it for the shoulder objects and for the head itself, but I didn't. Here's why: the more collisions the simulator has to calculate, the slower it's going to be. The slower it is, the less testing and tweaking time you have to get things how you want them to be. It could be that we'll need to have those objects enabled as colliders, but the best approach is to try it first with as few as possible, and only add more if you really need them. I'm guessing that if the hair can't pass through the neck, that will probably also stop it from passing through the back of the head. Also, while the shoulders may touch the hair in a couple of frames with an extreme pose, the odds are that the contact will be fleeting and their addition as colliders would produce an almost un-noticeable result.

Go back to Frame 1, change a setting in the Soft Body Goals panel and change it back to ensure that the simulator knows we want to recalculate, and press Alt-A. It's significantly slower this time, and the simulation turns to garbage very quickly. The video *Stuck Hair* shows it from the reverse angle this time. In **Fig. 8.26**, you can see what happens: the hair begins the simulation already partly inside the neck, and it just "gathers" the rest of it up as things proceed.

We told you that dealing with simulations can be a pain. The most obvious thing to do is to turn off collisions for the neck object and run it again. It actually works pretty well, as you can see in the video *Super Collider*. We're not

FIG 8.26 But Mom, All the Other Girls Do Their Hair Just Like This.

FIG 8.27 Meyer, Painted for Jiggle.

going to do it here, but if you really wanted to refine the simulation so that the hair works well with a colliding neck, you would have to go back to the original hair model and change it so that it doesn't begin its life already intersecting the neck. Then, you would re-enable collisions on the neck object.

Once you've learned the process, it becomes easy to use the soft body simulator to add this kind of secondary motion to your animation. Let's say that we want to apply our animation to Meyer instead of Junot. Use the skinned version and apply some soft body secondary action to his stomach.

On Layer 1 of the Chapter 8 demo file is the skinned version of Meyer. Meyer and Junot share an armature, so we don't have to worry about transferring the animation to a different rig. The Meyer model in the file has been fattened up just a bit, giving him a pot belly. I've also added a new vertex group to the model, called **flab**, assigning it a strength of 1.000 across the entire mesh. In **Fig. 8.27**, you can see the **flab** group in Weight Paint mode. I have used the painting tools to make the stomach blue, and add a little green to the chest. Remember that red represents complete solidity, and blue represents complete flexibility.

In the Soft Body controls, the only modifications I make are to select the **flab** vertex group in the Soft Body Goal panel, set the Minimum goal value to 0.950 (very tame), and Damping to 12.5 because we want it to actually jiggle a little. And for a first try, it's really not too bad, as you can see in *Chunky Meyer*. For a real production, you'd obviously want to play around with it some more.

For something a little different, you can try Blender's cloth simulator on the exact same set up. Remove the Soft Body simulation from Meyer's mesh by

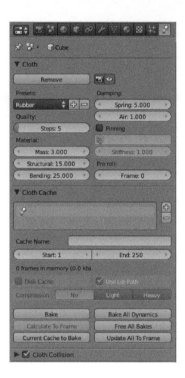

FIG 8.28 The Cloth Simulator.

clicking the **Remove** button on the main Soft Body panel, find the **Cloth** panel, and add a new cloth simulator. That's right—we're going to add a cloth simulation to Meyer's body.

The cloth settings, shown in **Fig. 8.28**, are quite a bit different from the soft body settings. However, they are capable of producing a similar (but different) range of secondary action effects. There was some internal development discussion a while ago that suggested removing the soft body simulator altogether, and only leaving cloth. This is because, despite its name, the cloth simulator is good for a variety of effects beyond, well, cloth.

The cloth simulator comes with a number of presets. For Meyer's body, we'll choose **Rubber** and then make two alterations. The first is to add **Pinning**. Pinning in the cloth simulator is very similar to the Goal concept in soft bodies. A fully pinned vertex will not experience any of the simulation, just like a 100% goal vertex does not receive any soft body motion. So, the vertex group we created for Meyer in the previous example still works. Enable Pinning and select the **flab** vertex group. The only other change is to disable **Cloth Collision**. The flabby bits won't be hitting anything important, so why waste the calculation time?

Pressing Alt-A in the 3D view should give you something like *Cloth Sim Meyer*. Things aren't quite as springy in this version. The chubby parts tend to act more like a flexible layer (like rubber) than like a solid but gelatinous mass.

Neither approach is right or wrong. What's right for your particular animation is simply what looks right.

You might be wondering at this point "What about real cloth?" You're not always going to be animating characters that are made of broken up pieces, skinned with a weird blue sheen and running around buck naked. Eventually, they're going to have to wear clothes.

The recommendation that I usually give is to not use the cloth simulator to drive the clothing of your characters. It's a tempting thought: model the body and then the clothes on top, apply the cloth simulator with the correct settings, and you've got a winner. In reality, this is pretty far from the truth. There are serious issues with Blender's approach to cloth sim that show badly when cloth needs to bunch: at knees, arm pits, and elbows. You can fight with it all you like, but the best approach for now is to make your character's clothes "be" the body itself, and only use the cloth simulator for secondary action on the pieces that will hang, flap, and ruffle in the wind. If your character wears a long coat, don't even bother putting arms or most of the body underneath. The coat becomes the body, for purposes of animation, and you can let the cloth simulator handle the bottom portion that hangs.

I've outfitted Junot with just such a coat in **Fig. 8.29**. In **Fig. 8.30**, you can see the coat in weight paint mode, with the "flex" vertex group selected.

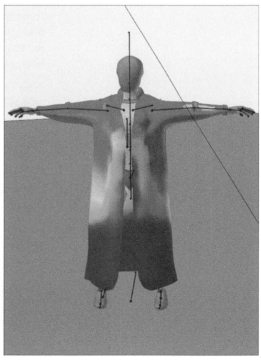

FIG 8.29 Junot's Coat.

FIG 8.30 The "Flex" Group.

As you can see though, even after doing this and playing around with it, the results aren't all that great (*Nasty Old Coat*). The problem is the classic one for simulations. The more realistic you make it, the more processing power and the longer it takes to calculate. This in turn means that your test cycle takes longer, and it becomes harder to "tame" the simulation. In fact, I've generally found the cloth simulator to be more trouble than it was worth, for anything more complex than a blanket, cape, or flag. Every time I've tried to use it in a production environment, I've ended up scrapping it in favor of a non-simulation technique. This is also the reason that larger productions devote entire departments to running simulations: it's tough.

Real Hair

When it comes to secondary action, one of the hardest effects to hand-animate is real hair. Unfortunately, because of the simulation trade-offs that we mentioned before, getting good moving hair out of Blender's simulators isn't exactly a day at the beach either. We're not going to deal with how to make hair, as there are ample resources elsewhere for learning the hair creation and styling tools.

First, watch the video, *Check Out My Hair*. In the Chapter 8 demo scene file, use Layer 5, which contains the Junot model with "real" hair. **Fig. 8.31** shows a sample frame.

To enable secondary action on an existing hair system, select the object that is the hair emittor, which is the head on Junot in this example. Enable the **Hair Dynamics** option, on the panel of the same name in the Particle properties. **Fig. 8.32** shows the panel.

Once you activate it, you get a nice set of options in the panel itself and an additional **Cache** panel. The defaults are shown in **Fig. 8.33**. Hitting Alt-A to play in the 3D view produces something very much like our first attempt at soft body simulation. The hair bounces nicely, but it's way too much and passes right through the head. Just like before, we'll try to get the motion under control before we add collision.

I could just tell you what settings to use, but they won't be appropriate for every model and situation. Also, I'd rather teach you how to delve into a

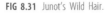

FIG 8.31 Junot's Wild Hair.

FIG 8.32 The Hair Dynamics Option under the Particle Properties.

FIG 8.33 The Default Hair Dynamics Panel.

control panel like this one with almost no knowledge, and be able to come up with something good.

Let's start at the beginning: **Stiffness**. It's the first control, so let's assume that the developers put the most important thing in the most prominent position. Going back to the rule of halves, I notice that the control goes the whole way to 50.0. Trying that, I get a wild result, with hair extending out from her head and pulsing like some kind of dying star. Halving the value to 25.0 tames **things down a little, but it's still crazy. 12.5 brings the same result. On a hunch, I** drop the value to 1.0 and give it a try. It looks just about right. Why did I abandon the rule of halves like that? Well, I was

thinking that the developers probably wouldn't have included an entire range of values that were basically useless *on purpose*, so I assumed that they had made a mistake. Considering then that a range of 0–50 is ridiculously inappropriate, and it's even bad as low as 12.5, where should I go? How about good old 0.0–1.0? I tried 1.0, and it worked.

The video, *Hair—Stiffness 1* shows the simulation with only the stiffness changed from the default. We're off to a great start!

The next setting is **Mass**, with a default value of 0.3. The maximum is 10.0, so we give it a try. It produces motion with way too much energy. The hair starts to pinwheel again. So, it appears that this setting helps to control how pronounced the motion is. It makes sense as hair with more mass will have more momentum, and consequently end up flying around more with sympathetic motion. We really don't want *more* motion than we have with the default value, so it's not even worth trying any other values between 0.3 and 10.0. Trying the rule of halves with 0.3 as our maximum takes us to 0.15 on our first stop. The hair goes crazy. Halfway up at 0.225, it stops going crazy, but appears to be still just on the verge. With those experiments done, I decide that maybe I'll stick with the default for now. We've learned something though: setting parameters outside of the good boundaries doesn't just produce a poor result with hair dynamics, it produces something that is radically unacceptable. To see what that looks like, check out: *Ms. Explosion Head*.

Applying the rules of halves to the **Bend** property, I'm faced with another strange decision. The default value is set to 0.5. The maximum value is 10,000. That makes me wonder again about the usefulness of that entire range. Just for kicks, I hit Alt-A with Bend set to 10,000, and the result is as expected: a hair bomb. Changing it to something reasonable around the default value (0.1, 1.0, 2.0…) doesn't seem to produce anything noticeably different than the default. So, another control stays with its default value.

The next one down the line is **Internal Friction**. I'm going to take a guess and hope that this refers to the way that the hair interacts with itself. Perhaps high internal friction will cause the hair to burn off some energy as the hair rubs against itself. Maxing the value out to 1.0 seems to do just that! The hair seems to hang together better, acting more like a set of affiliated, related strands, than just a bunch of strands that are doing their own thing and happen to be going sort of the same direction. Halving the value to 0.5 produces nothing better, and in fact I find myself wishing that I could push this value higher than 1.0, because I would like a little more of the effect. With that in mind, I choose 1.0 for the Internal Friction value. Watch *Hair—Internal Friction 1* to see it in motion.

Collider Friction is next, but as we don't have a collision object yet, we won't see any effects. Let's skip it and move on to the set of **Damping** controls. The first one is **Spring**. Damping in simulations refers to how

much energy is artificially sucked out of the simulation at every step, and directly affects how "bouncy" it appears. High damping should result in almost no bounce—a quick dissipation of energies. Low or no damping would produce lots of bounce and ongoing motion. If you think about hair, it doesn't really rebound all that much. If there's secondary motion involved, it finishes with its momentum and pretty much stops. Let's crank Spring Damping to the max (50.0) and try it. Looks good. Halving the value to 25.0 doesn't make things better. I try one more iteration at 37.5 just to be sure, but I still like 50.0 best. That's where I leave it. You can see it in *Hair—Spring Damping 50*.

I could play around with the **Air** control, but I decide not to for two reasons: First, I like the motion a lot already. Second, the tool tip for Air reads "Air has normally some thickness which slows falling things down." I'm guessing that I don't want to go fooling around with the density of air, and that the default value is most likely chosen to mimic the air that we're already familiar with.

So, all that's left to do is to enable the collision object. In this case, it's the head itself. So, take a trip back to the Physics properties and hit **Add** on the **Collision** panel. Don't forget to revisit the modifiers panel also. Modifier order is important, especially when dealing with collisions. I move the collision modifier the whole way to the top of the stack so that collisions are calculated before subdivision surfacing (which, recall, multiplies the mesh counts by 16). The resulting modifier stack is shown in **Fig. 8.34**.

FIG 8.34 Moving Collision to the Top.

With collisions in place, the simulation is a little slower to run on the computer that I use for general work, but it's still quite tolerable. The result is the rendered video from the beginning of this section.

If you ignore all of the trial and error that we did, we only meaningfully altered three of the available settings. And, the next time we need to do hair dynamics, we'll have a good place to start, and a nice methodology for approaching changes. For the amount of work we had to do, the results are great.

Conclusion

There are two main types of Secondary Action: voluntary and involuntary. Voluntary secondary action encompasses any muscular and skeletal motion that occurs while your character does something else. It might be a tapping foot, an idle action while the character is at rest, or anything that adds to the overall motion of the character that is not a part of the main action. Involuntary secondary actions are those things that just happen: breathing, flowing hair, bouncing flab. These types of actions can be animated by hand, but are often driven by simulations.

CHAPTER 9

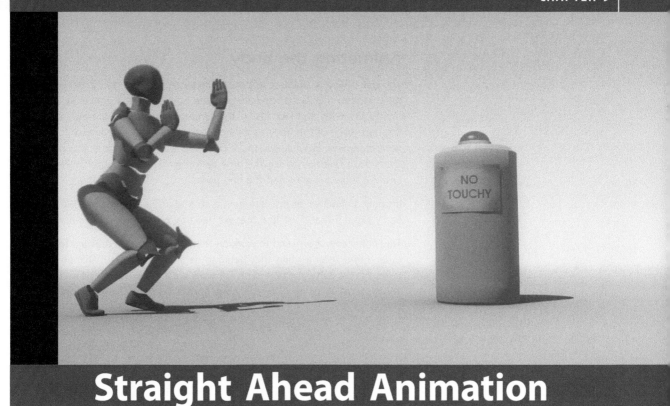

Straight Ahead Animation

So far, we've avoided the great unanimated area between Frames 266 and 301. After some initial attempts at choosing poses and trying to get them to interpolate nicely, it turned out that something else had to be done. The animation was jerky, unnatural, and just plain bad. Now, it's a certainty that someone who is a better animator than myself could have made this section work using the pose-to-pose work flow we've been learning so far. However, the very shortcomings that were noted about the trial animation are the ones that using the straight ahead animation method tends to fix.

Let's tackle this section using the principle of **straight ahead** animation. Instead of meticulously planning each pose of the motion, adjusting timing and velocity, and then going back to add overlap and other niceties, we're going to start at the beginning of the motion and work to the end. Note that this doesn't mean that we have to work with every aspect of the animation all at once. In fact, you can do straight ahead animation in several passes. That's what we're going to do. First, we'll tackle the overall body motion, and then go back for the arms. It's still valid as straight ahead animation, because each time, we'll go from the front of the timeline to the back without jumping around.

Animating the Body

You don't have to animate in passes like we're about to do. However, for a rapid motion that has a fixed starting and ending point, it makes sense to handle the body and legs first. If the center of gravity and the motion through space of the body as a whole are wrong, it's not going to look right regardless of what you make the arms do. Take a look at the video *The Area in Question* to see the time period we'll be working with. **Figs. 9.1 and 9.2** show the start and the end poses.

It's only 35 Frames, or just less than a second and a half of time. We can easily expand that if we find that we need to, but for now, that's our target.

Traditional animators tend to work on "twos," generating a drawing for every other frame. After a while, they begin to naturally think about animation in terms of that particular time slice. For working straight ahead like we're about to, making a new key every two frames is a good thing to shoot for.

FIG 9.1 Start and End Poses for Our Straight Ahead Sequence.

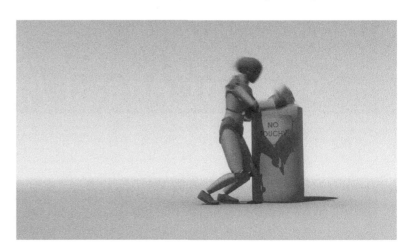

FIG 9.2 Start and End Poses for Our Straight Ahead Sequence.

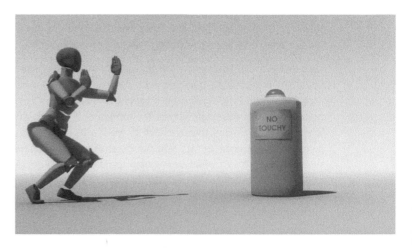

While we won't do the extensive planning for this compared with what we did in the pose-to-pose method, it's good to have at least *something* in mind when you begin. I'm going to try to have Junot leap backwards in surprise, landing in the defensive crouch around Frame 301. When a person jumps, the motion of his/her body is visibly affected by gravity. It's going to be important that the arc of the jump looks just right. You already know how to find out what the arc should look like: go to references. Particularly good for this sort of thing will be videos of skaters and other people doing leaping tricks, regardless of the success or pain of the final result. But even by knowing what kind of trajectory her body will take, how can we accomplish this with a straight ahead approach? Let's prepare our workspace with the **Grease Pencil** tool.

Fig. 9.3 shows the camera view of the scene on Frame 266, with the N-key properties panel on the right. Take a look at the **Grease Pencil** panel. The Grease Pencil allows you to draw directly on the 3D view using a variety of options. It can be used to pass notes about animation to different animators or departments. It can also be used for planning. Click the **Add New Layer** button. This activates a virtual drawing space within the 3D view. **Fig. 9.4** shows the default controls once a layer has been added. To use the grease pencil, simply hold down the **D-key** with the mouse over the 3D view and LMB click and drag. It draws a black line, like the one you can see in the figure.

You might notice that I've drawn a short arc followed by a fairly straight line, ending at the 3D cursor. What I've actually done is to advance the

FIG 9.3 The Grease Pencil Panel.

FIG 9.4 A Grease Pencil Drawing.

frame counter to the last pose, placing the 3D cursor in the center of Junot's hips. Then, back on Frame 266 where I drew the line, I have provided an arc that the main body should follow. When I animate Junot, this will be a guide for her hips—so the jumping motion actually makes an arc.

There is one last thing that we need to do before we start adding keys. If we were to proceed through the timeline two frames at a time from here, we would find that Junot is slowly gliding into her final pose. If I am trying to create a new pose that works with the ones I've just made before it in the time line, I do not want to be fighting with this interpolation. I'd rather create the straight-ahead poses out of whole cloth. So, in the Action Editor, I select all the available keys and change them to Constant Interpolation mode.

Now, with the 3D view maximized, I step two frames ahead and move Junot's body control bone up and to the left in the camera view. This produces **Fig. 9.5.** Easy, right? Here's where we have to start thinking of the rest of the principles. She has just flung herself backward, so her torso should exhibit some overlapping action. I rotate her two upper spine bones forward, as well as the neck and head. Remember that we're leaving the arms alone for now.

I then use the left and right arrow keys to toggle back and forth between this and the previous pose to see if the motion looks correct. This is just like traditional animators flipping back and forth between layers of

FIG 9.5 The First Move of the Animation.

FIG 9.6 Junot's Body with Overlap Built In.

drawings to test their animation. We don't have to deal with the legs and feet yet, because they will be pushing Junot off the ground and remain planted for the moment. In fact, the rig will tell us when to start moving the feet as we process Junot's center of gravity along the arc. **Fig. 9.6** shows the body posed with the bend in the spine.

Advancing two more frames brings us to Frame 270. Moving Junot's body control along the arc again, I'm careful to try to move it the same distance along the arc as I did with the first move. If we're creating keys on equal intervals (every two frames), it's important to keep in mind how position of keys affects velocity. In fact, I might even push her a little bit further on this key than on the last, because with the feet on the ground, she is still accelerating. A jumping person exhibits their highest velocity just before they leave the ground. When I move the body control into such a position

(Fig. 9.7), we can see that Junot's legs have almost snapped past the limits of their IK rigging.

I also continue the motion of the spine, remembering that I already bent the upper portions. So, I give it a little more bend—including the head and neck—but this time, I include the lower spine as well. That's the overlap (Fig. 9.8)!

Two more frames ahead and pushing the body control a little further up the guide line gives us Fig. 9.9. The legs and feet are starting to separate, meaning that it's time to make Junot jump. Keeping in mind the other portion of overlapping action—that limbs shouldn't move simultaneously—we'll make one foot come off the floor before the other.

I take the foot that's nearest to the camera, rotate it in such a way that the toe points toward the ground, and then move it straight up. I mark the

FIG 9.7 Body Positioning.

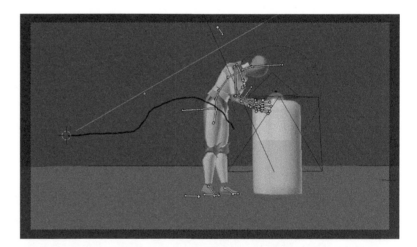

FIG 9.8 The Second Frame, with Spine Overlap.

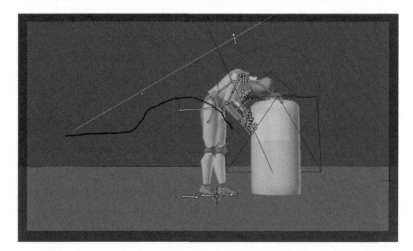

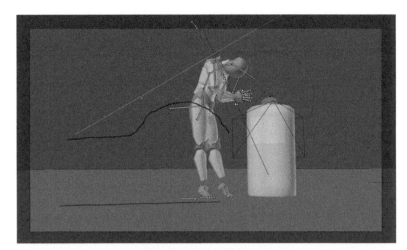

FIG 9.9 On the Next Move of the Body Control, the Legs Begin to Come Apart.

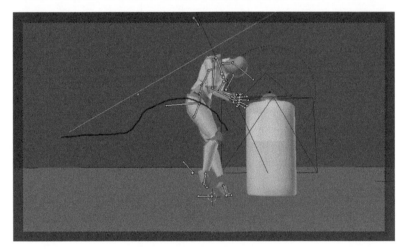

FIG 9.10 Adjusting the Legs, Feet, and Spine.

toe's previous position on the ground with the 3D cursor so that I can point the foot directly at it once it's in the air. I also rotate the foot bone (not the foot controller) of the foot that's still on the ground, so it looks like Junot is rising up on that toe. Of course, we can't forget the spine either. We'll start a reversal of the previous arc of the spine, as she is now starting to react to flying backward, instead of just being affected by the momentum. The movement will begin at the base of the spine and continue upward. In this frame then, we begin to straighten the two lowest bones in the spine and continue the previous curling motion of the upper spine, neck, and head. **Fig. 9.10** shows the final pose for this frame.

Advance two frames and build a new pose. This time, I bring both foot controllers along for the ride with the body control bone. Junot is completely airborne now, so they should move with her. Once again, I mark the old foot position on the ground and make the newly raised foot point

to it. The lower spine continues to straighten, and the motion makes it into the upper spine as well. My guess is that the spine is fairly close to "straight" now. So I actually clear the rotations on the upper bones with Alt-R and create a pleasing pose for them. I do this only because at this point in the animation, it can be hard to tell if things have become oddly rotated, even if they look okay from a certain perspective. Sometimes, it's a good idea to clear a bone's transformation and build its pose from scratch. This pose can be seen in Fig. 9.11.

Performing a rough estimate by looking at the Action Editor compared to where Junot is along the guide line, it looks like we're pretty well on track to have her reach the end of the line by the end of our available space in the time line. Even if it weren't going to work out though, it would be fine. We can scale the keys in the Action Editor to fit the proper timing after the fact. This is one huge advantage that 3D animators have over traditional ones who must create a distinct drawing for every interpolation.

Before we make any more poses, we need to consider one more issue. So far, I've been working in a camera view. As I've moved Junot along the guide line from left to right, it has been relative to the view plane of the camera. What if that view plane doesn't exactly match up with the direction that Junot needs to be moving? Sometimes in straight ahead animation, you will not have a specific target location to hit. Very often though, you will and you have to keep that in mind as you work. The best way to tell if we're on track or not (and I'm guessing we're not) is to move into a top view and step through the animation. Fig. 9.12 shows an accumulation of the frames we've built so far, as well as the location we have to hit.

Note that the last pose is out of line with the ones we've done so far. Also notice how the motion line of our straight ahead frames line up perfectly with the top view of the guide line. This is because the guide line was drawn

FIG 9.11 The Frame 276 Pose.

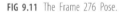

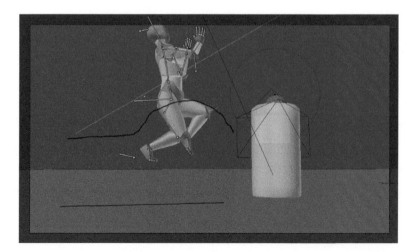

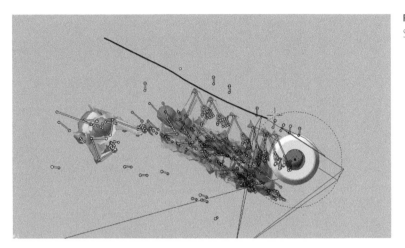

FIG 9.12 A Top View of Our Work So Far.

from the camera view, and just like the sideways motion of the armature, stayed within the view plan of the camera. Fixing this is pretty easy.

First, we show the N-key properties panel to bring up the Grease Pencil tool again. In top view, we mark the location of the body control bone at the start of the motion with the 3D cursor, and then move the frame marker forward until Junot is in her target location at the end. Holding down the D-key, LMB-drag between the 3D cursor and Junot's center of gravity at the end location. This is the line in which her body should follow from this perspective. Notice when you do this that the old guide line disappears! Don't worry though. It's not actually gone. The Grease Pencil tool saves each drawing on the frame on which it was created. By default, it displays that drawing and only that drawing until it hits a frame that contains a new drawing. At that point, it shows the new one. You can imagine how valuable this is when critiquing and annotating animation work, allowing people to take notes and give directions that change along with the animation in the timeline.

In this case, we'd like to see both our old and new guide lines at the same time. To do this, enable **Onion Skinning** on the Grease Pencil panel and set the **Frame** control below it to its maximum value: 120. Onion Skinning instructs the grease pencil system to display all drawings within the Frame value's distance from the current frame. So, on Frame 278, where we are now, we see all drawings from Frame 158 through 398. **Fig. 9.13** shows this in a top view. Additionally, you can disable any grease pencil drawing's relationship to any particular frame by clicking the "film clapperboard" icon on the drawing layer's panel in the N-key properties. Doing so makes it appear across all frames.

Now, we adjust Junot's position on each of our straight ahead key frames so that they fall along the secondary guide line. It won't take much, and you must be careful which bones you are moving. Any bone that touches the floor (the foot bones in the first few poses) should not be moved on

FIG 9.13 Both Guidelines, with Onion Skinning.

FIG 9.14 Adjusting Junot's Position.

those frames. However, the body controller and any feet that are in the air should be moved. While I'm doing this, I also rotate them a bit so that Junot is faced parallel to the new guide line. It's also important to make these adjustments to the frames that already have keys (we're doing this every other frame, remember?). **Fig. 9.14** shows the new positioning. From the camera's perspective, there hasn't been a lot of change, but doing this ensures that Junot lands near to where she needs to be.

Back in the camera view, her legs are beginning to reach back for the ground. On the next pose, the right leg will hit. We'll have to remember to send the shock of landing up her spine with overlapping action and to have her body follow through and continue the momentum of the landing. A few adjustments of the spine are all that remains to do to reach **Fig. 9.15**.

As we build a new frame, we must also remember to jump into a top view and make sure that Junot's body is still moving along the secondary guide line.

On Frame 280, the motion of her body brings the right foot into contact with the ground, as expected. So, we pose the right foot carefully using an orthographic front view to make sure that it lies perfectly on the ground. We just follow the rest of the existing motions for everything else. The spine has snapped back to attention, but the landing has started to bend the lower spine forward again. The left foot doesn't quite hit the ground yet, so it stays aloft—but only by a bit. **Fig. 9.16** shows Frame 280.

FIG 9.15 Just Before She Hits the Ground.

FIG 9.16 Contact!

We continue this every two frames, moving the body along the guide line, following through with the left foot striking the ground, bending the spine with the impact. By Frame 290, Junot's body has reached the end of the line. A glance at the Action Editor (Fig. 9.17) shows that we've hit our goal with 11 frames to spare. That's good, because we'll have to make a nice transition between our last straight ahead pose and the target ending pose. To get it right, we might have to add an additional pose or change our last straight ahead one, but that will be trivial.

Let's see how the motion looks. Back in the Action Editor, select all of the keys and change interpolation back to Bezier (use either Shift-T or the menus). Use Alt-A to play. I've recorded my attempt as the video *Body Only Straight Ahead*. You know what? That's not too shabby. It's already better than my first attempts at this segment using the pose-to-pose method, and we haven't even done the arms yet!

Before we touch the arms, an analysis of our motion is in order. Using the **Motion Paths** tool in the Armature properties, I show the motion path for the body control bone to check the arcs. Arcs were easy when we were making key poses far apart and letting Blender do large amounts of interpolation. With straight ahead animation, things can come out rockier. The motion path is shown in Fig. 9.18, and we can see that the arc is kind

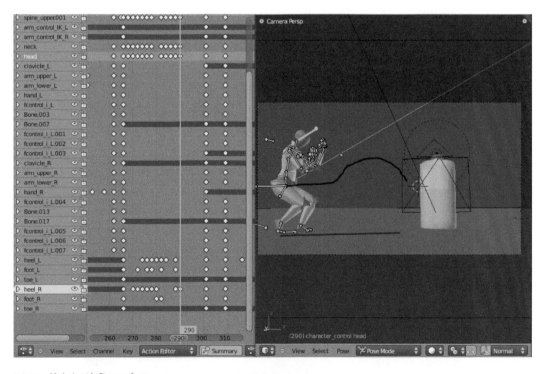

FIG 9.17 Made It with Time to Spare.

FIG 9.18 The Motion Path for the Body.

FIG 9.19 Fixing the Arc on Frame 276.

of bumpy and that the keys are not evenly spaced. As an example, let's look at the one for Frame 276.

By advancing to Frame 276, selecting the body control bone, and adjusting the position just a little bit up and to the left, we see a great improvement in both the arc shape and key spacing. Fig. 9.19 shows the fix.

Also, check out the area between Frames 280 and 288 (Fig. 9.20). There are sharp points in the path with no good reason for them to be there. Remember I mentioned at the beginning of this section that we were working in *twos*, meaning building keys on every other frame? We can break that here to better guide the motion. By inserting keys on the single frame intervals on 283, 285, and 287, we can provide a smoother curve. The process consists of nothing more than moving to the frame in question

FIG 9.20 Before Working on the Ones.

FIG 9.21 The Curve Is Fixed.

and slightly adjusting the position of the body control bone to better approximate a curve. **Fig. 9.21** shows the result.

I also add a number of new keys in the transition area between the straight ahead and pose-to-pose sections in Frames 288 through 309. When I do

this, I'm actually not even looking at the pose. I know that the feet are already anchored, so I can just play with the body control. I know that Junot has to absorb some of the impact of the jump and turn it into a slow backwards slinking walk. I need a motion path that smoothly changes. So, I add keys that make a new curve and gently move from the one to the other. Examining it with Alt-A playback shows that it actually works! You can see the result in the video *Transition*, and the final body control curve in **Fig. 9.22**.

The body and legs are in pretty good shape, especially considering how this section had been turning out using the pose-to-pose method. For the arms, I'm thinking about having the left arm push out toward the pedestal in a warding motion, while the right arm does a full windmill before coming to rest in the final defensive pose. The current state of things doesn't look bad, but it's a little lame. We want to exaggerate the motion if we can.

Between Frame 268 and 270, Junot leans pretty far forward, giving the right arm a start on its rotary motion as shown in **Fig. 9.23**. I select all of the keys for the arm bones and change them to Constant interpolation so that I don't have to deal with the Bezier interpolation of the arm motion at it exists now. Selecting the bone channels in the Action Editor and pressing the O-key selects all of the keys for those channels.

FIG 9.22 The Curve Transitioning Straight Ahead to Pose-to-Pose.

FIG 9.23 The Beginning of the Motion.

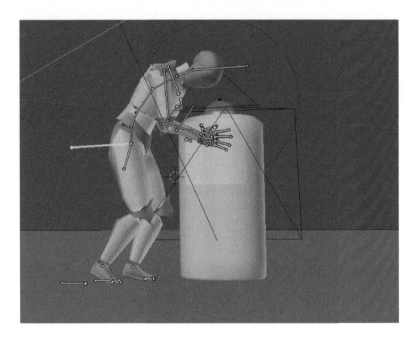

We all know what a circle looks like, and it's not too hard to make the arm straighten and describe one on every other frame. The process is simple: advance two frames, move the arm a little, advance two frames, and move it again. When you get back to the defensive position after going the whole way around the circle, hit Alt-A to see what it looks like. If it works reasonably well, select the right arm keys and release them to Bezier interpolation. If it doesn't, remove the keys in the Action Editor and try it again. You'll almost always come out ahead re-animating than trying to tweak something that isn't working. Alt-A plays it again.

The other arm is even easier. The goal is to have Junot hold the arm out, keeping the hand between herself and the light. In the timeline, wait for an appropriate place to start (around Frame 272). Move forward two frames. Using front, side, and top views, position the arm and the hand something like Fig. 9.24. Keep advancing by twos. On each stop, reposition the arm so the palm of the hand is pointing toward the light. Done.

You can watch the rendered straight ahead motion in *Straight Ahead Now*. Notice what's happened in Fig. 9.25. By advancing on twos and creating keys based on what makes sense for the motion and keeping in mind all of the principles that apply (such as exaggeration, arcs, overlap, secondary action, and follow through), we end up inadvertently creating excellent action poses like the one in the figure. Recall that we weren't looking for this type of dynamic pose. It just happened. It almost seems as though the pose-to-pose and straight ahead methods are opposites that meet in the middle. Pose-to-pose animation targets the creation of dynamic, beautiful

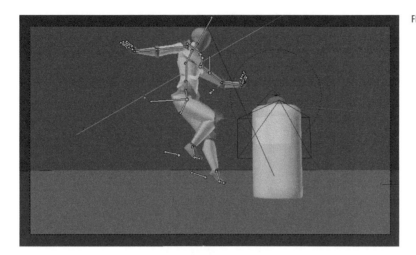

FIG 9.24 The Defensive Hand.

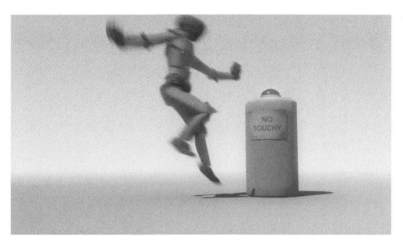

FIG 9.25 A Nice Accidental Pose.

poses. It is hoped that if the correct poses are chosen, the motion that joins them will also be dynamic and pleasing. Working straight ahead, you target the action itself, hoping that dynamic poses will develop as you work.

A Final Note On Pose-to-Pose and Straight Ahead Animation

Which method you decide to use is really up to you, though I recommend that you practice both. You may find that working straight ahead will give you a better sense of timing, and provide you additional insight into overlap and arcs for your initial pose-to-pose breakdowns. If you have a short subject that you would normally try with a planned out pose-to-pose approach, try the same thing using straight ahead animation. Then, go back and do the pose-to-pose. See how the results differ. Of course as I've

mentioned before, animating something once, like building something in the real world, can give you a great deal of insight for the second time you do it. Often, I find that my first (or second, etc.) attempt to animate a particular shot is junk, worthy of nothing but the X-key. The second time I work through it, I know my way around a little better.

Animation Extras

We've worked through using the twelve principles of animation within the context of Blender's animation system, but there's still more to do. There are some specific techniques and tricks that don't fit entirely within any of the principles, but that will need to be addressed so that you can have a more complete picture of how to finish your Blender-based character animation. In this chapter, we'll look at IK/FK switching, picking up and dropping objects, and an introduction to the Non-Linear Animation system (NLA).

IK/FK Switching

Way back in Chapter 3, we detailed the controls for the rig that we've been using throughout the entire book. One of those controls allowed you to switch the arms between their normal FK posing capability and IK, but we didn't use it in the main animation example.

Fig. 10.1 shows the default setup of a file named *against the wall*. If you hit Alt-A after opening the file, you see that animation is provided for Smith to stumble against a wall. He catches himself by putting his hand out, but as you can see, the hand and the arm don't "lock" against the wall like they

FIG 10.1 The *"Against the Wall"* File.

would in real life. If you wanted, you could key the hand and arm on every frame so that the hand appears to be anchored in place like we did with the finger on the light in Chapter 6. With the character's weight actually borne to a certain degree by this limb though, it seems like an ideal time to use IK.

Let's make Smith's arm transition from FK to IK as it touches the wall.

Scrubbing through the timeline, find the first frame on which his hand hits the wall (around 51). Bring up the Armature properties, and locate the IK/FK switches in the Custom Properties panel near the bottom (Fig. 10.2). Set the controls for both left and right arms to 0.0. Change the right arm's control to 1.0. If you have automatic keying turned on (which you probably do), the control will turn yellow to indicate that a key has been set for this value on the current frame. You'll notice when you do this that the arm falls way behind the rest of the body. The IK controller for the arm is still in its original location. In fact, if you press Alt-A now, the animation for the right arm that you saw before will be gone. This is because the key that was just set for the IK/FK switch is the only one that was set for the properties in the entire animation. We're required to add "0" values for this control at appropriate places in the timeline to set it back to FK.

Since we actually want to make the IK arm position mimic at least the initial positioning done with FK, we return to Frame 51 where we first set the IK switch key. Returning the value of the IK/FK switch property to 0.0, the arm and the hand return to their FK positioning. I mark the position of

FIG 10.2 Custom Properties Panel for the Armature.

the hand on the wall with the 3D cursor. Be sure to always do something like this from two different views (such as the front and the side views) so that the cursor is positioned accurately in all three dimensions. **Fig. 10.3** shows the hand's position.

With the position marked, set the IK/FK switch back to 1, grab the hand IK controller bone and try to get the hand to approximate the FK position. You'll notice that you don't get exactly the same arm pose with IK as existed with FK. **Figs. 10.4 and 10.5** show the two positions. The implication of this is that simply setting the IK/FK switch to 0 on one frame and changing it to 1 on the next frame won't be sufficient. It could introduce a "pop" in the animation as the pose changes instantly. In this example it's actually pretty close. You can end up with drastically different poses though. Note that you will probably have to hit the I-key while hovering over the IK switch slider to a set the first key.

The best way to handle this is to move several frames backward from the point on which the IK switch is fully activated and create a blend. Move five frames back from Frame 51 and set the IK/FK switch value to 0.0. Mark the hand's position with the 3D cursor. Now, push the switch up to 1.0 so the arm is IK controlled and match the previous point of contact using the IK controller bone. When that is done, drop the IK switch value back down to 0.0.

Now on Frame 46, you have both FK and IK arm positions that approximate, but don't exactly match one another, and the system fully uses the FK solution.

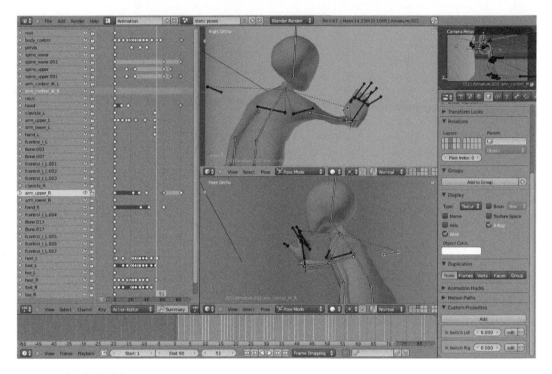

FIG 10.3 Marking the Hand Position.

FIG 10.4 The IK Position.

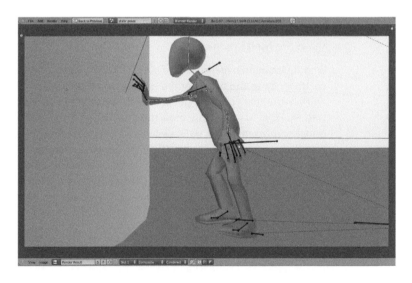

Similarly, on Frame 51, you have two arm positions, one IK and one FK, but the IK one is used fully. Between those frames, the animation system blends the two solutions based on the IK/FK switch value. This produces a pretty smooth transition that is fully locked in place when the arm touches the wall. You can see the result in the video *Stuck to the Wall*.

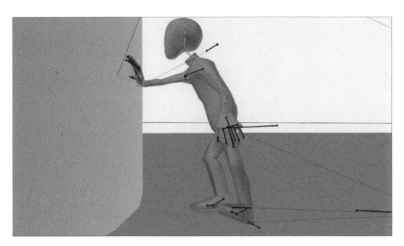

FIG 10.5 The FK Position.

In this example, the difference between the FK and the IK arm positions during the transition was small, so we were able to make it happen within a measly five frames. This will not always be the case. Sometimes the FK rotation on your arm might be almost impossible to approximate with IK positioning. When that happens, you can either choose to extend the blend period so the change looks more natural or alter the incoming FK position of the arm to more closely match the IK. In fact, there is nothing stopping you from building your IK pose first, turning off IK and matching the FK positioning to it, and then animating the previous motion to properly end in that pose.

When the IK limb needs to transition back to FK, you just reverse the process.

On the last frame of contact, mark the limb's IK position with the 3D cursor. Set the IK/FK switch to 0.0 and try to approximate the IK position with FK. Return the switch to the value of 1.0. Advance several frames and set the switch value to 0. Build your FK positioning as you will need it to be to proceed into the animation. Switch back to IK (1), and approximate the FK positioning. Set the switch back to 0. You now have a five frame transition from IK to FK. It's actually easier to move from IK to FK than the other way around because you will always be able to recreate an IK pose with FK, but the reverse will not always be true. Of course, many production-level rigs will give you a great deal of controllability when it comes to IK posing, so you may be able to actually pull off an exact match.

Picking Up and Dropping Items

In my work with beginning character animators, this is the most frequently encountered technical problem that they face. In a way, it's the inverse of the IK/FK switching problem. Instead of making a limb "stick" to a surface using the IK constraint, we need to find a way to make an object stick to an armature.

FIG 10.6 Holding a Monkey.

FIG 10.7 Bone Parenting.

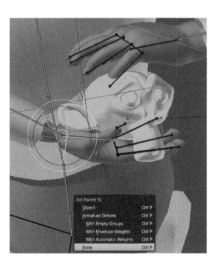

If your character is carrying something for the duration of your shot, the solution is simple. Position the object where it should be "connected" to the character. **Fig. 10.6** shows a monkey's head in Meyer's hand. RMB select the object, Shift-RMB select the hand bone (or whichever bone controls the part of the body to which the object attaches), and press Ctrl-P for Parenting. In the Parent menu that pops up (**Fig. 10.7**), choose "Bone." This links the object directly to the selected bone. Animating the armature now pulls the object along with it.

The problem arises when you need to pick something up or drop it. You can't animate a standard parent/child relationship on or off.

Fortunately there is the Child Of constraint, which allows you to animate this sort of relationship. For such a simple-seeming thing though, the process is quite complex, as you'll see in a moment. You can follow along if you like in the file *chapter_10_how_to_pick_up_a_monkey.blend*.

The Setup

First, place your object in its starting position. In **Fig. 10.8**, the monkey sits on the pedestal, while Meyer stands poised with his hand above it. At this step, it doesn't matter where the character is in relation to the object.

Add a **Child Of** constraint to the object. You can do this by selecting the object and either choosing the constraint from the drop down menu in the Constraint Properties (**Fig. 10.9**) or using the **Ctrl-Shift-C** hotkey, which brings up a pop-up with all of the different constraint types. When the constraint is added, you will have to enter both the Armature object itself and the particular bone that you want to use to "hold" the object in the constraint's panel. In **Fig. 10.9**, you can see that we've chosen our main armature object, targeting the right hand bone. Note that this technique

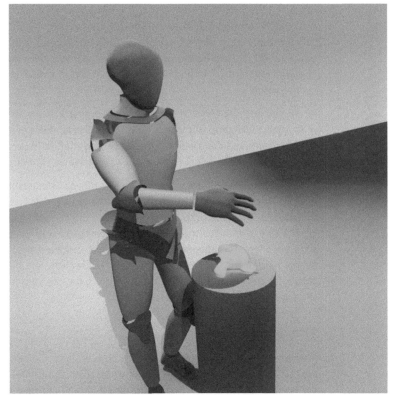

FIG 10.8 The Starting Position.

271

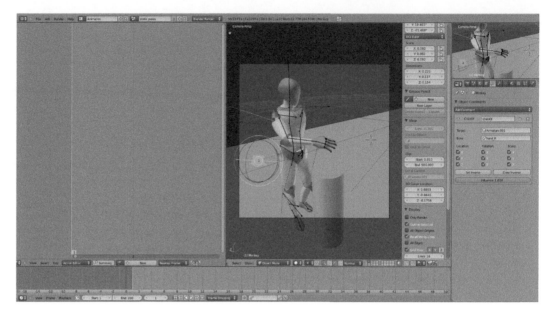

FIG 10.9 The "Child Of" Constraint Panel.

works with any situation in which you want an object to temporarily stick to your character. It doesn't have to be held in the hand. The process is equally valid for, say, a little monster that jumps onto someone's shoulder. The only difference is in finding the correct bone to use for the object's anchor point.

When you add the Child Of constraint and properly fill out its panel, your main object will jump out of position. This is a side effect of establishing the constraint and can be easily fixed. Pressing the **Set Inverse** button on the constraint panel returns the object to its original, correct position.

Now that it's back, set a **LocRot** key on the object. This establishes the object's location not only in space, but in the time line as well. Then, on the object's Child Of constraint panel, reduce the constraint's **Influence** control to 0.0. With the mouse hovering over the control, press the I-key to set a key frame for influence. You'll know you've done it properly if the background of the Influence control turns yellow. Now, we have a constraint created with good initial conditions, the object is in place, and the constraint is effectively turned off.

The Grab

Animate the hand into place around the object as you normally would. **Fig. 10.10** shows one possible pose for this. Find the frame on which the hand establishes control over the object. In the example animation,

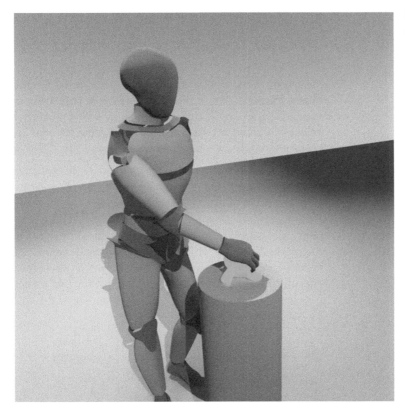

FIG 10.10 The Hand Closes around the Monkey.

it is Frame 10. The question to ask yourself when finding this frame in your own work is when is the object no longer in control of itself? From this point on the time line, move backward one frame.

Once again, hover your mouse over the Influence control on the object's constraint panel. It should still read 0.0. Use the I-key to set another key. The control, which was probably green, turns yellow. Go forward one frame, to the frame on which the hand gains control of the object. Set the Influence slider to 1.0 and create another key for it.

As it did in the setup phase, the object jumps out of position. To fix this, first press the **Clear Inverse** button followed by the **Set Inverse** button. I know this is some strange voodoo, but it works. I don't even personally understand exactly what these controls do behind the scenes, and I arrived at this process through a good deal of experimentation.

You will now find that the character has picked up the object. Any animation that is done to the armature brings the monkey right along with it. If you're not planning to have your character drop the object, then you're done with the process. Animate away!

However, if you need your character to drop the object in the same shot...

The Drop

Unfortunately, it's not as simple as merely reversing the previous instructions.

Manipulate the animation until the character is at the point where it will release the object. This might mean that it is in position on another surface (Fig. 10.11), or that the character is actually letting go of the object without anything to support it. The release process is the same for both cases and only varies in what you do afterward.

With the hand ready to let go, back up one frame. Set a key on the Child Of constraint's Influence control, which should still show a value of 1.0. Now, select the object itself and set a **LocRot** key. Because of the way that keying works, if you were to examine the F-Curve of the monkey head, you would see that it hasn't moved at all! The key you just set and the previous one are for identical location and rotations. In the animation system, constraints are applied after F-Curves. So while the object *appears* to be in the hand, its particular location and rotation are generated not by its F-Curve transformation but by the one generated by the constraint.

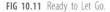

FIG 10.11 Ready to Let Go.

Move forward one frame to the actual place in the time line of the release. Set another key on the object, but this time, choose **Visual LocRot** from the I-key menu. Unlike setting a regular key, which just looks at F-Curves like we saw a moment ago, the set of keying options tagged with "Visual" operate on the object's final transformation. Regular keying looks at F-Curves. Visual keying is concerned with the state of the object that you can actually see in your 3D view.

Remember that any time you want to record an object or bone's transformation while under the influence of a constraint like this, you need to use one of the Visual keying methods.

On that same frame, set the Child Of constraint's Influence to 0.0 and set a key for it. If you had done this before setting a Visual LocRot key, the monkey would have traveled back to its starting location on the table. However, because of the special transformation key, the monkey stays exactly where we want it to be. Actually, that's not entirely true. Due to a display bug in the animation system, the monkey still moves back to its starting point, but it's not "real." Simply advancing the frame counter and moving it back fixes the problem. A lot of people actually get this far in figuring out the process for themselves, but completely lose it at this point because the stupid object won't do what it is supposed to do.

Now though, the process is finished, and the character and the object can once again move completely independently of one another. If the object has been placed on a surface, you're done. However, if the character is dropping or even throwing the object as it is in the example, you'll have to use regular key-framing methods to make it work. Just remember that a thrown object should continue along the tangent line of the arc of the hand when it is released. To help you visualize this, you can use the Motion Paths tool in conjunction with the Grease Pencil as shown in **Fig. 10.12.**

NLA

Through all the work we've done so far in this book, a character's animation has been driven only by the keys that appear in the Action Editor. The keys that appear in the Action Editor are grouped in a linkable data block called an **Action**, just like materials, meshes, and other linkable blocks in Blender. With the Non-Linear Animation (NLA) system, you can use many different actions at once to generate animation. Why would you want to do such a thing? Once an Action has been added to the NLA system, it can be mixed and blended with other actions or stretched and shrunken in time. This functionality probably doesn't provide sufficient quality for "hero"- level animation, but for background characters, you can create a small library of actions that contain behaviors such as walking, waving, and looking around, and then blend them together in different orders in the NLA Editor to give your background characters the illusion of being busy. Likewise, an action that shows a character taking a single stride

An Alternative Method
If the Child Of constraint gives you the willies, here's another way to go about it. Create an Empty that coincides with the starting location of your object. Make the object in question a regular (i.e., non-constraint) child of the Empty. Give the Empty both Copy Translation and Copy Rotation constraints, pointing to the hand bone, but set their influence to 0.0. When the hand is in place for the grab, turn their influence up to 1.0 and key it. The Empty and the object now stick to the hand. You'll have to experiment with the exact placement of the Empty object in relation to the grabbed one so that when the Empty is stuck to the hand bone, the object itself appears to be held in the hand, not passing through it. You should be able to figure that out yourself at this point.

FIG 10.12 Creating a Motion Guide with Motion Paths and Grease Pencil.

(a)

(b)

can be repeated and, in conjunction with a blended action that moves the character forward, produce a continuous forward walk of arbitrary length with little additional effort. At its extreme, the NLA system could even be used to string together pre-made actions via scripting to create a nearly automated system for crowd motion.

The second use for NLA, and one in which I have great difficulty seeing the practical value, is to build up animation for a single character in layers. Once you have created rough animation in the Action Editor, you can in theory add more Actions "on top" of the original one in NLA, providing layers of refinement. It can be used for making high-level adjustments to existing actions that are too complex to adjust by hand, like the kind of keying information you would get from a motion capture system. We're not going to cover that method in this book.

The third use for NLA is to quickly switch between different "takes" of an animation. If you're only working with a single character, this is simple to do without NLA. You just choose a different Action for your character in the Action Editor window. However, if you are working with multiple characters

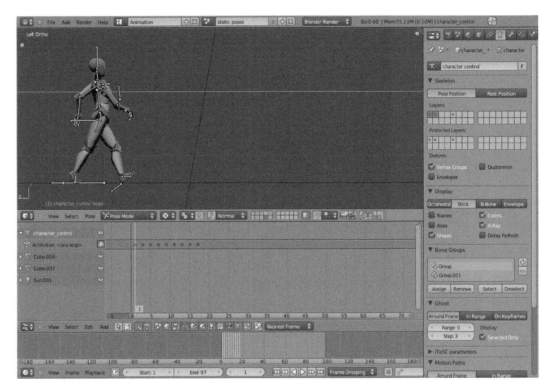

FIG 10.13 The NLA Editor.

and want to try different combinations of animation takes that have been recorded as actions, the mute and solo capabilities of the NLA Editor make this a breeze.

To understand the basics of how the NLA Editor works, let's take a simple forward stride (two steps) and use it to make our character take ten full strides with very little extra work. Open the file, *Chapter 10 NLA Experiment*. Previously, we've divided animation screens vertically, with the 3D view and the Action Editor side-by-side. This time, the division is horizontal, placing the 3D view above a wide NLA Editor, shown in **Fig. 10.13**.

Repeating and Blending Actions

Upon first view, the NLA appears to be a track-style editor like Blender's Video Sequence Editor. That is a correct analogy. Just like the VSE, the NLA Editor builds up tracks of animation, but in this case, the clips are actual Actions instead of imported movies or images. Every time you've begun to animate something in Blender, you didn't know it, but you were also creating an NLA entry. This NLA entry appears as a red strip right under the object's name in the editor. The strip, shown in **Fig. 10.14**, displays the action's name, and a snowflake button.

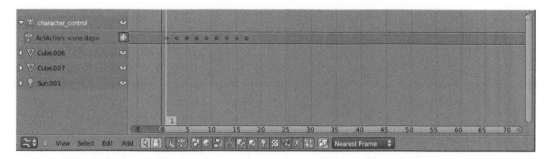

FIG 10.14 An Action Strip.

FIG 10.15 A "Frozen" NLA Strip.

At this point, there is nothing special about seeing the Action in the NLA. Pressing Alt-A in the 3D view (or with the mouse over the NLA) just shows Junot taking a full stride forward and then freezing. That's all the animation that there is. If you were to move a few frames into the animation and make a change, it would be recorded in the Action just as though you had the Action Editor or Graph Editor showing. If you click the snowflake button though, things change. The snowflake button "freezes" the current Action into an NLA strip. The main track for the object is cleared and the Action is moved into an NLA track (Fig. 10.15). If you were to check in on the Action

Editor at this point, there would be no Action linked to the character there. This is where the fun begins.

RMB select the strip and hit the G-key. The entire strip moves freely along the time line. You can position the entire action anywhere you like in time as a whole. If you found that you wanted your animation to begin on Frame 54 instead of Frame 1, you could select all of the animation's keys in the Action Editor and move them, or you could do it to the whole action at once in NLA. If you are only dealing with a single character and a single action it's probably not worth it to use the NLA, but if you are trying to coordinate actions across several characters and objects in a complex scene, the ability to direct them like this can save you a lot of time.

With that same action strip selected, press the N-key to bring up an in-window properties panel, shown in **Fig. 10.16**. From here, you can start

FIG 10.16 The n-key Properties for an NLA Strip.

to experiment with a number of effects. The first one to try is to change the length of the strip with the **Scale** control in the **Playback Settings** section of the **Action Clip** panel. Set the animation running with Alt-A in the 3D view. As you make the strip length larger, the animation slows down. Make it smaller, and things speed up. Changing the strip scale compresses and expands the action. You can also accomplish this by using the S-key as though you were scaling any other object in Blender. Note that the original Action remains unchanged: Frame 1 is still Frame 1 and Frame 120 is still frame 120. When it is interpreted through the NLA though, the overall timing can be altered.

But let's say that you've "frozen" an Action into an NLA strip, moved it forward in time and scaled it so that it happens slowly, and now you want to fix a bad pose that's a part of the action. How do you do that? If you just change the pose in the 3D view, something will happen, but it won't be what you expect. A new Action is added to the armature, on top of the track that was frozen. That's not useful for fixing the existing action though. To make a change to an action that has been frozen, you will need to make sure that strip is selected in the NLA and press...? Guesses? The **Tab key**.

Pressing the Tab key on an NLA strip enters "tweak" mode, which is just another way of saying that you are in Edit Mode on the Action. Little green keys appear in the NLA timeline to indicate that the actual keyed values are accessible (**Fig. 10.17**). As a default, you work in tweak mode with the Strip's timing displayed however you have it configured in NLA. If you prefer to make your tweak using the Action's original time line, press the "pin" icon. This temporarily shows the keys as though they had never been re-timed in the NLA. I highly recommend performing any changes to an Action in the NLA using its original timing via the pin icon. Here's why:

When you were working in the Action Editor, all of your keys (probably) ended up on single frame increments, because we were using nearest-frame snapping. As you scale an action in the NLA, those keys stop lining up with integer frame numbers. This isn't a problem for Blender, as it will happily calculate the correct interpolation on the integer frame that it is trying to display or render. However, it might become a problem for you.

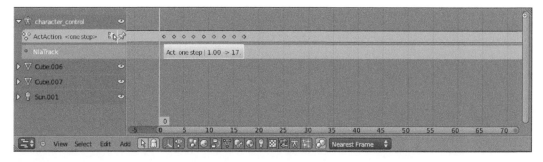

FIG 10.17 An NLA Strip in Tweak Mode.

Let's say that the pose you want to change sits on Frame 97 in the Action Editor. Because of the NLA adjustments, that column of keys is now really on Frame 54.32. If you were to try to tweak this pose using the NLA's time adjustments, you would find yourself either on Frame 54 or 55. If you made a change to the pose, it wouldn't really be a change: it would be a whole new pose, with new keys slightly offset in time from the original. In fact, if you've scaled a strip in the NLA, you should *never* attempt to tweak it there. You'll introduce new keys and weird jumps to your animation.

If you've been playing around in Blender while reading this, return the "simple walk" strip to its original scale of 1.00 (17 frames), leave tweak mode with the Tab key, and set its start back to Frame 1. Over in the N-key properties, find the Repeat control. Set it to 10.0. The strip expands to ten times its original length, and little dividers are shown to indicate where along the time line the repetitions take place (Fig. 10.18). Pressing Alt-A now shows Junot performing the same forward stride ten times, each time covering the same portion of ground. It would be great if there were some easy way to string these repetitions together so that she walks forward. In previous versions of Blender, different methods have been put in place, but they have always been subject to some arcane rules and never worked very well unless you executed their set up perfectly. Perhaps with that in mind, there is no "automatic" tool to accomplish this yet in Blender 2.5. Fortunately, the standard NLA tools make this a pretty trivial thing to do.

Go into a side view in the 3D view and set the time line to one frame before the first repetition of the walk (Frame 17). Mark the heel location of the forward foot with the 3D cursor. Back on Frame 1, select the armature's base bone (not the body control bone) and set a location key for it. Advance to the first frame of the first repetition, where Junot has jumped back to her starting position. In a side view, move the base bone to the right until Junot's front foot hits the 3D cursor. When you added the key for the base bone, a new Action was added to the armature, layered on top of the repeated walking animation. The new key on Frame 18 is also added to this Action. The NLA system will use the result of both this new action and the original frozen one to generate the final pose in the 3D view.

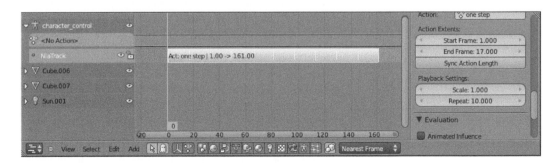

FIG 10.18 A Repeated Action Strip.

281

Scrubbing back and forth over Frames 1 through 18 though shows that there is a small problem. The base bone slides forward over the course of the stride, pulling Junot rapidly forward. What we really want to have happen is for the bone to stay in place for Frames 1 through 17, and then jump into its new position on Frame 18. Sounds like Constant Interpolation, no?

A quick trip to the Action Editor shows the two keys that are set on the base bone channel, and nothing else. Select those keys with the A-key and change them to Constant Interpolation with Shift-T. Now, the animation functions as we hoped, at least for the first repetition. Junot walks forward for the first seventeen frames, and then continues to advance on the next seventeen as well!

To extend this technique throughout the rest of the sequence, all that you need to do is:

- find the frame before the next repetition begins;
- mark the front foot's heel position with the 3D cursor;
- advance one frame;
- move the base bone forward until the front foot matches the 3D cursor location.

It only takes a few seconds for each iteration, and before long, you have Junot walking happily forward for ten full strides, even though you only had to animate one of them. You can examine the file named *chapter 10 long walk.blend*, which shows the result of this activity.

Examining Different Takes

Let's say that you have a scene with three different characters, and you've come to a good point in your animation work. For each character though, there are a couple of spots that you'd like to try to animate again to get them a little better. In the Action editor, you would duplicate the current action by pressing the number button beside the Action's name, highlighted in **Fig. 10.19**. This number indicates how many "users" the Action has, and clicking it creates a duplicate of the Action. From there, you rename it—something like *one step take 02*—and proceed to change the animation. You still aren't satisfied with that second take, so you do this again, making a third. Which is better? You're not really sure.

In fact, you perform this process for all three characters in your scene. So now you have three actions for each character, meaning that your final animation will be one of the nine possible combinations. You decide that you want to at least see an Alt-A playback of each combination of takes. To do this without NLA, you would have to select each armature in turn and choose the appropriate Action for it in the Action Editor.

However, if you use a "take-based" work flow in the NLA, it becomes much simpler. **Fig. 10.20** shows the NLA Editor with the last take as the active

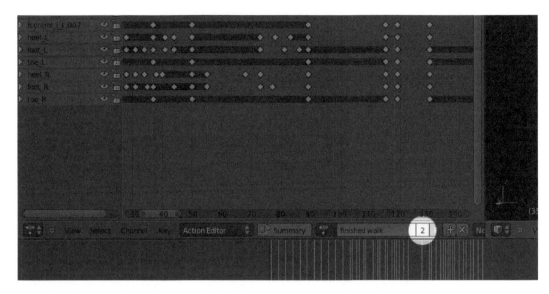

FIG 10.19 Duplicating an Action.

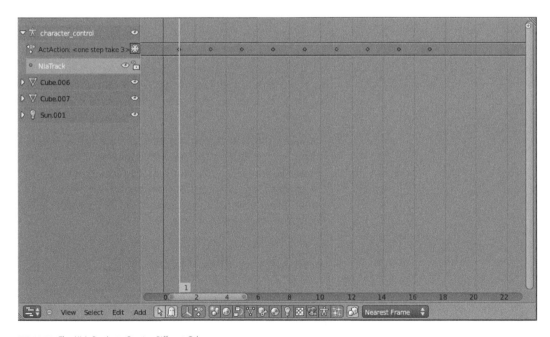

FIG 10.20 The NLA Ready to Receive Different Takes.

Action. Clicking the snowflake freezes it into an NLA strip. Now, with the mouse over the strip workspace, press Shift-A, the universal "add something" command in Blender. A list pops up with all of the available Actions. Selecting one of the other takes, it shows up as an additional

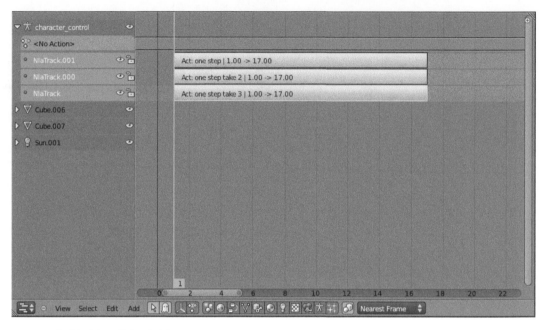

FIG 10.21 All of the Takes Added as NLA Strips.

track in the NLA. Repeating the process brings in the first take. The new strips will appear with their starting point wherever the Current Frame Marker resides, so you may need to adjust their positioning along the time line.

Fig. 10.21 shows all three takes added to the NLA as action strips. The eyeball icon in each strip's channel controls whether or not that strip is considered in the NLA. So, to try different takes, you disable the eyes on all the channels, and then enable the one you want to see. From the single control panel of the NLA, you can control which actions are used for any number of characters and objects.

Animating the Alarm

As a last bit of animation, we'll do the work on the props. The alarm system is mechanical, but that doesn't mean that we can't apply any of the principles to it.

Fig. 10.22 shows the alarm system rig. The armature only controls the horns, and there is nothing fancy about it. No mechanical constructions with constraints that operate the whole thing with a single control. It's just six bones, unrelated. The rotating lights are rigged by simply making them the children of a single Empty object, which is animated. The little flags receive direct key frame animation without any additional controls.

FIG 10.22 The Alarm System Rig.

FIG 10.23 The Alarm is Ready to Spring.

The first principle we're going to use is "**slow in/out**," and we're going to use it by violating it. This is a mechanical system, and to make it look that way, we will purposefully avoid using "slow in/out" on it in the form of Bezier interpolation. The motions of the alarm will be done with linear interpolation. Natural characters exhibit "slow in/out," so we go directly against that to highlight the un-natural flavor of the machine.

Fig. 10.22 also demonstrates the "deployed" state of the alarm from Frame 265, as it is the pose that I created first. We know from the way we animated Junot previously that the alarm is quite a surprise, so the horns must appear quickly. Dropping back three frames then, I rotate the control bones for the horns so that they all gather inside of the pedestal. I don't want them sticking out the back because even if you couldn't see them directly, you would be able to see their shadows in the long shot. Fig. 10.23 shows a wireframe view of the shot with the horns collapsed.

(a)

(b)

(c)

FIG 10.24 (a–c) Squash and Stretch on the Horns.

Automatic keyframing takes care of creating a set of keys for me on Frame 262. Once they are made, I select them in the Action Editor and use the Shift-T hotkey to set them to linear interpolation.

Now comes the fun part. I've decided to animate the horns completely with squash and stretch. The armature uses the Maintain Volume constraint on every bone, so scaling the bone up produces a proper stretch, and making it smaller produces a nice squash. You can see the three states in **Fig. 10.24**. To get the timing correct, I simply pretend that my hand is one of the horns, and make an alarm sound with my mouth. Braaaap! Braaap! I also try to count in my head as I do it. By using this extremely scientific and not at all humiliating methodology, I determine that each cycle of a horn should take just over a second.

It doesn't matter which horn I animate first, so I choose one at random: the upper left. I set a Scale key for its starting position and advance twelve frames. Automatic key framing takes care of things for me when I scale it upward to stretch it out. Twelve frames ahead I shrink it so it's nice, short, and fat. I repeat this process until I've reached the point where Junot is off camera. As precision doesn't matter here, it goes quickly. There is no set target for how large or small the horn needs to be at each stage. When everything is animated, it should look like systematic chaos.

I proceed to the next horn, the small one just below the upper left. So that the horns are not in perfect sync (overlapping action!), I set the first scale key, and then advance only eight frames for the first stretch. I also decide that to keep things chaotic, the two smaller horns will cycle more quickly than the large ones on a sixteen frame repeat. So, I go through the rest of the timeline eight frames at a time, squashing and stretching the little horn.

Working through the remaining four horns, I make sure that I use a slightly different beginning offset for each so that none of their animation lines up perfectly with the others, and even vary the cycle length (22 frames on

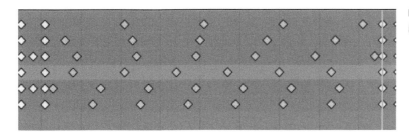

FIG 10.25 Keys for the Basic Horn Motion.

one, 25 on another and so on) so that even the out-of-sync gets out of sync. When I'm finished with all fix horns, I have an Action Editor that looks like **Fig. 10.25**.

That doesn't produce the vibrating animation that you see in the final product though. To do that, I adapt a technique from traditional animation for creating vibration or chaotic motion. Traditional animators use a trick where they animate the same sequence (on two's) two different ways, say, someone stumbling backwards. Then, they interleave those two animation sequences so that the even frames show one animation and the odd frames show the other. When run together, it produces a vibrating effect that imparts a lot of energy and chaos to the animation. That's what we're going to do.

The first step is to get our animation on twos. I proceed to the first frame of the alarm animation. Every horn already has a key here, so we don't need to do anything. Then, I advance two frames. In the Action Editor, I press the I-key to create a new key frame and choose **All Channels** from the menu that pops up. Be careful that you aren't in Dope Sheet mode, as you don't want to lay down a key for every single object in the animation right now!

Move forward two more frames and create another key for all of the channels. We're going to proceed like this through the rest of the sequence, setting keys every two frames for every bone in the armature. As you encounter keys on odd frames, just ignore them and keep working. It won't take long before you've filled in the whole section. Now, go back and find the odd keys—the ones that didn't fall on the twos—and delete them. We don't need them anymore. When you're done, you'll have something like **Fig. 10.26**: a nice set of columnar keys.

The traditional version of this technique called for an entire additional animated sequence to interleave with the columns of keys. We don't need to do that though. I just grab the last two thirds of the keys, duplicate them with Shift-D and slide them backwards in the time line until they are interwoven with their originals, as shown in **Fig. 10.27**. Pressing Alt-A shows me that it produces the exact effect I'm after: the horns squash and stretch chaotically, appearing to vibrate as they do so. Depending on exactly how the two

FIG 10.26 Keys Have Been Added for the Whole Sequence.

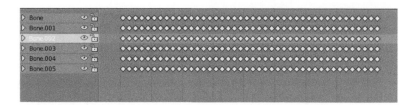

FIG 10.27 Lots of Keys.

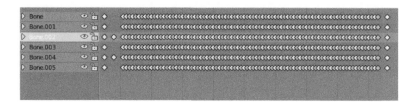

instances of animation lined up, I may have had to choose a different section to duplicate and interleave for the right effect, but luckily I hit it on my first try.

The last gasp of the horn uses the same technique, but incorporates one more principle: anticipation. Before the horn gives its final blast, it takes a deep "breath." So, even though we've been animating a machine, you can see how we've used some of the principles, as well as an old traditional trick, to try to give it some character.

The flags were animated by hand, and are nothing fancy. I set a rotation on them, advanced two frames, and gave them a twitch, then two more and another twitch. Twelve frames ahead, I changed the rotation and did it all again. The lights were set to a constant rotation throughout the entire animation by keying just less than 180 degrees of rotation on their parent Empty and setting the rotation to **Linear Extrapolation** in the Graph Editor.

When animating the settings for the lights, it is a simple matter of finding the frame on which you want to turn them on and off and setting keys on that frame and the one before it. Just like we keyed our constraint influences previously, key the lamp colors and intensities by hovering the mouse over the respective control in the properties panel and hitting the I-key. Unfortunately, keying a color swatch doesn't give you the nice visual feedback of the yellow/green controls like numeric buttons. You just have to keep your eye on the Action Editor and note the appearance of the keys.

It turned out that just keying the rotating alarm lights down to 0.0 energy did not make them disappear completely. **Fig. 10.28** shows what happened when I did this. The beam of light was generated by the **Halo** setting in the lamp properties, and apparently it made that kind of ugly artifact with no energy. So, I set the on/off keys for the Halo property itself. That's right: you can even key a simple check box, just like anything else.

FIG 10.28 Lamp Halos with 0.0 Energy.

Conclusion

And so we come to the end of our animation exercises. With the animation finished on the alarm system, it's just a matter of rendering the individual frames from the different camera angles, and then putting them all together in the Video Sequence Editor. That functionality is outside the scope of this book, but it's quite common. You can learn how to do it from various Web sites or from either of my other two books from Focal Press: *Blender Foundations* or *Animating with Blender*. The final video, which I'm sure you've already seen at this point, is titled *Junot Surprise*.

Appendix: Animation Playback and Rendering

I've put the goods on animation playback and rendering in this appendix because they really don't fit anywhere else, but you need to know them. When working as an animator, real time feedback is vital. In Blender, there are three ways to play your animation: live in the 3D view, as an OpenGL rendered animation file, and as a fully rendered animation. These methods provide trade-offs between the amount of time it takes to make them and the quality and usefulness of the end result.

The live playback you get in the 3D view with Alt-A is instant. There is no waiting involved. You press Alt-A and your animation plays. The drawback is that if your scene is even moderately complex, you will either get nonreal time playback or find the animation skipping frames to keep up. Performing an OpenGL render only takes a minute or two, but you have to do some preparation, and the result, while always in real time, can lack crucial visual elements like motion blur. Finally, a full render gives the best quality, but can take a very long time.

We'll spend a little time on each of these so that you can not only get the best performance out of Blender but also be able to choose the most appropriate method for your playback needs.

Live Playback

The easiest method of testing your animation is to hover the mouse over the 3D view and press **Alt-A**. This triggers Blender's live animation playback. **Fig. A.1** shows the Frame Dropping menu on the Timeline window. By default, your .BLEND files begin with the **No Sync** option chosen. This means that when attempting play your scene live in the 3D view, Blender will draw each and every frame, one after the other, regardless of how long it takes, up to the top speed that you have indicated in the **FPS** section of the **Frame Rate** controls in the Render Properties. This means that if you've set your animation to 24 Frames per second, and your computer can only draw 6 per second, that's exactly what you'll get: *slow* playback, which is unsuitable for animation analysis.

On the other hand, if your scene consists of nothing more than a six-sided default cube zipping around and you're running a dual quad-core system

FIG A.1 No Sync and Frame Dropping.

with a high end video card, Alt-A playback will earn you ... twenty-four frames per second. Blender targets your actual FPS request.

Let's say that your computer isn't quite up to real time playback of your scene though. You can help Blender along by changing from **No Sync** to **Frame Dropping**. With this enabled, Blender keeps track of how long it took to draw the last frame and skips an appropriate number of frames before drawing another in order to catch up. So, in the example where the computer is only capable of drawing six frames every second, instead of getting Frame 1, then Frame 2, then 3, etc., you get Frame 1, then Frame 7, then Frame 13. The animation mostly keeps pace with real time, even though what you see on the screen won't be as smooth as you'd like. Even with Frame Dropping enabled, there is some uncertainty to the process, and you probably won't consistently achieve your desired frame rate. To keep an eye on this, you can enable the **Playback FPS** option in the **Interface** section of the User Preferences (Ctrl-Alt-U, or the File menu). It displays the current FPS rating in the upper left of 3D views during playback.

As using Alt-A will be the workhorse of your real time feedback while animating, it's important to optimize your settings so that it has the best chance of working well. The first thing to do is to hit Alt-A with the Playback FPS option enabled and see what happens. If you're consistently getting around 24 FPS displayed while using No Sync, you're fine. Set the option to Frame Dropping and have at it. You'll get the correct rate of playback and won't be missing much. However, if your frame rates are pretty low, here are some suggestions to boost performance:

1. Disable subsurface modifiers on deforming geometry. While it looks nice in the renders, using armatures to deform models that use subsurfacing (and other geometry-generating modifiers) can destroy display performance. Leave it on for rendering, but set your **View** subdivisions to **0** (Fig. A.2). As a shortcut, you can enable the **Simplify** panel in the **Scene** properties and set the **Subdivision** control to 0. Don't forget to set it back to something reasonable (the default is 6) when you're done.

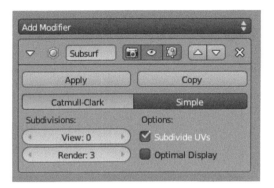

FIG A.2 Turning Subdivision Surfacing Off in the 3D View.

2. Use Solid shading mode. If you're used to working in the pretty GLSL shaded mode in the 3D view, switch to Solid. It doesn't look as sweet, but it's way faster.
3. Remove unneeded props and scenery. What do you really need to have showing in your scene to evaluate your animation? Would a few placeholders do instead? The less that Blender has to draw, the faster things will go.
4. Do you have multiple 3D views? Sometimes people work with several 3D views available. For each one that shows the animation, Blender has to do extra work.
5. Use a proxy character. Even with subsurfacing disabled, my laptop still had trouble giving me a decent frame rate with the skinned versions of Junot and Meyer. Once again, mesh deformation is hard. The versions of the characters that are made of separate pieces (sometimes called "tin cans"), parented to individual bones however, fly right along.

Once you can consistently achieve a good frame rate with a combination of these techniques, you can feel free to use Alt-A playback as your general previewing tool. Change the timing? Alt-A. Rework an arc? Alt-A.

To stop Alt-A playback, there are two separate commands. Hitting the **Esc-key** cancels playback and returns the current frame marker to its original position. However, if you press Alt-A again, the current frame marker will remain wherever it was during playback. So, if you're hitting Alt-A to look for a specific spot in the animation that you'd like to tweak, pressing Alt-A again when you find it is the way to go.

Once you're pretty sure that you have a section of animation how you like it, you can "upgrade" to the next tool for playback: the OpenGL render.

OpenGL Rendering

The next step up in quality is OpenGL rendering. Blender allows you to dump the OpenGL 3D view into a savable still render or animation with the two buttons on the 3D view header, highlighted in **Fig. A.3**. The camera icon on the left produces stills, while the movie clapper on the right makes

FIG A.3 The OpenGL Render Icons.

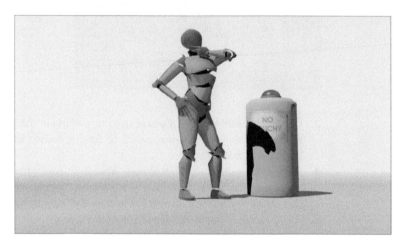

FIG A.4 A GLSL Render.

animations. While they use the view settings of the 3D window (camera view, drawing mode, perspective/ortho), the size and file format settings are drawn from the Render Properties.

So, if you have the 720p render preset selected for size and frame rate, and the H.264 option in the Output panel, pressing the movie clapper button on a 3D view set to camera view will produce a full 720p H.264 file rendered from the camera's perspective, but in the OpenGL mode chosen in the 3D view instead of using the internal renderer.

How fast is it? Pretty fast actually. In fact, it's just as fast as the Alt-A playback in **No Sync** mode. The difference is that instead of just piping the OpenGL result to the screen for you to watch through the view, it saves the results into an animation file. Find that animation file (an .AVI file if you used the H.264 preset) and play it back in your favorite animation viewer. This will basically guarantee that you see it in real time, and you can usually watch in full screen too.

The real advantage of using this technique is that Blender's GLSL textured mode provides some nice visual features. The image in **Fig. A.4** is an OpenGL "render" of the sample scene. Note that many textures—particularly those that were UV mapped—are present and correctly displayed, the mist effect is working, objects cast shadows, and the image is even anti-aliased. In order to get this decent quality (for a preview) out of the 3D view, use the following settings:

1. In the N-key properties panel, choose **GLSL** for the shading mode in the Display panel.

2. To cast shadows, you can use only spot lamps with buffered shadows. Also, I've found that having certain object types visible in the scene—like armatures—prevents shadows from working. Send them to another layer, or create a new layer for OpenGL preview "rendering" that contains on the objects that you want to see.
3. Use the **Only Render** option in the **Display** panel of the 3D view's N-key properties. This turns off all the grids, guidelines, and other sorts of things that normally show up in the 3D view but don't actually render. This is an easy way to give yourself a clean OpenGL view and render.
4. If you have Anti-Aliasing selected in the Render properties and are using Blender 2.54 or higher, your OpenGL render will be anti-aliased as well.

Even with these fairly robust settings, my laptop was pulling four or five frames per second. It's not real time (which is why we're dumping to an animation file), but the quality is pretty good and it's much faster than doing a traditional render. Of course, you don't get the sky background from the world settings, render-level subsurfacing on objects, and cannot pipe the result through the compositor for motion blur, etc.

The Real Thing

When you've done all that you can do with the various methods of previewing, there comes a time when you just have to see how it looks in the final render. Color grading, depth of field, and especially motion blur can have a definite effect on whether or not an animation works. While a full text on efficient rendering for animation is outside the scope of this book (the book *Blender Foundations* includes an entire chapter on optimizing renders, especially for testing), here are a few hints:

1. Always use the compositor. Don't let the raw render output be the final word.
2. Motion blur is a must. Use the vector blur node.
3. For short test renders, you can go straight to a video format. For longer animation renders that might need to be interrupted, render to the still .PNG format and compile an animation afterward in the Sequence Editor.
4. For gross motion, a lower resolution render blown up to full screen size on playback will often suffice.

Test your animation early and often. Remember: the more efficiently you can playback and test your work, the more chances you will get to revise it and beat it into shape before you have to move on to something else.

Index

Page numbers in *italics* indicate figures and tables

For Product Safety Concerns and Information please contact our EU representative GPSR@taylorandfrancis.com Taylor & Francis Verlag GmbH, Kaufingerstraße 24, 80331 München, Germany

T - #0065 - 090625 - C312 - 246/189/18 - PB - 9780240817576 - Gloss Lamination